MAKE IT NEW

KURT HEINZELMAN, GENERAL EDITOR HARRY RANSOM HUMANITIES RESEARCH CENTER

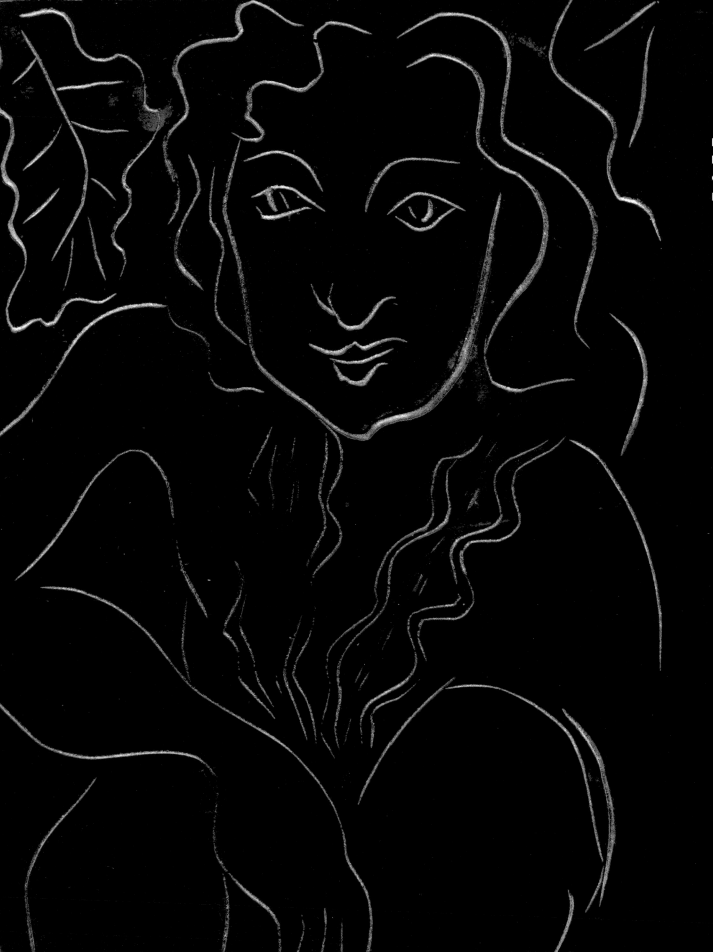

Henri Matisse (1869-1954), *La Tahitienne*, one of three linocuts completed in the 1930s for an illustrated deluxe edition of Baudelaire's *Les Fleurs du mal* that was never published.

HARRY RANSOM
HUMANITIES RESEARCH
CENTER

THE UNIVERSITY OF TEXAS AT AUSTIN

PUBLISHED ON THE OCCASION OF THE EXHIBITION "MAKE IT NEW: THE RISE OF MODERNISM"
Cathy Henderson, Curator of Exhibitions, Harry Ransom Humanities Research Center, University of Texas at Austin, October 21, 2003 to March 7, 2004.

This exhibition and book publication are supported by a grant from AT&T.

EXHIBITION CURATORS

Linda Ashton,
Associate Curator of the French Collection

Linda Briscoe Myers
Assistant Curator of Photography

Kurt Heinzelman,
Executive Curator for Academic Programs

Cathy Henderson
Curator of Exhibitions

Dell Hollingsworth
Music Specialist

John Kirkpatrick
Clarence L. and Henriette F. Cline Senior Curator of Modern British Literature

Peter Mears
Associate Curator of Art

Ben Stone
Graduate Intern

Rick Watson
Research Assistant, Performing Arts

Special thanks to Chris Fletcher, Curator of Literary Manuscripts, British Library

Production Assistance:
Margaret Barker

Publication Assistance:
Hilary Edwards

Permissions and Copyrights:
Tracy Fleishman and Eric Lupfer

Exhibition Services:
Ken Grant, John Wright, Jane Boyd, Joe Dugan, and David Dalrymple

Photography:
Pete Smith

Design:
Buckmaster Design

Printing:
CSI, Austin, Texas

CREDITS

The emended typescript of *As I Lay Dying* on p. 17, the letter from Toronto of 1918 on p. 140, the pen-and-ink drawing in *The Marionettes* on p. 141, the endpapers from *Royal Street : New Orleans* on p. 142, and the holograph page from *Absalom, Absalom!* on p. 143 are all courtesy of the William Faulkner Estate.

The portrait of T. S. Eliot by Wyndham Lewis on p. 67 © Wyndham Lewis and the estate of Mrs. G. A. Wyndham Lewis, by permission of the Wyndham Lewis Memorial Trust (a registered charity).

The letter to Blanche Knopf from F. Scott Fitzgerald on p. 85 © 2003 by Eleanor Lanahan, Thomas P. Roche, and Christopher T. Byrne, Trustees u/a July 3, 1975 by Frances Scott Fitzgerald.

The holograph letters from Dora Carrington on p. 102 are courtesy of Rogers, Coleridge, and White Ltd., on behalf of the Carrington Estate.

The emended typescript of Ezra Pound's *Hugh Selwyn Mauberley* on p. 104 © 2003 by Mary de Rachewiltz and Omar S. Pound, used by permission of New Directions Publishing Co.

CONTENTS

4

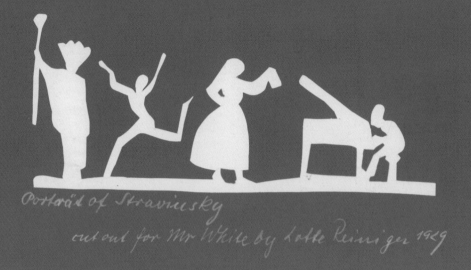

Portrait of Stravinsky cut out for Mr. White by Lotte Reiniger, 1929.

FOREWORD

THOMAS F. STALEY *Director, Harry Ransom Center*

At one time or another every serious historian of Modernism must feel empathy with Hugh Kenner's remark in *The Pound Era* (1971) that Modernism is so large and complex a subject no one historian knows enough to take it on. After nearly a century, the dates, places, manifestos, movements, and names still seem to swirl about like particles in a cyclotron. Although Virginia Woolf famously designated the year 1910 as the start of the modernist revolution, it was in fact during the first few years of the last century, and continuing into the 1920s, that literature and the arts underwent a dramatic upheaval. In 1903 Gertrude Stein, a student of William James, left medical school in Baltimore to settle in Paris. As early as the 1890s, Joseph Conrad departed Poland after years at sea and began his writing career in London. In 1913, another writer of Polish origin, Guillaume Apollinaire, immediately absorbed the "new spirit" of Paris upon his arrival. Ezra Pound, from Idaho by way of Pennsylvania, arrived in London in 1908; the same year Ford Madox Ford began to edit *The English Review*. From St. Louis by way of Harvard, T.S. Eliot followed a few years later, like Pound, in the shadow of an earlier American exile, Henry James. Meanwhile James Joyce settled in remote Trieste and began making *A Portrait of the Artist* out of *Stephen Hero*, moving after the War to Paris, where, earlier, Henri Matisse had left a law office in Picardy to study under Gustave Moreau at the Ecole des Beaux Arts. From Barcelona came Picasso.

Countless other young artists and writers from Europe and America converged on Paris and London in these early years, and the gigantic burst of creative energy that resulted we have come to call Modernism. In spite of the struggles to define the term, chart its shape and contours, formulate its styles and sensibilities, record the dislocations and even convolutions it brought to twentieth-century European and American culture, the term Modernism continues to elude us.

Make It New: The Rise of Modernism attempts to capture in essence the texture, structure, context, and dimensions of the most dominant aesthetic movement of the last century. There are more than three hundred objects in this exhibition and they are intended not only to give narrative shape but more importantly to provoke epiphany. Our purpose has affinity with Stephen Greenblatt's term, resonance: "the power of the displayed object to reach out beyond its formal boundaries to a larger world, to evoke in the viewer the complex, dynamic cultural forces from which it has emerged." We hope the individual works in our exhibition, be they primarily visual or written creations, encourage the viewer to connect each to each like nodes in a design, similar to the reader's experience of *Finnegans Wake*, a work regarded as the exclamation point to Modernism. The whole of *Make It New* is designed to point beyond the sum of its parts, but the relationship of part to part suggests a rhythm, capturing the explosive energy that made the early twentieth-century world modern.

Our vantage point from this new century gives us the perspective of distance, for as Eliot wrote, "no generation is interested in art in quite the same way as any other." Eliot argued that every hundred or so years it is desirable to review the past and set it in a new order. *Make It New* does not so much suggest a new order, but it does aspire to create a freshness of vision and a deeper awareness of relationships, a pervasive intertextuality, not of these creations simply to each other but to the deeper social and cultural forces from which they emanated through the pens, brushes, and cameras of those who created them. Our distance from the roots of Modernism also should be seen as more than an opportunity to gain perspective in the construction of yet another narrative of Modernism. For, just as Pound's famous injunction to "make it new" stimulated radical changes in literature, so too the term Modernism itself evolves and is made new by our continual engagement with its art and ideas.

Ours is an attempt not of definition but of discovery and rediscovery.

It is particularly appropriate that an exhibition on this subject should be held here in the new Ransom Center Galleries, for it is our modern collections that have brought international recognition to the center over the past five decades. The Ransom Center is an institution of Modernism, and from its thousands of authors' archives, books, photographs, and art, the curators have chosen these objects to represent the focus and achievement of Modernism. The choice for inclusion was frequently debated among our curators, and their debates sustained the seemingly endless questions: What was Modernism? And what is Modernism now, in 2003?

BLOOMSDAY, 2003

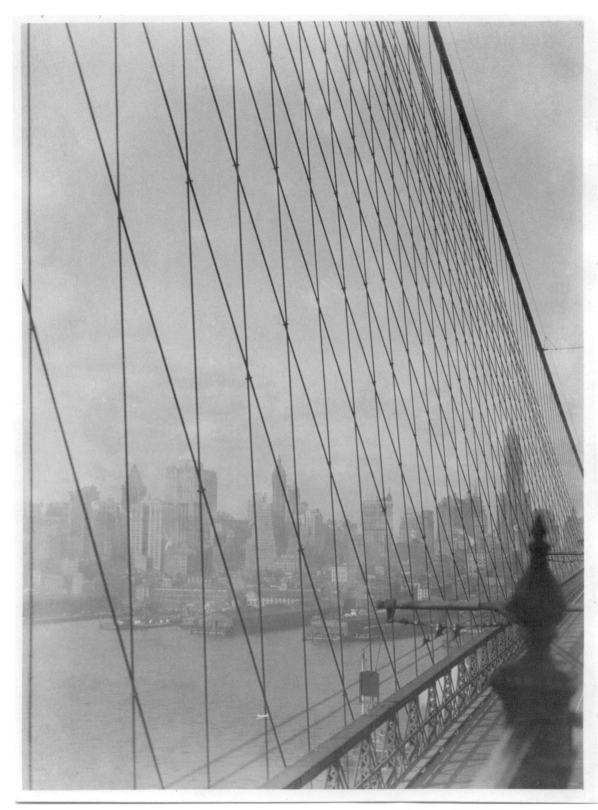

E. O. Hoppé (1878-1972), *Brooklyn Bridge*, 1917.

O Sleepless as the river under thee,

Vaulting the sea, the prairies' dreaming sod,

Unto us lowliest sometime sweep, descend

And of the curveship lend a myth to God.

—Hart Crane, "To Brooklyn Bridge" (1930)

We asked twelve writers and artists whose collections are housed at the Ransom Center to write an essay for this volume about another artist or artists or works of art from the modern period that were important to how they began their own careers.

THE SCALE OF WILLIAM GADDIS
RUSSELL BANKS

Photo © 2001 Marion Ettlinger

William Gaddis's project was noble and exemplary. Those books, the first three, especially, are like icebergs calved off a gigantic glacier. As a young writer, I mainly steered around them as they floated into my more southerly latitudes, knowing that if I hit one straight on, I'd sink. So I admired their colossal size and whiteness from a safe distance, mostly.

There are certain twentieth-century American literary projects, like Charlses Olson's *Maximus* or Ezra Pound's *Cantos*, that we need because of their gigantism, their absurdly vast scale, if only to take an accurate measure of our own feeble attempts. Gaddis is like that in prose fiction—like Edward Dahlberg, Paul Metcalf, Harold Brodkey—writers without whose work American literature would be a much diminished thing. Their existence enables the rest of us to be both more reckless and more ambitious than we'd ever dare to be otherwise.

Gaddis was to me a true deep modernist, only a little late for the party (we didn't know postmodernism back then), so he seemed almost anachronistic. His influence on me, such as it was, came early, in my twenties and, as I said, was about scale. I tried to marry him to Dreiser, which clearly would not have been a happy marriage for either, but it's one I try to live with myself and would not have dared to try without his example.

I have a theory, not very original, that postmodernism is mainly an intellectually nostalgic holding action against the death of Modernism. Gaddis might be a case in point. If literature is, or rather was, a church, and Joyce in the 1920s and 30s its pope, then Gaddis in the 1950s and 60s was its American cardinal. Possibly the last one. The shadow cast by the High Modernists was so long that, after they'd stepped out of the sun and were gone, it was hard in the 1950s and 60s (except for the Beats) to write anything not conceived in terms of that preceding generation's High Priestly ambition. Gaddis looms larger, casting a longer shadow than all the others of his ilk and kin—Donald Barthelme, John Hawkes, etc.—in that he helped keep the idea of ambition alive. His contemporaries, more wise than he, or more shrewd, may have backed away from it—too transparently oedipal, perhaps, or simply too risky to put so many eggs in one enormous basket. But when Gaddis went to market, he brought home the whole pig, and I love him for that.

THE IMMOVABLE FEAST OF MODERNISM

JULIAN BARNES

Photo © 1984 Caroline Forbes

In the first weeks of the new millennium, the Royal Academy in London organized one of the most necessary art exhibitions I have ever seen, also one containing the highest number of interestingly bad pictures put on public display for a long time. The aim of *1900: Art at the Crossroads* was to represent, as fairly as possible, a cross-section of what was being admired and bought a century previously, regardless of genre or affiliation or subsequent critical judgment. We are so used to exhibitions devoted to a particular movement or a particular artist—to follow a familiar narrative of beginnings, development, achievement, maturity, decadence—that we can easily submit to a simplified view of what is being created at any one time. The show's first lesson was just this: to display a cacophonous, overlapping, irreconcilable reality that would later be ironed out into art history.

Its second lesson followed swiftly behind: this was a demonstration, the more conclusive for being implicit, of the absolute necessity of Modernism. The moribundity of traditional late-nineteenth-century painting—inert academicism, tedious story-telling, curdled Victorian sentimentality, and naively unaware erotic musings—was manifest on every wall. That something needed to be broken, and broken violently and forever, was absolutely clear. The official decadence of a tradition is always more noxious than the individual decadence of any one particular artist.

Of course, great rumblings and shakings had been going on long before the final breakage called Modernism. Art movements do not exist between precise dates, however useful it might be to maintain that French Romanticism began with the *Bataille d'Hernani*, or modern painting with the *Demoiselles d'Avignon*, or modern music with *The Rite of Spring*, or the modern novel with *Ulysses*. The Impressionists and post-Impressionists were the lightning before the thunder; Debussy helped prepare our ears for Stravinsky; while the first modernist novel was probably Flaubert's *Bouvard et Pécuchet* (Fig. 1), published four decades before *Ulysses* (and, according to Cyril Connolly, Joyce's favorite novel).

The farther we get away from the grand years of Modernism—say, 1890 to 1939—the clearer it becomes that, like any other movement in the arts, Modernism was never as monolithic or as consistently successful as it appeared at the time. Like all victorious art movements, it was both imperialist and triumphalist; there was an implicit presumption that all modernist works were, by their modernity, equally virtuous. I remember my first visits to public art galleries and the dutiful chronological trudge which finally led to the heart-lifting twentieth century: light, energy, power, fragmentation, iconoclasm, rule-breaking, the subconscious—in summary, true reality, modern

reality, my reality, at last. In my generalized enthusiasm I even took Salvador Dalí for a genius. And in the same way, anything that shirked melody and defied chromaticism had my vote. In literature, about which I knew more, I was perhaps less supine in my opinions, but the hard-edged, the rebarbative, the incoherent, the willfully obscure and the impenetrably personal seemed to have added virtue and authority to them. I can't say I got very far into *Finnegans Wake* or Pound's *Cantos*, but I was happy to accept their agreed-upon pre-eminence.

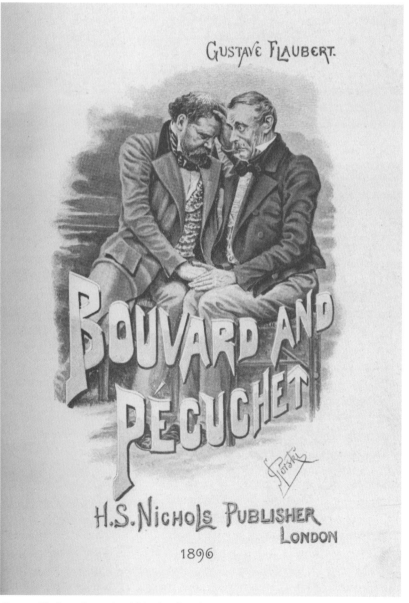

Gustave Flaubert, *Bouvard and Pécuchet*, first English edition, London 1896.

Nowadays, at further distance and with further knowledge, things inevitably seem more nuanced. Classicism, Romanticism, Realism, Modernism: the twentieth century's great contribution is now being mortared into its historical niche. It can now be seen to contain just as many derivative, time-serving, insincere artists as any other art movement; just as many who had their moment of fashion, who could ape the manner but didn't, eventually, have the matter. Modernism was also, clearly, something that came out of, exploited, alluded to and consumed previous movements. We flatter ourselves that art is in a constant state of progress (we flatter ourselves that society is too), but the truth is rather that it is in a constant state of change. The movement we detect is only in part linear. When artists and writers refer to their predecessors they are not looking back along a traveled road but across towards another point on the circumference of a circle.

Modernism attracted during its decades of pre-eminence more continuing hatred and rancor than any other major aesthetic movement; and even now that its greatest exponents are long dead, the case against it is put as vigorously as ever. Just as Ruskin accused Whistler of flinging a paint-pot in the face of the public, modernist architecture was and still is attacked for being anti-human, modernist literature for being elitist. Modernism was undemocratic — that is the basic charge. Odd to find Western conservatives allying themselves with Stalin and Zhdanov, but there it is. Bad, obscure, self-congratulatory Modernism surely existed, just as did bad, obscure, self-congratulatory Romanticism. But it strikes me as much more "democratic" to invite concert-goers or gallery-visitors or readers to open their faculties to the widest possible spectrum of sounds, sights and ideas; to expect the highest attention and to offer active participation rather than passive consumption. Is there anything more elitist and contemptuous than "giving the public what it wants"? Is there anything more patronizing than the "democratic" art that was Socialist Realism?

And is there anything more dead than contemporary art, of any discipline, which declines to accept, digest, argue with, and truly ponder Modernism? Is there anything more dead than a dinky little neo-Georgian terrace house whose only nod to the age we live in is a garage with an electronically controlled door? The locus classicus of debate about the form and function of the novel in the nineteenth century is the correspondence between Flaubert and George Sand. Travel and technology make it unlikely that an equivalent dialogue between great novelists is currently taking place in the public mails. Artists nowadays argue much more face to face, either in private or on a public stage. But it seems to me, as a writer at the start of the third millennium, that some present-day version of the Flaubert-Sand debate is what ought to be going on inside every writer, at whatever level of consciousness. And that debate cannot avoid Modernism. Literature is more tempted by conservatism than architecture, music, or the visual arts. There are novelists practising happily today for whom Modernism might as well never have taken place. As they tell us, with a large sense of pride and a residual sense of persecution, it's all

about telling a story, isn't it? Plot, character, detail, atmosphere — if it was good enough for Dickens, then it's good enough for me.

Except that Dickens born now would not write like Dickens born in 1812. Except that you're choosing to build your neo-Georgian hovel without even the power-operated garage door. Except — and this is the main point — that "traditional fiction" is not something "natural." Modernism spent much time questioning its artifice, and doubting its supposed infallibility. What is the authority of narrative? What is character, and does it really have the integrity and consistency claimed by pre-modernist fiction? What exactly constitutes a plot? How is contemporary reality most truthfully represented? As a novelist you can no more unask such questions than you can unknow knowledge. You may still choose to write traditional fiction, but you are not allowed to be unaware of the serious objections to what you are doing. Finally, we are all points on a circle. Bring that circle to life and make it a vast dinner table, with all the great writers of world literature seated around its edge. Over there, on your left, are Joyce, Eliot, Woolf, Pound, Proust, Apollinaire, Stevens, Valéry. You don't like them all? You don't like their personal habits, you find some of them snooty? But look who they are talking to on their other side: Flaubert, James, Rimbaud, Laforgue, and so on. Odd that they acknowledge their predecessors but you don't want to acknowledge yours. You don't want to meet their eyes? You ought to, I think. It is not just civil, it is necessary.

GIFTS ABOVE PRICE:
THE LEGACY OF EZRA POUND

CHRISTINE BROOKE-ROSE

Photo © Mark Gerson

During the seventies I was astonished to learn, when I visited America, that Ezra Pound was no longer well-considered, figured in no syllabus. Today I gather that he's out of the posthumous Limbo, or Purgatory as the French call it. He certainly had to go through an Inferno at the end of his life. In Italy in 1944 he was indicted as a traitor for broadcasting on Italian (i.e., enemy) radio, imprisoned in a cage at a U. S. disciplinary camp in Pisa for over six months, then sent to St. Elizabeth's Hospital for the Criminally Insane in Washington, where he stayed 13 years.[1]

I first came across Pound's poetry in the fifties, serving on a committee—one of many—for Pound's release. At the time, though still working on metaphor in medieval poetry, I plunged into *The Cantos*, and stayed there on and off for over fifteen years. Perhaps the most fascinating aspect for me, also a late developer, was the visible growth of his craft.

A broken man in Pisa, he gasps in canto 81: "To break the pentameter, that was the first heave." And he did. The first free verse of the moderns, usually attributed to Eliot, is stilted compared to Pound's, whose gift this has been to all successors, even those who never read him. The irony here, as Hugh Kenner points out, is that Pound makes this proclamation just when he "seems incredibly to fall back into the pentameter he had taken a lifetime to break," but is in fact recreating "the history of English versification from Chaucer to 1945," miming "the English tradition of weighty moral utterance."[2] And Kenner adds: "Is there another passage in literature that can number among the protagonists in its drama the meter itself?" (Well, Joyce perhaps, for style.) And in canto 98 Pound repeats: "And as for those who deform thought with iambics...." A further irony: both lines are good iambic pentameters, with internal variations (trochaic, spondaic). Most languages have a "national" meter that haunts their free verse, but English has two: the pentameter, imported by Chaucer from Petrarch, and the older Anglo-Saxon four-stress line, loosely revived in the fourteenth century, which made the pentameter more flexible for Shakespeare and Milton than, say, the French alexandrine, even if it could easily fall into rigidity.

In other words, just as in his essay "A Few Don'ts" (1913), whose list of things a poet mustn't do are all things he did do, so in his early poetry at the opening of the twentieth century the metrically experimental poet is metrically conventional. Indeed, he practiced complicated medieval forms such as the sestina but also translated from Provençal, early Italian, Chinese, Latin, and Anglo-Saxon. And the more Pound broadened out, the more he found his own voice.

For something happened between the appearance of the first cantos in 1917 ("Three Cantos") and the subsequent publications in 1925 (*A Draft of XVI Cantos*) and 1930 (*A Draft of XXX Cantos*). In 1919 he published *Quia Pauper Amavi*, containing, again, "Three Cantos," but also *Homage to Sextus Propertius*. And in 1920 came *Hugh Selwyn Mauberley*, a devastating portrait of a minor poet in the London society Pound was soon to escape from.

Apart from being a keynote text for the whole question of Pound's "creative" translations/mistranslations, *Homage to Sextus Propertius* is the real turning-point in his career, not only for the whole notion of "mimetic homage," but also for the rhythm.[3] Latin poetry played on long and short syllables, as did Anglo-Saxon but with four stresses that could come together and several short syllables allowed in the "dips." For example, typical later Pound spondaic endings occur here in the phrases "spattering wheel rims" and "a deal-wood-horse." This experimenting in *Propertius*, together with his translation of "The Seafarer" from the Anglo-Saxon (less successful I think), freed him for *The Cantos*.

But not overnight. There was a drastic cutting and revision of those first "Three Cantos," very self-indulgent for such a planned long poem. "Here's but rough meaning," he announced after having cut some lines about the ships, "And then went down to the ships, set keel to breaker" (still a pentameter, this line is the present opening of canto 1): and we're off, riding to the ships on the keel of a pronounless first line. For the opening canto is a version of Homer's Odysseus descending into Hades, via a medieval Latin translation by Divus ("lie quiet, Divus"), but also freed by Pound's other translations of *Propertius* and "The Seafarer." Four languages, four rhythms. It may be "rough meaning" compared to the rambling chattiness that precedes it, yet how much more precise it is.

This brings up a number of points. Pound was learning:

- that accuracy was important: *le mot juste*. "His true Penelope was Flaubert," he says of *Mauberley*. Or, at the end of canto 51, the first ideogram, untranslated and unnamed, but later given (in canto 60) as *ching ming* with the French translation (*la pureté du langage*) and later still (canto 67) reproduced with only its *ching* image and translated "clear/as to definitions"—this illustrates the echoing system I shall describe in a moment;

- that translation of old texts need not be archaic if they seemed dynamically modern to their own time (e.g., Cavalcanti to the 13th century);

- that sometimes there is no need to translate—"It can't be all in one language," he has someone tell some Pope in canto 86, and two cantos (72-3), long withheld, are wholly in Italian; and from *How to Read* (1928): "No one language is complete." That poses a problem of course, but Pound here prefigures reader-response criticism of the seventies when he speaks of "The 'new' angle being new to the reader who cannot always be the same reader" (*Guide to Kulchur*, 1938).

Even more important, he had learned from both Homer and Propertius what his poem was going to do. He would be Odysseus (or ΟΥΤΙΣ, canto 74), no man, the code-name for himself that Odysseus discloses to Polyphemus. On a journey through time and flux, he would raise the shades of the dead (and the texts of the dead); he would give them blood and make them speak to us; he would set them in motion. But how?

During that turning-point period Pound also launched the Imagist movement. The word "image" has often been loosely used to mean all devices from metaphor to mere comparison or anything literally visual. Indeed, the modernist movement emerged from Symbolism, so that anything "literal" can sound vaguely symbolic, especially in Eliot, who favors the "you-know-what-I-mean" definite article or the demonstrative adjective without co-reference (see "the dead tree" or "this red rock" in *The Waste Land*). Yet Pound was very clear on images: "The point of Imagism is that it does not use images as ornaments."[4] And he tells us how he wrote a 30-line poem about lovely faces following each other in the Paris Métro (darker then than now), then six months later destroyed the poem as of "second intensity," and a year later wrote the hokku-type sentence famous now to all students of modern poetry:

The apparition of these faces in the crowd;
Petals on a wet, black bough.
 (Lustra, 1916)

Not all that original, but an equation occurs: the faces are the petals, the Métro is the black bough (a "like" between the images would have debilitated them). Moreover, the "image" is the whole text, not just an ornament. A Poundian image is a metaphor, but without the many and complex grammatical links more often used. A mere juxtaposition, here marked by a semicolon, but sufficiently close to need only a comma.[5]

And out of juxtaposition in a two-line poem, Pound develops *The Cantos*, sometimes throwing in the colon or semi-colon or comma, sometimes no link at all except closeness, or a masterly ellipsis (as in the quotation below), or a slightly varied repetition of a striking phrase many cantos later, in a completely new context. Which also creates change. And change is dynamic, not static. This is perhaps Pound's most important contribution to poetry, and the pivot around which all other features turn; his ghosts, whether personae or poems or just a word or a phrase, or even groups of cantos (the American cantos, say, with the Chinese ones) are metamorphosed by new contexts, jostling each other, over continents and centuries, by simple juxtaposition.

Well, of course, it doesn't always come off. He can give the impression of forcing his esoteric reading down our throats or, sometimes, of becoming purely documentary. His juxtapositional method has been criticized, notably by Donald Davie, as not "pregnant" enough. Nevertheless, entire poems, and the whole of *The Cantos*, are built on it. The very use of Chinese ideograms (and each ideogram itself, if deciphered) is built on juxtaposition. So is the well-known feature of personae. After the Hades episode for instance, canto 1 ends with Aphrodite,

 with golden
Girdles and breast bands, though with dark eyelids,
Bearing the golden bough of Argicida. So that:

And then, following that colon, canto 2 begins:

Hang it all, Robert Browning,
there can be but the one "Sordello."
But Sordello, and my Sordello?
Lo Sordels si fo di Mantovana.

There are in fact five Sordellos here: Browning's, Pound's, the "real" historical one, "Sordello" as represented in his poetry and, in the last line (which will be echoed much later), Dante's. But we have also moved away from Virgil's "bough of Argicida" with its pseudo-logical "So that:" That concluding colon is not taken up again until canto 17, after more ghosts, Greek myths, Provençal stories, Eleanor of Aquitaine, Malatesta, Renaissance Italy, Kung (i.e., Confucius: see canto 13), and the three "Hell" Cantos. In canto 17 we read at last: "So that the vines burst from my fingers."

I have chosen early and well-known examples for this short essay because *The Cantos* do become more and more mind-leaping with always more juxtapositions and more allusions, and therefore hard to quote without resorting to the layerings of interpretation or to the patient source-hunting that many Poundians have helped build up. And which was all necessary, as Pound suggested in canto 98 by recalling Ford Madox Ford: "And as Ford said, get a dictionary and learn the meaning of words." But who wants to know the meanings of all the words? Does anyone care about Erigena, or Mr. Clayton, or Uang-iu-p'uh, Commissioner of the Salt Works?

For, of course, Pound is a modern, or a modernist. And such writers used classical allusion as a two-layer allegory (literal + allegorical—there were two more layers in medieval allegory, moral + anagogical) to reinforce their literal meaning, even when (in the words of T.S. Eliot's *The Waste Land*) the allusions were mere "fragments I have shored against my ruin". But Pound went much further than most moderns, and wider and wider. Indeed, he is postmodern in his non-linear history: "These fragments you have shelved (shored) / "Slut!" "Bitch!" "Truth and Calliope / Slanging each other sous les lauriers" (canto 8, the "shelved -> shored" referring to Pound's corrections of Eliot's text, dedicated to Pound as *il miglior fabbro* [better craftsman].[7]

Yes, he made mistakes. He was very naïve in economics, but who isn't? Even economists err. And even here, was he so very wrong about usury, as

defined by him?[8] Because of this obsession, he fell into blaming Jews for the capitalist system and Roosevelt for entering the war when he had electorally promised not to, but so did others of his time, if not on enemy territory. As the young Pound said about the anthropologist Leo Frobenius, who could be wrong and amateurish: "The question whether I believe Frobenius right or wrong in a given point seems frivolous. He could be wrong in 40 points and still bear gifts above price" (*Guide to Kulchur*, 1938).

Pound's gifts above price were 1) the breaking of the pentameter and 2) the metamorphosing technique of "making it new," itself richly various and constantly changing. The first gift could hardly influence me except negatively, since I gave up writing poetry on reading his, realizing I was not a poet and redirecting my passion for language elsewhere. But the second did. In many of my novels (to mention only one feature), I used echoing repetition in changed contexts, one of his ways of changing meaning by using new kinds of juxtaposition. As I said somewhat hyperbolically in *A ZBC of Ezra Pound*: "I find *The Cantos* funny, soothing, exhilarating, infuriating, tender beyond endurance, dogmatic beyond belief, bawled out, murmured, whispered, sung, true, erroneous, beautiful, ugly, craftsmanly, confident, contradictory, collapsing—in short, totally human, and relevant."

Back in the fifties, a friend used to tease me by saying half a proverb, "Penny-wise," which I was meant to finish, "Pound-foolish." But reverse it, I say: "Pound-wise, penny-foolish."

NOTES

1. For details of this absurd episode, see Julian Cornell, *The Trial of Ezra Pound – A documented account of the treason case by the Defendant's Lawyer* (New York, 1966); Charles Norman, *The Case of Ezra Pound* (New York, 1968); and Hugh Kenner's analysis of the transcripts, harmless, and hilariously inaccurate if it were not so sad, in *Poetry* (July 1957), quoted in the *Congressional Record* of April 1958 (A3944). The last chapter of my book, *A ZBC of Ezra Pound* (London, 1971), gives more detail.

2. Hugh Kenner in "Blood for Ghosts," *Texas Quarterly* X, No. 4, Winter 1967.

3. Kenner's splendid phrase from "Leucothea's Bikini," in *Ezra Pound: Perspectives*, ed. Noel Stock, 1965.

4. "Vorticism," in *Fortnightly Revue*, Sept. 1, 1914.

5. See my *A Grammar of Metaphor* (London, 1958), where I analyze these grammatical links in 15 poets from Chaucer to Dylan Thomas, but not including Pound. "Juxtaposition" is there called "Apposition."

6. In *Ezra Pound, Poet as Sculptor* (New York, 1964; London, 1965).

7. See T. S. Eliot, *The Waste Land: A Facsimile and transcript of the orignal drafts including the annotations of Ezra Pound*, ed. Valerie Eliot (London: Faber & Faber, 1971). Here, on p. 81 we read, "These fragments I have spelt into my ruins," corrected in the manuscript as "shored against my ruins." The next version (typscript + print, p. 89) has "shored against." Eliot told a correspondent (Peter Russell) in 1948 that he couldn't remember whether Pound's canto 8 followed or preceded Pound's emendations of *The Waste Land* (see note to p. 81 on p. 129). So, it is not entirely clear whether Pound is misremembering just what he corrected, echoing *The Waste Land* in homage, or claiming some credit for the echo.

8. "It [Usury] is not to be confused with the legitimate interest which is due, Del Mar says, to the increase in domestic animals and plants. The difference between a fixed charge and a share from a proportion of the increase." (Interview with G.D. Bridson, *B.B.C. Third Programme*, 11, July 1960).

By courtesy of the Saturday Review of Literature

"WELL, OFF HAND, I'D SAY IT WAS SOMETHING BY EZRA POUND."

We Moderns: 1920-1940, sales catalog for the Gotham Book Mart, back cover.

THE RISE OF (INDIAN) MODERNISM

ANITA DESAI

Photo © Mark Gerson

The first time I visited the United States, my publisher asked me, over dinner at his club, "What is it like, being a writer in India?" I searched for a way to describe my situation and finally replied, "It is like living deep inside a cave, in silence and darkness." "And no bou-um-m," he asked, "no bou-ou-mm at all?" "No," I said sadly, "no bou-ou-mm at all."

That is how it had been, for a writer in the 1950s, '60s, and '70s in India, the years when I was starting—scribbling away with no one aware of it, interested in it, or understanding it. I had been writing since I first learnt how to put words on paper, but the only person to whom that putting of words on paper meant anything was myself. It was, in fact, a kind of secret.

The truth was that no one cared. Indians who read English, the language I wrote, would not read an Indian writer; they would go to a bookshop and pick up the "real thing," a book by an English or American writer whose language it "really" was. And, in fact, these were the books I read myself. There were few publishers in India, and they made a living by reprinting books from abroad, particularly those that could be used as textbooks. Textbook publishing was the only safe, secure way of succeeding.

And yet, and yet...there were writers in India, even writers of English. There was R. K. Narayan, driven to publishing his own work, the cheap Pearl paperbacks that caught the eye of Graham Greene and made him a candidate for the Nobel Prize; Raja Rao who was trying to reproduce the convoluted, unhurried speech of Indian philosophers into written English; Mulk Raj Anand who was translating into English from his native Punjabi the speech of coolies, farmers, the illiterate and deprived; and women like Attia Hosain and Nayantara Sahgal who were recording the feminine lives of tradition. Brave experimenters all, since no one cared, and Indian readers continued to read Faulkner, Scott Fitzgerald and Hemingway instead.

But in 1981 a revolution took place. Salman Rushdie brought out *Midnight's Children*, a novel about the post-Independence generation. Even if this was the very material that pre-1980s writers had been working on for thirty years—the freedom movement and the creation of two separate nations—it was written in an idiom that no one had seen on paper before. In England the book won the Booker Prize. And this breakthrough set free the tongues of an entire generation. Books began to pour out as if they had been dammed for so long; they gathered strength and were seen as fresh and new.

To write in English in the India of the '50s and '60s had not been considered respectable; to have won Independence and yet to be using still the language of the former empire was a distinct sign of weakness, and such writers were deemed "mimic men." The fact that the writers I have named—and others like the extraordinary G. V. Desani—had been experimenting with how to adapt the language to Indian material convinced no one. The argument was that the Indian material—the age-old traditional world of family, community, society, caste and religion—kept such work trapped in the past.

Yet after Rushdie the English language provided the key to unlock a hundred clamoring voices. Now there were writers using the language of the erstwhile colonial power but putting it to their own uses—irreverently, fearlessly and confidently. English proved to be a modern language for the modern Indian world, supple as the world of cinema, journalism, television, trade and commerce. Through English translation, too, connection was made to the larger world of fiction: Gabriel Garcia Marquez, Günther Grass, and Milan Kundera became the icons that replaced Chekhov and Tolstoy, Dickens and Austen.

An indispensable effect of such writing and its success was that Indian publishers—discouraged men in the shabby backwaters of old cities—sat up to take notice, scratched their heads and asked themselves if had they been missing something. Perhaps there was talent here, right under their noses. It seemed now to be in demand. Once condemned by such reputable literary figures as V. S. Naipaul as being sucked dry, wasted and discarded, the literature of the former colonies exploded on the scene like fireworks. The old empire itself was willing, even eager, to hear the other side of the story, and now it was being told, oh yes it was. There emerged a glorious legend of the agent who flew out of Britain to sign up an unknown Indian writer for a million pounds! A new generation of Indian publishers pounced on this new generation of writers who, far from being ignored, became celebrities.

It was a heady time. And just as with every party, every carnival, it was edged with anxiety. Will it last? What will be left besides the debris, the pages and pages of paper?

Well, isn't this what "Modernism" means? The timeliness of the moment, the coming together of fortuitous events to create the momentous moment, and the energy to utilize it when it occurs?

Yet everyone who has looked further—not merely forwards but backwards too—will have been struck by how much the writers of today take the ancient epics like the *Mahabharata* and the *Ramayana* for their inspiration and their cultural reference points. That tradition of oral storytelling, new perhaps to the West, certainly is not new to the East or the South (see Latin America). Nor is the circularity of the traditional stories, their tendency to begin at any point so that the story can be dropped and resumed seemingly at random. Nor are their stock characters—heroes, heroines and villains capable of continually reinventing themselves. The language is "new" in that it is foreign and Western but now incorporating the slang, tones and rhythms of the region.

GETTING STARTED
DAVID DOUGLAS DUNCAN

English is not a transplant any more but has adapted to Indian soil, Indian history, and Indian ways of thought and behavior.

It is as if that great serpent, Time, which had been curled up in the depths of a cave, had stirred, yawned, lifted an eyelid, and then emerged like a streak of lightning to dazzle and illuminate. Will this Time-serpent of English continue to perform its dance, or will it retire again, exhausted, and let another cycle go by before it strikes once more? Whatever comes, it has already shown that it is capable of shedding its old skin, of assuming a fresh new one and of asserting its survival and its relevance to our own times.

How was my early life and career influenced by modern artists?

At that stage of my career there was no career—only wonderment about the world that existed beyond the horizon of those Great Depression years that had trapped Dad and Mother in Kansas City (but which pressures and hardships and ever-dimmer visions of their dreams they shared with each other and never discussed in front of their five children) but left me free to work my way up through the Boy Scouts, develop a fast eye that started with shooting running rabbits with a .22 while my pals used 12-gauge double-barrel Winchesters…and was probably profoundly feared by neighbors and many schoolmates because of my reputation (based upon reality) that I caught both copperheads and timber rattlesnakes with my bare hands…and kept them in wire cages behind our home on West 57th Street Terrace.

No one ever came through our backyard.

My heroes then were my scout master, Spencer Gard; world boxing champions Jack Britton and Jack Dempsey; Roy Chapman Andrews after his explorations in the Gobi Desert; and our own KC world-renowned dermatologist Dr. Richard L. Sutton who spent his free time and expeditions off New Zealand where he hunted giant black marlin with Zane Grey and Michael Lerner. Lerner, uncle of the later Broadway composer Alan J. Lerner, sponsored expeditions from the American Museum of Natural History, and one winter morning, phoning by radio from a boat off the Bahama Islands, called me in my fruit-closet darkroom in Kansas to tell me that Doc Sutton had once spoken to him, while off the Bay of Islands, New Zealand, about a young neighbor in KC "who could play a tune on a Graflex" and asked why didn't he—Mike Lerner—find a place in the museum's next expedition for a young guy who was educated as an archaeologist and marine zoologist—but might do better in photography.

Michael and Helen Lerner made a place on their next expedition—to Peru and Chile—for broadbill swordfish, and my odyssey with cameras had begun.

The star of stars of twentieth-century art, Pablo Picasso, was not yet in my field of vision.

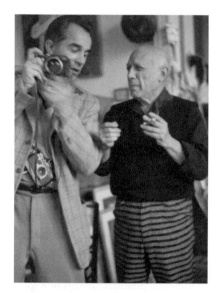
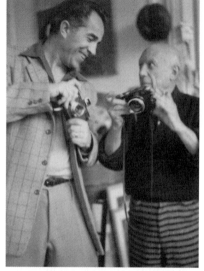
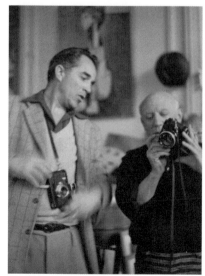
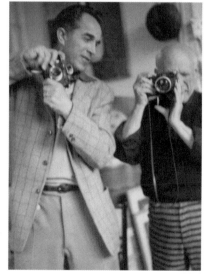

David Douglas Duncan and Pablo Picasso. Photo: Jacqueline Roque

ON *AS I LAY DYING*

ELIZABETH HARDWICK

Photo © Marion Ettlinger

As I Lay Dying: William Faulkner's 1930 masterpiece about a poor, cotton-raising family in the rural South. Their homestead and reluctant fields are on a hill, a scrabble hill, as if nature or fate meant them to tote things up and down as a special insult. But then, they're used to it, not trying too hard, just going on. The book is a daring composition, on the surface a simple folk-tale; but as it unfolds, the landscape and human beings caught up in the rhythms of life have an antique, imperishable reality.

The Bundren family: Addie Bundren, wife of Anse (or Pa), mother of Darl, Jewel, Vardaman, Cash, and a daughter, Dewey Dell, is dying. Her story is a requiem, told by the family and a few local neighbors in a broken, repetitive, magical flow of language and thought, all of a country-people musicality. Cash, the older son, is a carpenter and, at the opening, the sound of his saw is heard. He is making a box, plank by plank. "Addie Bundren could not want a better one, a better box to lie in." As she fades away, she can hear the clang, clang of the creation of her coffin. And then she's "taken and left us." Left them with a solemn obligation, for she wanted to be buried with her own people: "I give her my promise. Her mind was set on it."

The woeful journey begins to Jefferson, forty miles away. "It's just like him [that is, Anse] to marry a woman born a day's hard ride away and have her die on them"—thus the thoughts of a neighbor. An epical journey it is, a pilgrim's progress to Jefferson, not a celestial city, but a landing-place where the hill people can catch up on pressing worldly matters. Anse hadn't been in town for twelve years and his toothless, inconvenient gums can look forward to getting "them teeth."

The family sets off in the feeble, creaking mule-wagon, Jewel following on a horse he has bought from the shrewd, thieving Snopes. Jewel is restless, hot-tempered, and reckless. He sneaks out of the house at night and comes home in a battered condition. The family gossips about his adventures, pondering whether it's some young chick of a girl or a more prudent married woman. Cash, the older brother, decides to follow Jewel one night and returns saying, "It ain't a woman." Cash "never told," but one may feel they all *knew*. Faulkner, in a sort of ghostly narrative atuning to his fictional family, is often indirect, both plain and guarded, as the folks themselves would be in their suffering.

A pounding rain, and the river the wagon must cross is dangerously swollen. The bridge is out. "I wonder if they ain't heard about the bridge," someone says along the way. "I reckon we'll get there," Pa says. The wagon, the mules, the disappearing ford, *her* in the box almost going under, Jewel and

his horse, the horse going down, down, struggling in Homeric-like battle with the water. The visual turmoil, the human consternation, burst forth in an uncanny flowing brilliance:

The water was cold. It was thick, like slush ice. Only it kind of lived. One part of you knowed it was just water, the same thing that had been running under that bridge for a long time, yet when them logs would come spewing up outen it, you were not surprised, like they was a part of water, of the waiting and the threat.... Before us the thick dark current runs, it talks up to us in a murmur become ceaseless and myriad, the yellow surface dimpled monstrously into fading swirls travelling along the surface for an instant, silent, impermanent and profoundly significant, as though just beneath the surface something huge and alive waked for a moment of lazy alertness out of and into light slumber again.

Cash has a bad limp from having fallen off the roof of a church he was working on. How far did he fall? He knows exactly, as if he had taken the distance with a measuring rod; he fell "twenty-eight feet, four and a half inches." Trying to get the wagon back out of the water, he falls and wounds his leg again most painfully. His tool box, an emblem of skill and industry for the farming family, has fallen into the water, there to be heroically rescued by the diving Jewel. First the plane and the square are found and then the rule. "It's right new. He bought it last month out of the catalogue." Jewel dives once more for the chalk-line.

Cash, saying again and again, "It don't bother me none," is ashen and holding on in a mute resignation to pain. The family, remembering the ministrations from the first broken leg, round up some cement, moisten it and cover his leg. When at last in Jefferson they get to a doctor, he, seeing Cash's black, bleeding leg, will say, "Didn't none of you think to grease his leg first?" The answer is: we done the best we could. The country people, ever improvising, clumsily making out, are, in the eyes of the shopkeepers, those offering services here and there, like primitives found in a forest. The Bundrens' hesitations, their poverty, their broken straw hats, dollar canvas shoes, and paper suitcases are picturesque, if you want to put the best possible name on it.

But the Bundrens are proud in their way. Their stubborn, rain-drenched passage will arouse a bewildered countryside to make offerings of supper and hot dishes, but the patriarch says, "I thank you....We got a little something in the basket. We can make out." How about getting out of the wagon then and staying a night in the barn? "I thank you kindly, but I wouldn't be beholden." So it goes.

• • •

In the drowsy treachery of the relentless sun and one mishap after another, old Anse is brought to reflection about the Almighty: "I am chosen of the

Lord, for who He loveth, so doeth He chastiseth. But I be durn if He don't take some curious ways to show it, seems like." At last, journey's end, the wagon and the blinking hill-folk roll into Jefferson. Nine days it has been and the beloved *her* in the box is giving off a high smell.

Dewey Dell, young and pretty, is in a drug store looking for a doctor. "I got the money," she says. "He said I could git something at the drug-store for hit." The druggist wants to know which one gave the money to her, and she says, "It ain't but one." The druggist is on stage, playing a cunning role. It's noon and the owner won't be back until one. "I got the money," Dewey Dell says. Ten dollars. The druggist says he can't do nothing "for no little paltry sawbuck." What do you want then? He answers: he'll show her. "She looks behind her and around, then she looks toward the front. 'Gimme the medicine first.'" A bottle of something that smells like turpentine is produced. "You come back at ten o'clock tonight and I'll give you the rest of it and perform the operation." Dewey Dell comes in at ten and he gives her a box of capsules. Will it work? "Sure, when you take the rest of the treatment." Where do I take it? Down in the cellar, he says.

Darl, in some confusion about Jewel and horses, has burnt down the barn on Mr. Armstid's place. He's on his way to Jackson by train, on his way to prison. "It was nothing else to do. Either send him to Jackson, or have Gillespie sue us, because he knowed some way that Darl set fire to it. I don't know how he knowed, but he did."

. . .

In Jefferson, the forlorn wagon, smelling of rotting flesh, passes a more fragrant house where music is playing on a tinny phonograph—a house of ill-repute very beckoning to the widowed Anse. But first they must dig a hole for the hallowed coffin that wanted to rest among its own people. Since they forgot to bring spades from home, some must be borrowed, and returned. That done, the burial journey accomplished, Anse has fresh notions about the house:

While we was there pa said he was going to the barbershop and get a shave. And so that night he said he had some business to tend to, kind of looking away from us while he said it, with his hair combed wet and slick and smelling sweet with perfume, but I said leave him be; I wouldn't mind hearing a little more of that music myself. And so next morning he was gone again, then he come back and he told us to get hitched up and ready to take out and he would meet us....

Pa has got them teeth, which "made him look a foot taller." He returns to the wagon "with a duck-shaped woman all dressed up, with them kind of hard-looking pop eyes...." Pa introduces Cash, Jewel, Vardaman, and Dewey Dell.

And to the family he announces, in the final line of the novel, "Meet Mrs. Bundren."

Meet Mrs. Bundren: a wild and memorable finale indeed to what is a kind of sacred chorale. A chorale the Bundrens sing, in their perfect, dirt-poor pitch, about the humble patience of the poor. Faulkner's greatness, his supreme interrogation of the formal conventions of fiction, is to compose this journey in a fractured idiom. For all of the novel's apparent simplicity, it is often very hard to know what's going on, since the many incidents, the little stories, are not told all of a piece but scattered here and there, a modernist shattering of the confines of literary realism.

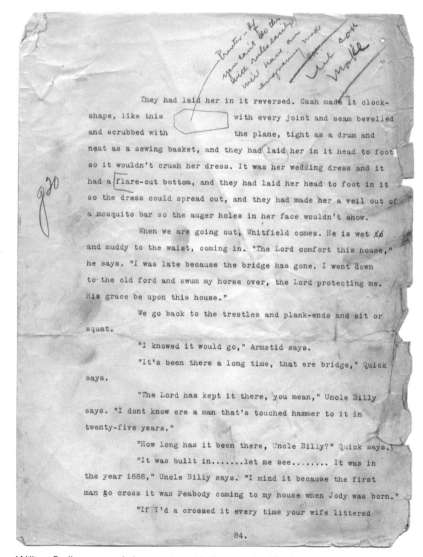

William Faulkner, emended typescript, with drawing of coffin, *As I Lay Dying.*

COLONIALISM, E. M. FORSTER, AND THE CARIB BONE-FLUTE

WILSON HARRIS

Photo © Guido Villa

E. M. Forster took ten to fourteen years to write *A Passage to India*. He abandoned the work on more than one occasion. It was a trial of extremity to him to write such a novel that reaches across horizons and across peoples normally fixed as if by a sculpted fate. A complex animation is missed or abhorred, because of its strangeness, in sculptures of nature (such as the Malabar Caves in the novel itself) never before suspected of sentience and diverse life beyond the strictures of mechanical laws and narrow customs.

The Indians of the Caribbean are not Indian at all. The name "Indian" stems from an error of judgment that Christopher Columbus made when he thought he had arrived in India on reaching the islands of the Americas. "Indian," however, has stuck fast on the various peoples who are the natives of South, Central and North America. All this brings an uneasy, curious fixture into place stretching from 1492 to the present age and across oceans from Asia into the Caribbean. It may be possible therefore to turn that fixture into a spatial art that gives original meaning to what seems a name but is an imposition.

In 1988 I wrote a "Note" for the re-issue of *Palace of the Peacock* (the first volume in *The Guyana Quartet*) in which the following passage appears:

> [The] "original vessel" on which Palace *rests validates itself, in my judgment, through vestiges of the Carib/cannibal bone-flute in the soil of a place though I was unconscious of this when I traveled in the heartland of Guyana and when, after discarding three novels, I struck what I knew at last was the right note with which to commence the* Quartet....
>
> *I became aware of the bone-flute some years after I had written* The Guyana Quartet *and upon reading the Appendix to* The Marches of El Dorado *by Michael Swan. This led me to research the articles of Walter Roth, an Australian anthropologist, who traveled in British Guyana and whose work began to appear in 1909 from the Bureau of Ethnology, Washington, D. C.... I was fortunate in the late 1960s and the 1970s to have the opportunity for research in specialist libraries in Canada and the United States.*

The Age of Conquest, with regard to the Americas, began in the sixteenth century. In the wake of Columbus, the Spanish conquistadores saw their battles with the Caribs as a struggle between civilization and barbarism. The Caribs were marked as gross cannibals and it was not until the twentieth century that scholars began to repudiate this fierce indictment of these people of many parts—courageous, masterly, and yet susceptible, it seems, to acute

melancholy—who had been exploited and left in a void of history. It was then discovered by Swan and others, through Roth's articles, that the Caribs had a sacred ritual in which they consumed a portion of flesh over a bone of the enemy. This gave them, they felt, an inner knowledge of the enemy's plans and they hollowed the bone into a flute. Music became a transfigurative impulse—momentary perhaps—that lifted them through and beyond themselves into a wider, somewhat inexplicable understanding of themselves as part of a diverse humanity. Swan calls this complex ritual "transubstantiation in reverse." By this he means that one may reverse an absolute judgment of unity by intense self-searching and imagination extending into others. The extension was difficult. It implied warring clashes between diverse peoples who sought to impose their values one upon another. But it signified in depth a crucial, imaginative difference in the arts that could be pursued.

That difference may be seen as follows. The Spanish conquistadores believed that the Catholic Host, which they consumed in their own Mass and rituals, was an emblem of absolute justification for the unity of Man. They felt this to be so important that it justified coercion and conquest, the taking of other lands, gold and money. The Caribs instinctively and subconsciously reversed this notion. They consumed a morsel of the others' flesh not as the emblem of a God but as a diverse symptom through which they felt themselves involved in the psyche of Man, bringing events of unpredictable nature to be learnt by inner degrees of intense imagination. Thus, they instinctively rejected total control and conquest by another who exercised his domination through the imposition of his own values on all he met.

It is absurd to speak of the twentieth-century novel as a sphere of conquest, but one wonders whether in essence this may not reflect a Western pattern of rules in which other cultures may be involved, provided they obey the rules. Forster challenges this principle of absolutes, it would seem, in a character in *A Passage to India* whom—as we shall soon see—he is driven to regard as *dust*, as outside of his artistic vision of control.

The bone-flute, in its shadowy reversal of conquistadorial dimensions, offers an approach to art we may only now have begun to understand in modernist strategies. The characters one creates can turn on one—in the digestion of psyche—and, apart from giving one information of their intentions, can create one's imagination anew. Let me once again qualify what I have been saying as carefully as possible. The bone-flute raises an astonishing possibility akin to quantum unpredictability in the subjective and mysterious insights it affords. These seek, I feel, to translate natures that loom in ourselves and others through multiform controls which may bring into play the universalities of diverse cultures in an open rather than a closed and dominant unity.

How may this apply to Columbus? Let us say he set sail in a vessel of art for an unknown destination, India in America, America in India. He arrives and in the paradox in which he is engaged calls the natives of America "Indian." It was an admission of a severance of control of territory and character.

18

An imaginary drift follows, which brings him into Forster's novel. The title he gives to natives, who were cast into a void of history, has slumbered but now partially comes awake in a specific courtroom in India in a character of dust whom Forster depicts as a stranger he cannot place.

The inability to "place" that character brings a hint of particled or waving dust, a quantum edge, into Forster's novel. I shall in a moment quote the passage I have in mind. Let me say that we cannot help seeing in that passage someone drawn from a void of history, someone who relates, I would think, to the famous Malabar Caves in Forster's novel which become a gigantic animated bone in the territory from which or in which one hears the echoes of a spatial song that fills Adela Quested with acute abhorrence. The Malabar Caves, when she visited them with Dr. Aziz, came alive and filled her with a sensation of being assaulted by Dr. Aziz. It is not until she enters the hot, crowded courtroom to give her evidence and sees the figure in the void, fanning with a punkah all who are assembled, that she becomes aware of imposing her own values in the report she gave to the police and to the English residents of Chandrapore. She had been drawn compulsively to fill the Caves with Dr. Aziz's apparition. This information, if I may so put it, comes through to her now in the figure pulling the fan in the hot courtroom. She is so stricken by this strange, eruptive knowledge that she can no longer accuse Dr. Aziz. Her case falls apart. Her values become partial and they yield to a pattern of universality born of moving lines and voids and spaces and echoes she had never considered before. It is but an intimation of universality hinted at in Columbus's Indian natives in America. Forster also hints at such a void in a figure he presents fanning spaces that are condensed into a moment of revelation. That figure, I should report, does not appear earlier in the novel nor does he ever return.

Here follows the quotation I have in mind from A Passage to India:

> The court was crowded and of course very hot, and the first person Adela noticed in it was the humblest of all who were present, a person who had no bearing officially upon the trial: the man who pulled the punkah. Almost naked, and splendidly formed, he sat on a raised platform near the back, in the middle of the central gangway, and he caught her attention as she came in.... He had the strength and beauty that sometimes come to flower in Indians of low birth. When that strange race nears the dust and is condemned as untouchable, then nature remembers the physical perfection that she accomplished elsewhere, and throws out a god – not many, but one here and there, to prove to society how little its categories impress her. This man would have been notable anywhere; among the thin-hammed, flat-chested mediocrities of Chandrapore he stood out as divine, yet he was of the city, its garbage had nourished him, he would end on its rubbish heaps. Pulling the rope towards him, relaxing it rhythmically, sending swirls of air over others, receiving none himself, he seemed apart from human destinies, a male Fate, a winnower of souls. Opposite him, also on a platform, sat the little Assistant Magistrate, cultivated, self-conscious and conscientious. The punkah-wallah was none of these things, he scarcely knew that he existed and did not understand why the court was fuller than usual, indeed he did not know that it was fuller than usual, didn't even know he worked a fan, though he thought he pulled a rope. Something in his aloofness impressed the girl from middle-class England, and rebuked the narrowness of her sufferings. In virtue of what had she collected this roomful of people together? Her particular brand of opinions, and the suburban Jehovah who sanctified them – by what right did they claim so much importance in the world, and assume the title of civilization? (Emphasis mine; A Passage to India, Penguin ed. 1985, first published by Edward Arnold, 1924).

A Passage to India has been filmed, yet the man who pulls the punkah appears to defy representation in a medium like the cinema which has no language for him. In the movie he is barely noticeable: it's the fan that commands our visual attention. In the novel he appears to be a piece of sculpture without knowledge of the courtroom and with a mechanical arm that pulls the fan. Yet he is subtly animated into a god whose context is the animated bone of the Malabar Caves. He is "particle and wave" and this brings a quantum edge, as I have said before, of which Forster himself may have been unaware. This uncanny development in the changing models of art lies still in the unconscious but foretells possibly a modernist development of considerable importance.

GET ON WITH IT

DAN JACOBSON

You stand on the brink—not shivering exactly, but hesitating, doubting if you will be brave enough to take the plunge, wondering how much of a fool you will make of yourself if you do. You are twenty years old, say, or a little older or younger, and as far back as you can remember the printed word has been the source of one of your greatest pleasures. Almost any item that comes your way will do: boys' books, girls' books, comic books, war stories, stripped-down versions of novels by Dickens, thrillers, anthologies of short stories, current best-sellers. Naturally, as the years pass you begin to take on more demanding things: Dickens's novels with no bits stripped out, *Crime and Punishment* which you read to impress yourself as much as others, Albert Camus. Poetry too, or at any rate a handful of favorite poems ("Morte d'Arthur," "Ode to a Nightingale") which you go through over and over again. Out of the fantasies that works like these encourage, and out of the other fantasies that inhabit your mind anyway (about being much stronger and braver than you are, better at sport, more successful with girls, living in a more glamorous and exciting part of the world), there emerges yet a further fantasy: that of being not just a reader of stories and poems, but a writer of them too. Of putting yourself at the opposite end of this silent, intimate exchange of experience which all reading involves; of being the person who gives pleasure rather than the one who receives it; and of thus becoming to others what the writers you most admire have been to you. And of enjoying the applause and fame which will doubtless follow.

Who—*you?* A writer? Who do you think you are? Just because you like reading and have enjoyed writing "compositions" at school? Because you have been so affected by this or that piece of fiction or passage of poetry? Is that what makes you think you have it in you to become a writer—and not just any kind of writer either, not a journalist on the local paper or an advertising copywriter or a compiler of manuals, but a writer of poems and thick novels? What a laugh. What a hope.

So there you remain, on the brink, hardly daring to acknowledge to yourself, let alone to others, what is in your mind. Naturally you have tried several times to write stories and poems; but when you re-read them, after the initial excitement of producing them has subsided, they fall so far short of what you hoped they would be that you tear them into small pieces and put them in the bin—the bottom of the bin, preferably, to make sure that no human eye will fall on them again. And by now you're no longer a child, you've left high school or have graduated from university, and most of your friends seem to have a much clearer idea than you do of what they will go on to do next. Inwardly you are still just hanging about, waiting for some sign from within or without that

will justify this ambition you can neither commit yourself to nor leave behind.

Then—and here I must abandon the semi-anonymous "you" and speak directly through the bald, unadorned first-person pronoun—then I happened to read a volume of the collected short stories of D.H. Lawrence. It would be wrong for me to suggest that my life changed overnight as a result, in cartoon or fairy-tale fashion. Nothing of the kind. But I did learn something wholly unexpected, even revelatory, from those stories that I have never forgotten — and, appropriately enough, I learned it from the very beginnings of the stories, their opening lines and paragraphs, the manner in which they came into being. It was not that they began with a bang; on the contrary, it was their nonchalance that I wondered at. There was no shivering here, no fear on the author's part that he might be making a fool of himself, no uneasy speculation about the figure he would cut if he plunged into the task. Nothing mattered to him apart from getting on with it. Everything else could wait. That was what made the writing so quick, so offhand, so dramatically and lyrically fluent. Reading the first paragraphs of the tales was like watching an exceptionally gifted sportsman making his strokes: there is no gap whatever between eye, brain and hand; the words just seem to happen on the page rather than to arrive there as the result of any conscious calculation.

Like this:

They had marched more than thirty kilometres since dawn, along the white, hot road, where occasional thickets of trees threw a moment of shade, then out into the glare again. On either hand the valley, wide and shallow, glittered with heat

Or this:

She had thought that this marriage, of all marriages would be an adventure. Not that the man himself was exactly magical to her. A little wiry, twisted fellow, twenty years older than herself, with brown eyes and greying hair, who had come to America a scrap of wastrel, from Holland, years ago, as a tiny boy, and from the gold-mines of the west had been kicked south into Mexico, and was now more or less rich, owning silver mines in the wilds of the Sierra Madre: it was obvious the adventure lay in his circumstances rather than in his person....

Or this last one (though there are a score more I could use to illustrate what I mean):

"Well, Mabel, and what are you going to do with yourself?" asked Joe, with foolish flippancy. He felt quite safe himself. Without listening for an answer, he turned aside, worked a grain of tobacco to the tip of his tongue and spat it out. He did not care about anything, since he felt safe himself.

PAUL ROBESON: THE POWER OF A RECITAL (1937)

ADRIENNE KENNEDY

Much later I was to realise that the peculiarly improvised air that so struck me about Lawrence's stories—and not only about their openings—was one of the marks of their modernity. Hence the discomfort I had felt with *Sons and Lovers*, which was then the only other book by Lawrence I had read, and which seemed to me to have been written in a moody, "plotless," impulsive manner I had not come across before, and did not like for that reason. (I now believe it to be one of most original novels in the English language and a greater work than the longer and apparently more ambitious fictions he wrote subsequently.) Though Lawrence's voice and subject-matter were distinctively his own, I soon discovered other gifted prose writers and poets of the period who had been driven to dislocate their predecessors' literary habits and manners in order to achieve a greater degree of closeness to the fluctuations of consciousness they wished to explore. For all the differences between them, each of them had sought to make the haphazard appear exact—and the exact, haphazard.

Reflections of that sort, however, were far from my mind then. The examples Lawrence had just put before me were irresistible. They made it plain that a beginning by itself is never enough, but without a beginning there is nothing. Either I dived in forthwith (and I had just seen what it looked like to do so) or I must turn my back on the whole business. Of these alternatives I chose the former, obviously. Soon after this liberating encounter with Lawrence's stories, I learned lessons of a different kind from the style of "scrupulous meanness" which James Joyce sardonically claimed to have employed in writing the stories in *Dubliners*. As exemplars the two men could not have been more different from one another. Not surprisingly, neither cared at all for the other's work. But that was their business. Mine was to go off and do what I could. Nobody else would do it for me.

In 1937 when I was six years old, on a winter Sunday afternoon my father took me to see Paul Robeson. Winter afternoons in Cleveland, Ohio were quite dark and heavy. The concert was about five o'clock. Darkness was coming. I had on my plaid taffeta dress with a lace collar and carried my muff. My father, Cornell W. Hawkins, had on a navy blue suit, a white handkerchief at his lapel; Paul Robeson was also dressed in a dark suit...like my father's, I thought. We were in one of Cleveland's best-known black churches. Paul Robeson was not far away on a stage but stood in the front of the church. He was singing on the same level where we sat. His pianist was to our left. My father and I sat only five or six rows away from Robeson.

Paul Robeson's name belonged to a litany of names that my parents and their friends sang constantly: Du Bois...Marian Anderson...Mary McCleod Bethune... Eleanor Roosevelt... President Roosevelt.... For me to be sitting so close to this Paul Robeson who, I saw, had similar coloring to my father's, and was dressed so much like my father, was a revelation. And I'd never been to a recital. I had only seen recitals in movies. Robeson sang a series of songs as dusk filled the church.

Then he sang "Water Boy"(Fig. 1). I looked into his face. It seemed so important that I could look right into his face. He's a friend, I thought. He is my friend. Even though I was a little girl I had a friend....Paul Robeson, the man my parents and their friends talked about. And he was singing to me as I looked into his face as winter evening came on.

When I write, I try to sing through the winter dusk.

The Robeson influence continued when, years later, I discovered on film that Robeson spoke against injustice, just as my social worker father and his friends had. On film I saw Robeson traveling over the world speaking of injustice.

Now I not only want to sing through the winter afternoon when I write, I also want to travel and speak of injustice. To this day when I travel to colleges to speak, I often show a film of Robeson's life. The power of his recital is in my blood.

"Program of Negro Music," Paul Robeson and Lawrence Brown, May 3, 1925.

THE FRIENDSHIP OF VIRGINIA WOOLF

PENELOPE LIVELY

Photo © Ellen Warner

Engagement with a writer, over time, is as flexible as relationships with friends. At one point you are in harmony; at another you are not getting along so well. I can't remember when first I read Virginia Woolf. But I do know that my response to her work has changed again and again, down the years. She has been not so much an influence as a presence. The fact that her novels exist colors a perception of writing and how it can be done. Along with a handful of others, which includes Henry James, Ivy Compton-Burnett, Henry Green, and Elizabeth Bowen, she has been an essential fix when I want to be reminded of the versatility and range of fiction writing. It is not always a pleasurable fix. I read *The Waves* with irritation rather than with enjoyment. But each time that I revisit *Mrs. Dalloway* or *To the Lighthouse* I notice some felicity or some resonance that seems to have escaped me previously. This quality is the ultimate test of a novel—the way in which it meshes differently with the reader's own preoccupations from one reading to another—and Virginia Woolf's work seems to me especially rich in this mercurial virtue. In that sense, it is like a peculiarly provocative but stimulating friend.

So, what is it that provokes? What stimulates? On the one hand, there is the opacity, the self-indulgence, the apparent absence of any editorial rigor (all those repeated words and phrases—intentional, presumably, but they grate). And against that can be set the immediacy, the accuracy, the moment pinned down by the exact image, the brilliant evocations of a time and a place. These strengths win out, of course, or her work would not have the power that it does. Where *The Waves* is concerned, I pass (opacity, self-indulgence, etc. in spades); I have an unfashionable admiration for *The Years*, generally regarded as a less successful work. To see, smell, and hear London in 1880 and beyond, you can hardly do better than sink into the atmosphere of this book. The effect is as though different strata of the city were miraculously revealed: the world of muddy streets and hansom cabs, the intimacy of afternoon tea and the kettle that will not boil until the wick beneath has been teased with a hairpin, the febrile comings and goings at a party in 1937. These are the Woolf strengths at their most compelling.

A character in *The Years* feels as though "she was living two different times at the same moment." She is thinking of the operation of memory, of course, and it is here that I feel the greatest empathy with Virginia Woolf—those insights that bring you up short, evoke instant agreement: yes, that is how it is. Of all writers, she is perhaps the most concerned with memory, and singularly adept at giving fictional form to its processes. *To the Lighthouse* is a hymn to memory, and perfectly suggests its shimmering, random quality, its rejection of any linear, chronological process, its maverick preservations. A long while ago, when first I read it, I don't think that I quite recognized this.

As memory and its quirky performance became a theme of my own fiction, appreciation of that book—and of other Woolf works—quickened: a nice instance of the way in which great novels assume some kind of personal relevance with successive readings. *The Waves* has of course similar intentions, so that my resistance to that book may seem perverse. It is a question of style, of manner; the jerky, edgy quality of *The Waves*, the medley of voices that often seem to echo one another, appear to be in direct apposition to the fluid, evocative narrative of *To the Lighthouse*, or, indeed, of *Mrs. Dalloway*, which is equally vivid in its interlacing of now and then, of the onward rushing moment and the static past.

There is an abiding difficulty about responses to Virginia Woolf's novels, and that is simply that we know too much about her. The Bloomsbury industry has left a society so flayed by analysis that it becomes impossible to react to the books without images of those people and their relationships floating above the page. But of course she herself has contributed massively to this intimate knowledge. As a diarist, she is without equal. Even those resistant to her fiction find the diaries mesmeric reading. Like all good diaries they conjure up another time—its attitudes and assumptions, what it looked and felt like, people and places and the climate of the early twentieth century. But they are also an extraordinary revelation of her own complex existence, startling in their honesty, displaying a blistering candor not least about herself, and given narrative power by that racing, glancing style, as though her thoughts ran faster than the pen. The diaries are for dipping into, time and again, and I have been doing so for decades, lighting upon familiar passages with fresh appreciation. And, sometimes, with irritation—once again, the two responses can chase one another. There is the snobbery, that coterie complacency. But there is also the freshness of vision, her curiosity and range of interest, her eye for the compelling image. Some of those qualities surface in the letters, too, but there I find myself with a feeling of voyeurism, of looking over someone's shoulder, albeit with the connivance of editors and publishers. The diaries do not leave you with that sense; she seems to be talking to herself, but in such a way that it is quite permissible for others to eavesdrop. Perhaps this is the ultimate refinement of the diarist's art.

Books beget books. Intertextuality is the stuff of criticism, and novelists do best to leave well enough alone when it comes to navel-gazing—examination of their own influences. And I always feel that influence is the wrong term; it is more that reading, over a lifetime, is some kind of osmotic process—what is read seeps into the perception of fiction and of writing itself. You write out of everything that you have read, in both a positive and a negative sense. And some writers have affected this creative vision more than others. We may not want to write like Virginia Woolf, even if we were capable of doing so, but absorption of her work means that she is there as an exemplar, for better and for worse, and therefore the possibilities of fiction are given a further dimension.

HENRY MILLER TO HENRY JAMES

RONALD SUKENICK

Consider things from the point of view of Lady Chatterley's husband. Physically deprived of his passions all he could do was roll around in that big old house and think, or rather, maintain a state of sentience, assuming thinking and feeling are included in the term. With which state he seemed quite happy until the game-keeper started sniffing around his wife. Lawrence believed that anything arising from the passions was— well, yes, virtuous. He invented a new, inverted kind of morality. But in doing so, naive as it seems now, he preserved the very idea of morality for a generation of liberated readers. Or at least, that was the effect on me of *Lady Chatterley's Lover* and of Lawrence's offspring, Henry Miller: the presumptive morality of a life force that undercut traditional morality (Figs. 1 and 2).

Now, in a post-Fascist world, it's easy to see the disastrous consequences of a vitalistic morality, just as, in a post-Marxist world, the malignancy of a purely rational mentality has become obvious. But the history of consciousness staggers, it seems, from doctrine to doctrinaire to correction to over-correction. One could argue that for a kid growing up in the ultra-conventional 1950s of Bensonhurst, Brooklyn, the Lawrence-Miller axis was the most liberating path, given the going hypocrite/conformist morality.

The '60s, Vietnam and the baby boomers gave the coup de grace to that conventional mentality. But the loosening up of the psyche in the direction of liberated passions eventually enlisted passions in the service of hypocrite conformity. One could argue optimistically that we are a loop higher in a spiral of liberation. Sexuality, though more exploited, seems to be more free. Relations between parents and children, when there are any at all, seem to be more open and affectionate. Men are more expressive and women have more drive. One heritage from the Lawrence-Miller mode that seems beneficent is a matter of style—in a word: the extemporaneous. The appeal of the extemporaneous is a combination of the freshness of spontaneity combined with the moral bonus of a presumed honesty. The biographer, John Tytell, tells us that Miller found his enabling style by writing the way he talked rather than the way he had been writing. The spontaneous quality of speech is what gives Miller's style its power. The case of Lawrence is more subtle as regards speech. He moves in the direction of the incantatory, which is the direction of ritual and magic, hypnotizing the conscious mind to allow more primal understanding to make itself felt. I use the word "hypnotic" advisedly in this connection since there are passages in his work whose rhythms appear to be intentionally mesmerizing.

So here we have a polarity: Miller's speech patterns leading him to an improvisational freedom, and Lawrence's leading to a kind of releasing compulsion. But there is a problem common to both styles. Lawrence's invocation of the incantatory leads to a numbing repetition, just as Miller's garrulousness leads to a loss of sensitivity, of introspective reflection. If these two writers stylistically are similar in their celebration of passion, they are also similar in their suppression of thinking. I say "thinking" rather than thought because I do not wish to imply intellectual, much less philosophical, formulation. Rather, I mean the normal train of thought of sentient individuals reflecting on the course of things. I mean the kind of monologue that sifts through the mind of Joyce's Bloom, or Conrad's narrators, or most notably through Proust's Marcel.

I once had a job as a nightwatchman in a factory loft building. I had little to do. It was in that unlikely setting that I came across this sentient strain in the work (and it is possibly no accident that the three practitioners mentioned above are all European) of Henry James (Fig. 3). An American. But an American steeped in the ambience of Europe, and therefore a bridge. Reflection does not come easy to a modern American, it having been elbowed out of the way by a simplistic pragmatic tradition. This was especially true of a twenty-year-old nightwatchman whose shift began with the cleaning of toilets and the mopping of halls and continued with seven hours of staring at walls. But I could read. And maybe it was the very unidimensionality of the job that drove me in the direction of a faceted sensibility such as James's, one that emphasized a hyper-activity of interior life, for above all it was the complex later novels that attracted me, with their endless serpentine sentences and intricate ambiguities. Maybe it was the flat pragmatic character of American culture in the '50s, with its

1 and 2) Cover and first page, D.H. Lawrence, *Lady Chatterley's Lover*, first holograph version.

It could be argued that the main thrust of American literary modernism, despite Ezra Pound's damnation of the man in the street, was a prejudice in favor of the demotic. The man in the street was an ally, if an ambiguous one, for the modernists. It may have been the ultimately unsustainable tension between populism and elitism that accounted for the final failure of *The Cantos*. James, on the other hand, made no concession to the man in the street. At least not in the later novels which, dictated to a secretary, resembled some-one thinking out loud. By the time you get to the end of one of those sentences you have completely forgotten how it began, creating the impression, not so much of a stream of consciousness as of a kind of streaming thought without beginning or end. Add the Faulkner of *The Sound and the Fury* with its narra-tive stream and I would guess you have the kernel of my series, *The Endless Short Story*, as well as other works. So James brought together for me the influ-ence on writing of speech and thought in an amalgam that left ample room for thinking and nuanced feeling, and in fact demanded it. The extemporaneous driven by feeling and the drift of ideas provoked me to consider fiction as a kind of thinking—narrative thinking, as I have described it elsewhere—thinking as enactment.

Henry James was Lady Chatterley's husband. He was the sentient man cut off from his passions, his passions reinvested in the energy of feeling and thought. For us, almost a century away, the release of the passions is both expected and inadequate. For a boy working in a factory loft, fiction as an expansion of thinking and nuanced feeling, of speculation and emotional realignment, came as revelation, one that put him outside the going tide of American letters.

3) Alvin Langdon Coburn, *Henry James*, photogravure, published in *Men of Mark* (New York, 1913).

allergy to nuance, its auto-immune reactions to its own subtleties, to which James provided an alternative. In any case, my experience with James was an experience of liberation. The discovery of a style that above all gave one room to think, to speculate, to interpret, was a move quite out of character to one nur-tured on Hemingway and Fitzgerald and whose conception of manners was analogous to lying and hypocrisy. Subtlety was for eggheads. The idea of man-ners as an extension of the thoughtful had never occurred to me. It is proba-bly no accident that the James vogue of the '50s was spearheaded by Jewish intellectuals whose modus operandi was often rudeness mixed with Marxism, although one suspected, as one got to know them, a kind of reverse snobbism.

WHAT MAKES US MODERN

ARNOLD WESKER

Photo © 1997/John Downing

Everything makes us modern: it's the condition of being alive. All that needs to be observed is that the nature of our modernity changes from day to day. We were differently modern after we closed the last page of our first D. H. Lawrence novel, our first Hemingway, our first Joyce, and, for me at least, the book of essays by disillusioned Communists called *The God That Failed*. And we were certainly very differently modern on the morning of September 12th, 2001.

Not being an academic I neither use the term nor really understand what "Modernism" is. What talent I have is not operated on like that. Novelists, painters, and thinkers from diverse ages made their impact on me and added to the sum total of who I am, the way I think, and the way I write— from Montaigne through Ruskin to Roger Fry; from Shakespeare through Chekhov to Miller; from Austen through George Eliot and Balzac to Philip Roth, to name a few.

Groupings worry me. They limit understanding of the individual artist, confine what might expand beyond what the label implies. It might help academics to be orderly, this parceling out, but I'm not sure how deeply it gets to the essence of an artist's work.

I don't think I'm even interested in what makes me modern, only in what makes me human. Or rather, to be more precise, what makes me the human being I am. Ten years ago when I agreed to write an autobiography *As Much As I Dare* I did so on the understanding that it would not be a "showbiz" autobiography but would cover only the years up to the writing of my first couple of plays. I was interested in the twenty-five years of "chemistry" that made this modern playwright. Two intense years went into writing what could therefore be described as a response to the set task—in 567 pages.

Certain images or relationships in literature linger more than others informing one's understanding of human nature. Understanding doesn't always help, of course; we still make a mess of our lives. But finding one's feelings echoed in literature is a comfort; the sense of isolation is diminished. And if the purpose of this essay is to identify with precision, to pinpoint specifically, what writers writing in the early years of the century before I was born in 1932 touched me later in the same century, then I can point my pin at two works that come to mind at once, perhaps because they are among the most powerful.

The first was Thornton Wilder's *The Bridge of San Luis Rey*. The novel traces the lives of two brothers who, with others, fell to their deaths when the bridge collapsed; and I remember a line, more or less, that Wilder attached to their relationship: "of two people who love, one loves the less." I have carried that knowledge with me forever.

The second novel bequeathed me not a line but a relationship—between the brilliant psychoanalyst, Dick Diver, and the patient he marries, Nicole, suffering from a father's sexual abuse. F. Scott Fitzgerald's *Tender Is The Night* is the story of a patient who is healed and grows, as if feeding off her healer who diminishes. It is a long time since I have read the novel, but I carry in my memory a sense of the untalented one who is determined not to be intimidated by her brilliant and talented partner, and of the slow process by which the strong are destroyed at the hands of the weak.

The universality of this struggle spread for me not only through similar kinds of competitive relationship but across culture and politics—whether into the debate that concludes Bob Dylan's lyrics are greater than Keats's poetry, or the Chinese cultural revolution sending artists and intellectuals out to the fields to farm and be diminished to size, or the murderous nothings who imagined they grew by bringing down the twin towers. Correctly or not, the love affair of Fitzgerald's two protagonists alerted me throughout life to the pernicious effects of the inferiority complex as well as to the almost impossible relationships between men and women.

And because there is also in me the tales of King Arthur as well as Chekhov's stories, and Voltaire's *Candide* as well as Saul Bellow's *Humboldt's Gift*, and Chinese poetry as well as Chaucer's (and let's not go into Gothic cathedrals and *The Stones of Venice*), I must conclude that what has made me modern is the past, thousands and thousands of years of it.

RUSSELL BANKS

Russell Banks is the author of a dozen books including *Hamilton Stark*, *The Sweet Hereafter*, and *Affliction*. In 2001, Banks was elected President of The International Parliament of Writers, following such writers as Wole Soyinka and Salman Rushdie. He has twice been a finalist for the Pulitzer Prize—for *Continental Drift* in 1986, and for *Cloudsplitter* in 1998—and has received the John Dos Passos Award and the O. Henry Memorial Award. His most recent book is *The Angel on the Roof*, a collection of short stories, published in 2000.

JULIAN BARNES

Julian Barnes has written nine novels, a book of short stories, and two collections of essays. He has twice received nominations for the Booker Prize—for *Flaubert's Parrot* in 1984 and for *England, England* in 1998—and is the recipient of the Somerset Maugham Prize, the Prix Médicis and Prix Fémina, and the American Academy and Institute of Arts and Letters Award. Barnes has written four crime novels under the pseudonym Dan Kavanaugh, and has been a regular contributor to the *Guardian* and *The New Yorker*. His most recent book is *In the Land of Pain* (2002).

CHRISTINE BROOKE-ROSE

Christine Brooke-Rose is best known for her novels *Xorandor* and *Verbivore*, though she has produced numerous experimental works that reveal her fascination with language and her postmodernist philosophy on the aims and methods of fiction. She is also an accomplished translator and literary critic whose two studies of Ezra Pound garnered her broad critical acclaim.

ANITA DESAI

Anita Desai's novels focus on the struggle of her characters to cope with the problems of contemporary Indian life. She has been shortlisted for the Booker Prize on three occasions: in 1980 for *Clear Light of Day*, in 1984 for *In Custody*, and in 1999 for *Fasting, Feasting*. Desai is a Fellow of the Royal Society of Literature and a member of the American Academy and Institute of Arts and Letters. She is at present a professor of creative writing at The Massachusetts Institute of Technology.

DAVID DOUGLAS DUNCAN

David Douglas Duncan took his first photograph in 1934 of John Dillinger escaping a hotel fire in Tucson, Arizona, and has since become known as the premier photojournalist of World War II, the Korean War, and the Vietnam War. During a decade on the staff at *Life* magazine, Duncan earned the moniker "Yankee Nomad," covering assignments in India, Turkey, Eastern Europe, the Middle East, and Africa. Duncan has photographed the treasures of the Kremlin, documented a period in the life of Pablo Picasso, and provided some of the world's best-known images to such magazines as *Life* and *National Geographic*. He has published over 20 books of his photography.

ELIZABETH HARDWICK

Elizabeth Hardwick has published thirteen books of fiction, essays, biography, and history. In addition to the producing three novels, Hardwick helped found the *New York Review of Books* and has written criticism for *Partisan Review*, *The New Republic*, and *Harper's*. She is a recipient of a Guggenheim Fellowship, the George Jean Nathan Award for Dramatic Criticism, and the National Academy and Institute of Arts and Letters Award in literature.

WILSON HARRIS

Wilson Harris's divergence from the norms of writing has earned much praise and criticism, signifying his importance to the evolution of modern fiction. His novels incorporate philosophy, metaphor, and myth to create distinctive visions of reality. Perhaps best known for the four novels in his "Guyana Quartet"—*Palace of the Peacock*, *The Far Journey of Oudin*, *The Whole Armour*, and *The Secret Ladder*—Harris has also published notable editions of poetry and literary criticism. The author is a Guggenheim Fellow and has received the Guyana Prize for Fiction and the Mondello Prize (Italy).

DAN JACOBSON

Dan Jacobson is a Jewish native of South Africa, whose novels often reflect the ambiguities extant in the culture of apartheid. His early novels, such as *The Trap* and *The Evidence of Love*, focused on the corruption, violence, and betrayal inherent in the system. Jacobson has regularly contributed to an array of periodicals, including the *Guardian*, The *London Review of Books*, and The *New Yorker*. He has received the John Llewelyn Rhys Award, the W. Somerset Maugham Award, and the J.R. Ackerley Award for autobiography.

ADRIENNE KENNEDY

Adrienne Kennedy is the Obie-award-winning author of *Funnyhouse of a Negro*, which opened off-Broadway in 1964. The recipient of Guggenheim, Rockefeller, and NEA grants, Kennedy has written many plays including *A Rat's Mass*, *A Movie Star Has to Star in Black and White* and *Sleep Deprivation Chamber*, which she co-wrote with her son Adam P. Kennedy. Kennedy has taught creative writing at Harvard University, Yale University, Princeton University, and the University of California at Berkeley. Last year, Kennedy received the Anisfield-Wolf Lifetime Achievement Award, given to individuals whose life work contributes to the understanding of racism and the appreciation of the rich diversity of human cultures.

PENELOPE LIVELY

Penelope Lively has authored more than forty books for both children and adults, including two works of non-fiction: *The Presence of the Past: An Introduction to Landscape History*, and her childhood memoir, *Oleander, Jacaranda*. Lively won the Booker Prize for *Moon Tiger* in 1987, and is the recipient of numerous other honors including the Whitbread Award, the Carnegie Medal, and the Order of the British Empire for her contributions to literature. Her most recent novel is *The Photograph* (2003).

RONALD SUKENICK

Ronald Sukenick has enjoyed as much notoriety for his advocacy of literary innovation and experimentation as for his own writing. Author of such novels as *Up and Out*, and of such short story collections as *Death of the Novel and Other Stories*, Sukenick is also a founder of The Fiction Collective, a publishing group of writers formed in 1974 as a reaction to conservatism in the publishing industry. The group re-formed in 1988 as Fiction Collective 2, with Sukenick named as permanent director. Since that time, he has acted as publisher of *American Book Review* and *Black Ice*, a magazine of innovative fiction.

ARNOLD WESKER

Arnold Wesker has produced a prodigious body of work, including 42 plays, four books of short stories, three volumes of non-fiction, and an autobiography. His work is performed worldwide and has been published in 18 languages. Growing up in London's East End as the child of working-class parents, Wesker drew on his own experiences to write *Chicken Soup with Barley*, *Roots*, and *I'm Talking about Jerusalem*, a trilogy about a family of Jewish Communist intellectuals. Later successes include *Chips with Everything*, *Shylock*, and *Caritas*. Wesker has received numerous honors, including the Goldie Award and—three times—the gold medal for best foreign play by *El espectador y la critica*.

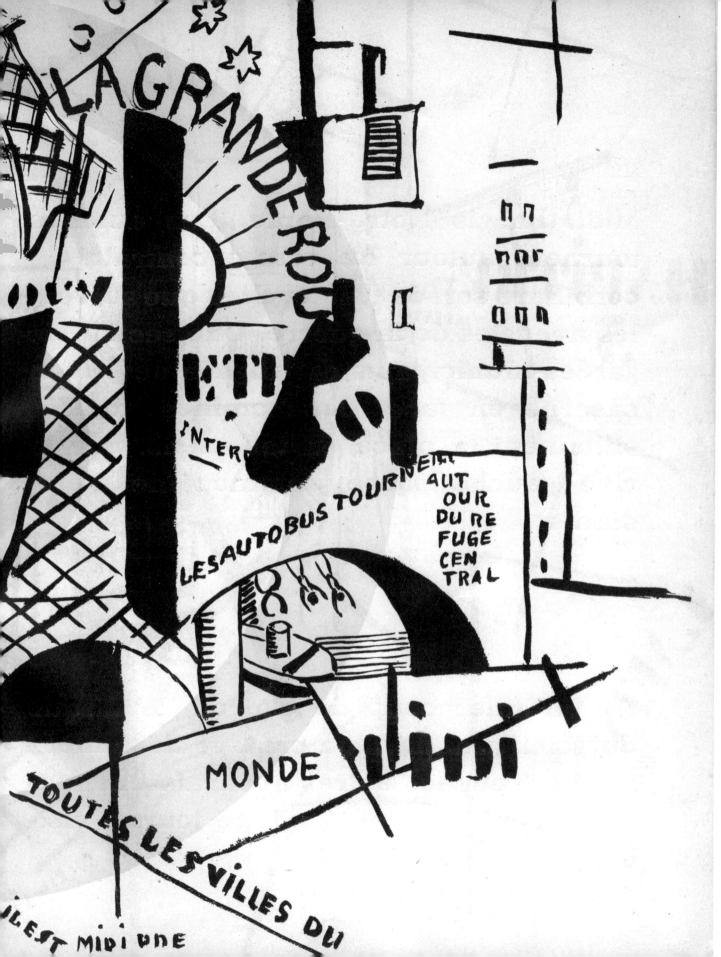

Fernand Léger (1881-1955), illustrations for Blaise Cendrars's *La Fin du monde filmée par L'Ange N.-D.* (The End of the World Filmed by the Angel N.-D. [Notre Dame]), 1919. According to Léger, "A modern man registers a hundred times more sensory impressions than an eighteenth-century artist."

"Léger's lettering—both handwritten and 'stenciled'—seems at once to define the surfaces of city walls and to cause their disappearance, leaving letters suspended like reflections of an electric sign or words caught in a mirror"
—Jodi Hauptmann (1998).

We asked a scholar who has written on Modernism in many of its aspects—literary, musical, pictorial—to meditate upon how an exhibition might emphasize the hybrid nature of Modernism, its blending of discrete genres extending the limits of artistic forms.

EXHIBITING MODERNISM: A VIEW FROM THE AIR

DANIEL ALBRIGHT

HERE TIME TURNS INTO SPACE.

In the first act of Wagner's last music drama, *Parsifal* (1882), the wise old knight Gurnemanz decides to escort Parsifal, the holy fool, to the castle of the Grail. Parsifal is surprised to find himself borne along effortlessly over great distances:

> *Parsifal.* I scarcely walk, and yet I seem to race.
> *Gurnemanz.* You see, my son, here time turns into space.

Wagner was showing off the expensive technology of his new theater at Bayreuth, in which scenery could be shifted on the fly. As the two men slowly walk, the forest landscape vanishes, and they find themselves on a path leading upward through walls of rock. Wagner was sensitive to the metaphysical dimensions of such a stage: time and space fuse, dissolve, grow permeable to realities greater than our own. In his 1870 essay on Beethoven, Wagner wrote that through music we are brought into an unconscious and intuitive realm in which we touch "the essence of things that eludes the forms of outer knowledge, time and space," and in *Parsifal* Wagner attempted to undo the most basic categories through which the mind apprehends the surrounding world.[1]

The motto **here time turns into space** was to be oddly prophetic of the world of modern physics, in which time is so intimate with space that it bulges and deforms in a similar rhythm. According to Einstein's "Special Theory of Relativity" (1905), as an object approaches the speed of light, its measurements contract while its internal clock gets slower and slower. I want to begin with this motto not only because it vividly expresses a certain delirium that would become

characteristic of twentieth-century thought, but also because it expresses the necessary character of a museum exhibition centered on the evolution of art. We pass from decade to decade exactly as Parsifal flew in the midst of a simple stroll— a few footsteps bring us from Paris to London, and from the 1910s to the 1920s.

For an exhibition, then, every layout in time is reconceived as a layout in space, as a floor plan. What does the time-layout of Modernism look like?

When I was flying to Austin in November 2002 to study some of the materials intended for the Ransom Center exhibition, the airplane passed high over Washington D.C. at night. Pierre L'Enfant's design was a faint haze of light beneath me: with its twinkled circles and rays thrusting out of invisible centers, it looked like a group of luminous jellyfish extending their fronds through black water, or like a vast spider's web, blurring out at its margins into a nest of lesser webs. I thought also of luminous plankton caught on a swirling surface of water. Most of the images that occurred to me were organic in character, but if I had been flying in the daytime I might have seen Washington more in terms of wheels and pistons and connecting-rods, like the undercarriage of a locomotive.

Modern art can also be understood through the figure of a radial net, in which a number of nodes are connected by lines. Such diagrams started to appear fairly early in the twentieth century: in 1936, for example, Alfred H. Barr, Jr., published a chart of modern plastic arts (Fig. 1), in which Seurat's Neo-impressionism and Cézanne's geometric volumes contribute to the great central nexus of Cubism, from which shoot arrows leading every which way, to Orphism, Dadaism, Purism, Neoplasticism, and so forth. (Barr's diagram is itself a fine piece of modernist graphic: certain works by Wassily Kandinsky have the same general form of vectors proceeding from arcs.) And

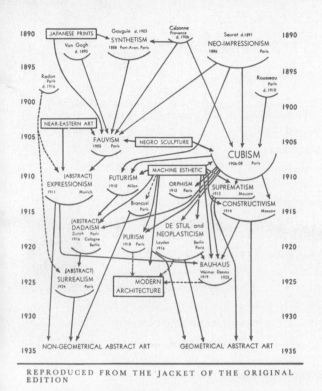

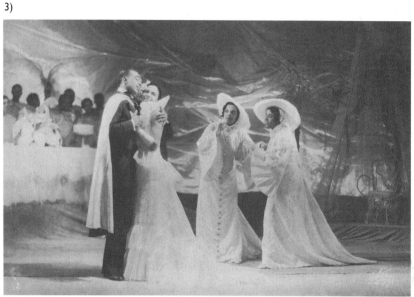

REPRODUCED FROM THE JACKET OF THE ORIGINAL EDITION

1) Chart prepared by Alfred H. Barr, Jr. for the jacket of the exhibition catalog *Cubism and Abstract Art* (New York: Museum of Modern Art, 1936; rpt. Arno Press, 1966)); 2) Illus. of Noh-style dancer from W. B. Yeats, *Four Plays for Dancers* (1921); 3) Photograph from the original production of *Four Saints in Three Acts* by Gertrude Stein and Virgil Thompson, 1934. From Act 2 ("It is easy to measure a settlement").

if we add all the other arts, the map would grow nearly black with interconnections. Draw some dots on a piece of paper, then draw lines from three or four of the dots to every other dot; then draw some lines connecting the less favored dots to a few other dots, but not to all. In this design the favored dots represent the pressure points of the modernist movement, where its grand syntheses took place:

- Paris in 1913, when the composer Igor Stravinsky, the impresario Serge Diaghilev, the choreographer Vaslav Nijinsky, and the archeologist and set designer Nicholas Roerich made *The Rite of Spring*;
- Stone Cottage, Sussex, in 1916, when the poets Ezra Pound and William Butler Yeats, with the help of the dancer Michio Ito, reinvented Western drama by means of models from Asia (Fig. 2);
- Paris in 1917, when the scenarist Jean Cocteau, the painter Pablo Picasso, the composer Erik Satie, and the choreographer Léonide Massine devised the ballet *Parade*;
- Berlin in 1928, when the playwright Bertolt Brecht and the composer Kurt Weill created, through close scrutiny of an eighteenth-century anti-opera by John Gay, an anti-opera fit for the jazz age, *The Threepenny Opera*;
- Hartford, Connecticut, in 1934, when the author Gertrude Stein and the composer Virgil Thomson put on a dazzling exercise in nearly contentless chic, *Four Saints in Three Acts* (Fig. 3).

The less favored dots represent important but not crucial experiments where several strands of the modernist movement came together. The more vertical lines represent evolutions of a single theme (Expressionism, say) or chains of influence from artist to artist; the more horizontal lines represent affiliations, convergences, between artists unaware of one another's work. For an example of the latter, consider the year 1899-1900, when Joseph Conrad was bringing out a key work of literary Impressionism, *Heart of Darkness*, as Claude Debussy was composing a key work of musical Impressionism, the three *Nocturnes* for orchestra. One of the pleasures of the Ransom Center's exhibition is that viewers can draw their own thread from object to object, text to text, gallery to gallery. Modernism is not, and never will be, laid out in a single correct pattern; in the end it will always look less like a constructed labyrinth than like the internet itself, in which packets of information are shunted through any available circuit.

THE CRISIS OF VALUE IN MODERNIST ART

The great pieces of the modernist canon—the texts printed in every anthology, the musical compositions frequent on concert programs, the paintings (such as Edvard Munch's *The Scream*) reproduced to sell cars in television commercials—attained their gravity and specific import by making various sorts of radical claims about the locus of value in art.

The story of twentieth-century art is a story about a series of crises in value: how can art justify itself in a loud deaf century, an age reeling between terror and apathy? Art has always been able to proceed because its creators were confident about the validity of the delight and edification they provided; but during the twentieth century art had to writhe in insecurity. It is an era of aesthetic manifestoes precisely because artists had not only to create new art but also to propagandize

Value: make your audience feel edified and enlightened.

Value: flatter the taste of those who can afford to buy your work.

new standards of value by which their art could be judged as successful.

Modernism, like every artistic movement, defined itself against its enemies; and it began by choosing certain aspects of the nineteenth century as particular objects of hate. From this point of view, the nineteenth century could be loathed as an age of complacency and coziness. Much of its art seemed to have lost all intensity by trying to please a bourgeois audience craving safe arousals of sentiment.

In England especially, Queen Victoria seemed to have given her name to an artistically inglorious age. Painting (according to this caricature) had dwindled into lax depictions of real life (George William Joy's *The Bayswater Omnibus*), lax depictions of unreal life (Joseph Noël Paton's *The Reconciliation of Oberon* and *Titania*), heart-tugging story pictures (Ford Madox Brown's *Take Your Son, Sir!*), and the cute puppies of Sir Edwin Landseer. Similarly, literature had grown diffuse, adrift, purposeless, for it had forgotten its mission and was bulging with irrelevancies. For example, Yeats wrote in 1898 that the poetry of Victorian England had failed because it "tried to absorb into itself the science and politics, the philosophy and morality of its time"; and the Anglo-American poet T. S. Eliot complained in 1933 that Matthew Arnold, the old Victorian sage, had gone hopelessly astray because he had tried to make poetry do the work of religion.[2] While Robert Browning maundered on, in "Mr. Sludge, 'The Medium,'" about the relation of God's creative will to intestinal parasites, the modernists felt that literature had got itself hopelessly compromised with unliterary matters.

Victorian art looked as overstuffed as its armchairs—a reflex of a stifling, mildewed, wetly vegetative century, as the novelist Virginia Woolf described it in 1928:

A change seemed to have come over the climate of England [in the nineteenth century]….The sun shone, of course, but it was so girt about with clouds and the air was so saturated with water, that its beams were discoloured and purples, oranges, and reds of a dull sort took the place of the more positive landscapes of the eighteenth century. Under this bruised and sullen canopy the green of the cabbages was less intense, and the white of the snow was muddied. But what was worse, damp now began to make its way into every house…Damp swells the wood, furs the kettle, rusts the iron, rots the stone…furniture was muffled; walls and tables were covered too.[3]

Of course, such anti-Victorianism can be refuted by pointing to any number of sophisticated, forward-looking artistic experiments in Victorian England. But it is nonetheless true that during the nineteenth century there was, in England and elsewhere, a sense of malaise concerning the future of art. Indeed, there was a sense of malaise about the future of the future itself. Little white space was left

on the world's map, the source of the Nile was found at last, and by the end of the century it was clear that the North and South Poles would soon be conquered; scientists were suggesting that the physics was essentially complete, and, after a few minor problems had been cleared up, physicists could pack up their apparatus and go home. The political philosopher John Stuart Mill, a man who much delighted in opera, fretted that he might outlive the art of music itself:

I was seriously tormented by the thought of the exhaustibility of musical combinations. The octave consists only of five tones and two semitones, which can be put together in only a limited number of ways, of which but a small proportion can be beautiful; most of these, it seemed to me, must have been already discovered, and there could not be room for a long succession of Mozarts and Webers, to strike out, as these had done, entirely new and surpassingly rich veins of beauty.[4]

Some feared that the invention of photography might make painting obsolete as well. By the end of the nineteenth century, the arts seemed to have thinned as they distended—they seemed to have lost creative power, lost a clear path for future development. The whole canon seemed in danger of closing; a century dedicated to the building of museums seemed almost ready to shut the arts into sealed glass cases once and for all.

What exactly had gone wrong? Why, in an age devoted to progress, were the arts proceeding on a narrowing path? The answer lay, in part, in a confusion between the arts and the value system that had long sustained the arts: it was the value system that was disintegrating, not the arts themselves. The instant that artists renounced the value system, they felt an influx of new power.

The traditional value system embraced many elements, but prominent among them were these: truth telling; obedience to rule; and imitation of the classics.

Truth-telling. In classical times, the painter Zeuxis was said to paint grapes so exactly that birds tried to peck at them. The notion that a representation of a grape should possess as many traits as possible in common with a real grape—roundness, purpleness, semi-opacity, a faint luster of mold, a luscious sense of pressure beneath the skin—has always been a criterion for evaluating excellence in art. Literature bound itself to a similar oath to tell the truth, in the nineteenth century as much as any other. In 1810 the Romantic poet William Wordsworth wrote, "ages must pass away before men will have their eyes open to the beauty and majesty of Truth, and will be taught to venerate Poetry no further than as She is a Handmaid,"[5] and in 1864 the novelist George Eliot made telling the truth the whole justification for her art:

Value: judge your art by its fidelity to fact.

Falsehood is so easy, truth so difficult. The pencil is conscious of a delightful facility in drawing a griffin—the longer the claws, and the larger the wings, the better; but that marvellous facility which we mistook for genius is apt to forsake

us when we want to draw a real unexaggerated lion. Examine your words well, and you will find that even when you have no motive to be false, it is a very hard thing to say the exact truth....

It is for this rare, precious quality of truthfulness that I delight in many Dutch paintings, which lofty-minded people despise. I find a source of delicious sympathy in these faithful pictures of a monotonous homely existence, which has been the fate of so many more among my fellow-mortals than a life of pomp or of absolute indigence, of tragic suffering or of world-stirring actions. I turn, without shrinking, from cloud-borne angels, from prophets, sibyls, and heroic warriors, to an old woman bending over her flower-pot, or eating her solitary dinner, while the noonday light, softened perhaps by a screen of leaves, falls on her mob-cap, and just touches the rim of her spinning-wheel, and her stone jug, and all those cheap common things which are the precious necessities of life to her;—or I turn to that village wedding, kept between four brown walls, where an awkward bridegroom opens the dance with a high-shouldered, broad-faced bride, while elderly and middle-aged friends look on, with very irregular noses and lips and probably with quart-pots in their hands, but with an expression of unmistakeable contentment and goodwill. "Foh!" says my idealistic friend, "what vulgar details! What good is there in taking all these pains to give an exact likeness of old women and clowns? What a low phase of life!— what clumsy, ugly people!"

But bless us, things may be lovable that are not altogether handsome, I hope?....Yes! thank God; human feeling is like the mighty rivers that bless the earth: it does not wait for beauty—it flows with resistless force and brings beauty with it.[6]

It is helpful to compare this amiable manifesto for the realistic novel with the French writer Émile Zola's far more antiseptic manifesto for the naturalistic novel, from 1880:

The experimental novelist is therefore the one who accepts proven facts, who points out in man and in society the mechanism of the phenomena over which science is mistress, and who does not interpose his personal sentiments, except in the phenomena whose determinism is not yet settled, and who tries to test, as much as he can, this personal sentiment, this idea a priori, by observation and experiment.... The metaphysical man is dead; our whole territory is transformed by the advent of the physiological man. No doubt "Achilles' Anger," "Dido's Love," will last forever on account of their beauty; but today we feel the necessity of analyzing anger and love, of discovering exactly how such passions work in the human being.[7]

Both Eliot and Zola demand that artists test and correct their representations against an external standard of truth: but Eliot looks for her ideal to such old masters as the painter Brueghel, whereas Zola looks to the sociologist, the neu-

rologist, the geneticist. For Zola, the domain of the novelist's personal feeling is steadily contracting, as guesswork is replaced by fact; for Eliot, the domain of the novelist's personal feeling is steadily expanding, as she is swept further and further down the mighty river of human sympathy.

And now we can see one inadequacy in upholding truth as a value in art. Sentimental truth and scientific truth are not the same: truth breaks down into competing truths. (This has been the case in every age, but the professionalization of truth during the nineteenth century, especially in the sciences, tended to aggravate this splitting.) Different novelists, all with an equally fierce claim to verisimilitude, inquired into different domains of verity. To read a novel by George Eliot or Charles Dickens is to gain a sense of the depth of experience: just as, in a carnival-scene by Brueghel, a few brush-strokes suggest the astonishing multiplicity of textures in the world—burlap, tree-bark, greasy metal, splintered wood—so the novelist's accumulation of detail imitates the sheer variety of emotional and visual and tactile experiences through which we engage ourselves with the world. The purpose of such a novel is to restore to us the complexity of our own feelings by showing us the complexity of other peoples'. But the purpose of reading a Zola novel is to plot the course of certain vectors that determine human conduct—to watch catabolism, or destructive metabolism, in action. Zola wanted insight into the causes of degeneration; George Eliot wanted to promote love of human beings just as they are. In a sense Zola was the greater idealist, despite his hardness of tone, for, if human life is a disease, as Zola believed, then it is theoretically capable of cure.

Throughout nineteenth-century literature we witness a certain uneasiness about the impossibility of reconciling discrepant notions of truth. In 1855 Robert Browning published "Andrea del Sarto (Called 'The Faultless Painter')," a dramatic monologue in which a Renaissance painter mutters about the futility of his career: he can paint with perfect accuracy of representation, and yet Raphael, whose draftsmanship is far less exact, reaches artistic heights forever denied to Andrea.

*Ah, but a man's reach should exceed his grasp,
Or what's a heaven for? All is silver-grey
Placid and perfect with my art: the worse!...*

*That arm is wrongly put—and there again—
A fault to pardon in the drawing's lines,
Its body, so to speak: its soul is right,
He [Raphael] means right—that, a child may understand.
Still, what an arm! and I could alter it:
But all the play, the insight and the stretch—
Out of me, out of me![8]*

Andrea accuses himself of painting the truth of external husks; Raphael, on the other hand, paints the vivacity, the exuberance of things, paints the truth of life

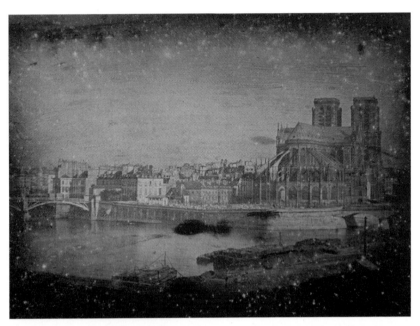

4) Louis Jacques Mandé Daguerre (1787-1851), *View of the Isle de la Cité with Notre Dame*, c. 1839, daguerreotype.

itself. By calling his art "silver-grey," Andrea is, from Browning's vantage-point in the nineteenth century, relegating his painting to a sort of photography, even before photography actually existed. Of course, because photography staked its claim to one sort of truth so triumphantly, the painters of the nineteenth century found it convenient to re-define the field of truth to cover sorts of representations not available to the photographers Louis Daguerre or Joseph Niépce (Fig. 4).

Other symptoms of truth's fracture can be seen in what is perhaps the century's most successful novel, *Madame Bovary* (1857), by Gustave Flaubert:

> *the new boy was still holding his cap on his knees even after prayers were over. It was one of those head-gears of composite order, in which we can find traces of the bear- and the coonskin, the shako, the bowler, and the cotton night-cap; one of those poor things, in fine, whose dumb ugliness has depths of expression, like an imbecile's face. Ovoid and stiffened with whalebone, it began with three circular strips; then came in succession lozenges of velvet and rabbit fur separated by a red band; after that a sort of bag that ended in a card-board polygon covered with complicated braiding, from which hung, at the end of a long thin cord, small twisted gold threads in the manner of a tassel. The cap was new; its peak shone.*[9]

This passage comes from the very beginning of the novel, and it disturbs us to find that truth is a property of things rather than people. With a few exceptions, the characters of this novel are rather inarticulate—they have strong emotions, but they are too stupid or repressed or unlearned to vent those emotions properly, to give them adequate expression. Charles Bovary, for example, is a wisp of a man, a chuckle-headed cuckold, without a determinable inner life. But in a world of boring vague people, things become marvelously expressive: Charles Bovary's schoolboy cap, a complex, absurd, unintelligible thing, an incoherent but precise assemblage of odds and ends, stands for and even in a sense replaces Charles himself. It is as if the novelist had surgically removed Charles's brain, and displaced all his psychology onto the cap. In Flaubert's novel, as in certain nineteenth-century Pre-Raphaelite (that is, neo-medieval) paintings, the human beings in the foreground are of far less importance than the knotted, over-figured, teasingly intricate background. Truth has fled from the human subject to the peripheries of the compositional space.

These nineteenth-century games with repositioning the locus of value, the object of truth, into unusual and even preposterous places would continue, with increasing gusto, in the twentieth. For now, it is only necessary to note that the concept of truth itself was under considerable assault. In 1873 the fiery German philosopher Friedrich Nietzsche wrote (but did not publish) a remarkable essay called "On Truth and Falsehood in the Extra-Moral Sense," in which he claimed that all discernment of truth is delusion, since language knows nothing of truth: "What is a word? The image of a nerve stimulus in sounds. But to infer from the nerve stimulus, a cause outside us, that is already the result of a false and unjustified application of reason."[10] The harder we look for truth, for something outside ourselves that is solid and durable, the more we find simply a neural twitch, or a breath of air standing in place of a neural twitch—that is, nothing at all.

When we turn from philosophy to literature, we find a far better publicized attack on truth in Oscar Wilde's 1889 essay, "The Decay of Lying": "What we have to do… is to revive this old art of Lying…. All bad art comes from returning to Life and Nature, and elevating them into ideals…. The moment Art surrenders its imaginative medium, it surrenders everything. As a method Realism is a complete failure."[11] Or, as Wilde put it elsewhere, "The nineteenth century dislike of Realism is the rage of Caliban seeing his own face in a glass. The nineteenth century dislike of Romanticism is the rage of Caliban not seeing his own face in a glass."[12] Wilde was remembering Shakespeare's claim that "the purpose of playing…is, to hold as 'twere the mirror up to nature"; but Wilde advocated an art that renounces mirrors altogether, that has nothing to do with truth, at least with that sort of truth familiar to biologists, engineers, and newspaper writers.[13] And the motto **shatter the mirror** indeed became part of the normal rhetoric of twentieth-century art: near the century's beginning, in 1897, Yeats wrote a story about a too self-controlled man—"a man is a great man just in so far as he can make his mind reflect everything with indifferent precision like a mirror"—who undergoes a hallucinatory, life-transforming vision of divine presences, and hears a voice "cry with an exultant cry, 'The mirror is broken into numberless pieces.'"[14] Similarly D. H. Lawrence wrote in a love poem

of 1929, "Let us lose sight of ourselves, and break the mirrors."[15] The depiction of reality (in some sense of the slippery word "reality") was still the business of a good deal of twentieth-century art; but we rarely feel that the artist is simply (according to Stendhal's famous aphorism about the novelist) a mirror dawdling down a lane. The twentieth-century artist's reality is usually an imposed, manhandled reality, not merely what a mirror or a camera would show if aimed in no particular direction.

In music the value of truth-telling is a little less conspicuous than in painting or literature, since music's truths can't easily be compared with some external phenomenon. There is a large body of music that imitates nature-noises, including Ludwig van Beethoven's sixth symphony (1808), which employs explicit evocations of nightingale, quail, and cuckoo, as well as an impressive orchestral storm; and Joseph Haydn's *The Seasons* (1801), where frogs do a bit of croaking. But such special effects have rarely been accepted as part of the major purposes of music, and a number of commentators, such as the philosopher Arthur Schopenhauer, have flatly dismissed sound-mimesis as a betrayal of music's higher mission: poor music "does not express the inner nature of the will itself, but merely gives an inadequate imitation of its phenomenon. All specially imitative music does this; for example, *The Seasons*, by Haydn… Such music is entirely to be rejected."[16]

For many composers, music tells the truth not by conforming itself to cheeps, thunder, sloshing of waves, and rustling of trees, but by representing states of feeling and desire as accurately and immediately as possible. Such composers don't aspire to be Zola, testing theses about the behavior of sound, but instead aspire to be George Eliot, working to establish a warm emotional connection among her readers. For example, when the French Romantic composer Hector Berlioz heard the first movement of Beethoven's fifth symphony (1808), he was excited by the astonishing nakedness of feeling thrown out by the music:

> *disordered feelings…overwhelm a great soul prey to despair; not the concentrated, calm despair that has the look of resignation; not the black mute pain of Romeo learning of Juliet's death, but indeed the terrible rage of Othello, receiving from Iago's mouth the poisonous slanders that persuade him of Desdemona's crime.*[17]

For Berlioz, Beethoven could embody the deep truth of jealousy as well as (perhaps better than) Shakespeare did. In the twentieth century some composers continued this research into states of intense feeling, often seeking to express subtler, more arcane, more pathological feelings than the nineteenth-century composers did—music, like the other arts, explored the diminishing field of the as-yet-unmapped; whereas other composers sought truth in different areas of acoustic possibility, even including the complete absence of feeling.

Obedience to rule. Art may seek to justify itself by accuracy of representation and by sincerity of feeling—what I have been calling truth-telling. But art may also attempt a different strategy for vindication: it may preen itself on its conformity to long-tested and long-confirmed principles of construction.

Obedience to rule may seem a somewhat weaker value than truth-telling, insofar as it pertains more to the absence of vice than to positive virtue. Recently we have been so accustomed to art that is challenging, threatening, in-your-face, that it is hard to remember how strongly past centuries valued inoffensiveness or simple good taste. No twentieth-century composer, to my knowledge, ever gave to a piece of music a title like that of a 1736 cantata by Georg Philipp Telemann, *Moderate Happiness*. Anti-conventionalism is a vehement convention of much twentieth-century art, but every artistic convention, every formula, every set of *thou shalt nots*, no matter how pat or trite, is potentially a source of power—whether in Renaissance pastoral poetry or in television situation comedy.

Poetry has strict rules of meter concerning the placement of accented and unaccented syllables—when Matthew Arnold learned that he had mistaken the pronunciation of the name *Tintagel* he felt obliged to rewrite several lines of a poem for the sake of good syllabic bookkeeping—but most of the other rules of literature are fairly loose. Aristotle legislates in the *Poetics* that a good tragic plot consists of the fall of a great but not completely good man; the story should also manifest a unity of action, and should avoid improbabilities at all costs. And indeed for thousands of years writers have attended to these rules, sometimes rigidly, sometimes not. Aristotle's unity of action was still an important force in the nineteenth-century theater. In a "well-made play," such as those of Victorien Sardou or certain ones of Henrik Ibsen, every detail was cooperant to the final effect. If a pistol was shown in the first act, the audience could rest assured that it would be fired before the final curtain. The novel, though much baggier than the drama, was supposed to be plausible, logical, and ethical in the Aristotelian fashion. The fictitious world was to be consistent and reliable, cause and effect clearly determined, and the outcome governed by a sense of moral design. A novelist who made errors in chronology could expect hostile letters from readers, and a novelist who inflicted immitigable suffering upon innocent children, or showed the triumph of the wicked, ran the risk of alienating the audience.

But here, of course, the value of obedience to rule starts to diverge from the value of truth-telling. We all know that the wicked sometimes do triumph, and that the innocent suffer horribly for no reason. The tendency of art to streamline, to impose justice upon the general mess, to create beauty through careful elimination of the extraneous, may work toward prevarication, not toward truth. And so, among many literary figures in the nineteenth century, a certain contempt for lucid plot-design, even for beauty itself, starts to be felt. Here is the

Value: construct your work according to time-honored principles.

French writer Victor Hugo, writing in 1827 in the famous preface to his play *Cromwell*:

> There is only one type of the beautiful, but the ugly has a thousand types. The beautiful… is merely form considered in its simplest relation, in its most absolute symmetry, in the most intimate harmony.… It offers to us a finished ensemble, but circumscribed.…What we call the ugly, on the contrary, is a detail of a great ensemble that escapes our grasp, and which harmonizes itself, not with man, but with creation in its entirety.[18]

Flaubert expressed a similar thought more pithily, referring to the fat earthy sidekick in Cervantes' *Don Quixote*: "The human consciousness has broadened since Homer. Sancho Panza's belly has burst the seams of Venus' girdle."[19] Literature shouldn't try to accommodate itself to the corset of conventional plot-lines, in which the romance terminates in marriage, and the couple lives happily ever after. Instead, literature should bulge, should barge into every unsavory corner of the universe. It is no wonder that, in one of Hugo's novels, gypsies mutilate their own children in order to make them more pitiable to the passersby, and therefore more effective as beggars.

A literary rule based on moral symmetry clearly promotes a notion of human life contrary to fact. But the rules concerning plausibility and logical consistency are also suspect. How many of us can look at our lives and find an orderly sequence of cause and effect? When I remember the critical events that shaped me, I find them unpredicted and spasmodic: my world is fragilely tied together by an effort of will, perhaps by rationalization and self-deception. The "novel" of my life is, by any aesthetic canon, a wretched thing—I can find no omniscient narrator for it, scarcely even a half-wit narrator. In other words, the very rules that are designed to impart a feeling of heft and credibility to a novelist's world are themselves likely to lead to a certain disbelief and loss of gravity.

This is in fact typical of artistic rules in every medium: *the rule created to persuade us that the artist is telling the truth will, if followed slavishly, erode the sense of truthfulness that it tries to enhance.* Since the Renaissance, painters have sought to make credible images by following the rule of perspective: that is, by depicting parallel lines as toed-in, converging at an infinitely distant point on the horizon opposite the viewing eye. This method is indeed faithful to the eye's apprehension of receding grids and creates a methodical space in which the relative size of distant objects can be judged. But it can be said to tell the truth about nature only if we identify nature with space. The rule of perspective tends to make space more fascinating than the objects that inhabit that space. So, in many Renaissance paintings we find an abnormal prevalence of open public squares with cross-hatched paving, or of huge tables yawning into the foreground (as in Leonardo's *Last Supper*—who arranges a dinner party so that nobody sits on one side of the table?), or of other scenic devices that call attention to the artist's virtuosity with perspective. If railroad yards had existed in the Renaissance, there might have been a whole sub-genre of the Madonna of the railroad yard.

Every artistic rule based on truth-telling tends to cherish one aspect of truth at the expense of others. Even such a simple rule as the outline has its disquieting aspects. In the real world, an object does not have an outline but an edge, a "flowing contour where the body suddenly leaves off, upon the atmosphere."[20] An outline is a convention that we use to make objects easier to recognize, and to draw with outlines is to promote an idea that nature consists of a heap of finite objects. But nature is not a thing-dump; nature is not an empty space parceled out into narrowing boxes; nature is… what? Whatever it is, it is beyond the power of art to do more than to suggest that it is *there*, more *there* than we can possibly imagine.

In the second half of the nineteenth century, a number of painters decided that the old rules for visual representation had become a hindrance, not a help, in the attempt to seize nature as it really is:

> I can do nothing without Nature. I do not know how to make things up. As long as I have tried to paint something in accordance with the lessons I have been taught, I have never produced anything worthwhile. If my work has any real value today, it is because of the exact interpretation and truthful analysis.[21]

The speaker was Édouard Manet, and the reporter was Zola, whose portrait Manet was painting. The great naturalist was highly intrigued by recent developments in painting, and indeed was to write a novel about an advanced painter, *L'Oeuvre* (1886). But the question arises: how can an artist interpret nature exactly, and analyze it truthfully, without an established lesson-plan, without the body of rules that painters devised over centuries to accomplish exactly that?

"Impression," the word that gave its name to this school of anti-conventional French painting, contains a clue to an answer. What is nature, if it is not an articulate space occupied by a poised collection of lucid objects? Perhaps nature is a shimmer of fleeting precepts. Claude Monet said his goal was "to paint directly from nature, striving to render my impression in the face of the most fugitive effect."[22] If Nietzsche claimed that truth, far from being a stable idea of the external world, was nothing more than a stutter of sensations through our nerve-endings, then the French Impressionists tried to convey a visual representation of these nerve-stimuli not yet fully mapped into a coherent world. Traditional painting had addressed itself to the mind, had done everything it could to facilitate the sense of *recognition*. If this young boy has a slingshot, he must be David. But Impressionist painting addressed itself to the eye and did everything it could to facilitate the sense of shock *prior to* recognition: Monet told an American painter that he tried "to see the world as a pattern of nameless color patches—as might a man born blind who has suddenly regained his sight."[23]

Traditional painting tended to do homage to nature by presenting it in a familiar and generalized form: a willow tree tended to possess every single trait characteristic of willows, so that the mood associated with willowness—pensive, brooding—could be potently embodied. But Impressionist painting tended to do homage to nature by presenting it in its most specific, temporally acute manifestations: not *the* willow but *this* willow. One Impressionist, Auguste Renoir, even denied that generalities had anything to do with art. He proposed to found a Society of Irregularists, devoted to the proposition that "nature abhors regularity":

> *the works of nature from the most important to the most insignificant are infinitely varied, no matter what type or species they belong to. The two eyes of even the most beautiful face are never exactly alike; no nose is ever situated immediately above the middle of the mouth; the segments of an orange, the leaves of a tree, the petals of a flower, are never exactly identical. It would seem that every type of beauty derives its charm from its diversity.[24]*

It is remarkable how closely this project of 1884-85 echoes Nietzsche's then-unpublished essay on truth and falsehood:

> *Every concept originates through our equating what is unequal. No leaf ever wholly equals another, and the concept "leaf" is formed through an arbitrary abstraction from these individual differences, through forgetting the distinctions; and now it gives rise to the idea that in nature there might be something besides the leaves which would be "leaf"—some kind of original form after which all leaves have been woven, marked, copied, colored, curled, and painted, but by unskilled hands, so that no copy turned out to be a correct, reliable, and faithful image of the original form.[25]*

Here Nietzsche mocks Plato's notion of transcendent form (which affirms that only the concept "leaf" is real and that any mere leaf that you pluck from a tree is but a shadow). For centuries, painters had been painting the concept "leaf," but the Impressionists were much less interested in the idea of the leaf than in the impinging of the leaf's light on the sensory network.

So, an impression looks like an antidote to rule, for impressions seem too vagrant to solidify into rules. But this was not quite the case, and indeed, in the domain of the arts, every method of transgressing against the old rule quickly stiffens into a rule of its own, a codifiable procedure. The Impressionists, far from escaping from law, had simply traded the laws that govern the spatial placement of solid objects for the laws that govern impalpable forces. If they were no longer under Newton's thumb, they were still bound by the rules of the physiology of sensation, the rules of electromagnetism itself. The painter Camille Pissarro closely studied the contemporary physics of Hermann Helmholtz and James Clerk Maxwell (who taught that electromagnetic lines of force could be understood through analogy with the motion of liquids; and who created the color photograph by understanding that the eye has three kinds of color receptors). But the great scientific hero of the Impressionists was Eugène Chevreul, a chemist who worked for the Gobelin tapestry factory. Investigating the optics of dye-stuffs, he discovered that nearby colors influenced one another, since a spot of any pigment swims in a little halo of its own complementary color. A drop of red, say, discolors the surrounding field with blue-green. As Pissarro wrote, the work of advanced painters was "To seek a modern synthesis of methods based on science, that is, based on M. Chevreul's theory of colour and on the experiments of Maxwell To substitute optical mixture [juxtaposed dabs of unmixed colors] for mixture of pigments."[26]

But this image of the painter as a researcher in ophthalmic neurology is not easy to reconcile with the image of the painter as pure wild heroic eye, confronting reality without preconditions, without rule. Impressionism was, alas, from its very origin, a method—a new and powerful method, to be sure, but not the simple truth of things. Truth is always someone's truth, and to reject the truths learned in art school—from the Canon of Polyclitus (concerning the ratio of limb-length to body-length in a statue) to the law of perspective—means that the artist must seek truths from other fields of inquiry. A grainstack might be better, or at least more intriguingly, conveyed by reconstructing on canvas the firing-processes of the rods and cones of the retina than by quoting a traditional image of a grainstack; but Monet was just as dependent on a method as the Old Master was.

Pissarro was not the only nineteenth-century artist inclined to look for inspiration to modern science. As we have seen, Zola preferred to construct the plots of his novels according to the rule of sociological and biological determinism instead of the rule that a romance should end with the delighted heroine's marriage. Elsewhere in literature we find close parallels to the science that moved the Impressionist painters, for writers too were swept up in a vision of a world in which solid objects dematerialize into a whirlwind of electromagnetic forces. Here is the Oxford don Walter Pater, exalted in 1873 by Maxwell's notion of reality:

> *For us, necessity is not, as of old, a sort of mythological personage without us, with whom we can do warfare. It is rather a magic web woven through and through us, like that magnetic system of which modern science speaks, penetrating us with a network, subtler than our subtlest nerves, yet bearing in it the central forces of the world....*
>
> *At first sight experience seems to bury us under a flood of external objects, pressing upon us with a sharp and importunate reality.... But when reflexion begins to play upon those objects they are dissipated under its influence; the cohesive force seems suspended like some trick of magic; each object is loosed into a group of impressions—colour, odour, texture—in the mind of the observer....To such a tremulous wisp constantly re-forming itself on the stream, to a single sharp impression... what is real in our life fines itself down.[27]*

As it turned out, a literature that obeyed the rule of impression rather than the rule of denotation had a strange and exciting texture. In the twentieth century, Joseph Conrad, Virginia Woolf, and others experimented with sentences in which all seemed a spattering, a rushing, a vagrancy, a wash of color, not a presentation of a definite world. A simple example of literary Impressionism can be found in Conrad's *Heart of Darkness* (1899), in a passage describing the jungle's sudden attack on the steamboat: "Sticks, little sticks, were flying about, thick: they were whizzing before my nose, dropping below me, striking behind me against my pilot-house. All this time the river, the shore, the woods, were very quiet . . . Arrows, by Jove! We were being shot at!"[28] The whizzing so confuses the speaker that he cannot immediately find the right noun: he seizes on the provisional and generic *stick* before figuring out the verbal concept he needs to know: *arrow*. Out of the blur there develops a specific idea, in the manner of a Polaroid photograph slowly taking shape.

In the field of music, the notion of obedience to rule can be treated more quickly, since the rules didn't concern correspondence to an external reality as much as proper adjustment of internal processes of composition. The rules of music gravitated around the concept of the tonic, the fundamental note from which music's orientation was forever derived, and to which music must in the end return. Much of the art of composition lay in creating an unambiguous sense of the tonic. Therefore, composers were told never to write passages in consecutive parallel fifths, since this tends to confuse the ear about the identity of the fundamental note. The tonic ought to be specified irrevocably by contrast with the dominant—that is, the key which corresponds to the tonic as *sol* corresponds to *do*. The interaction of tonic with dominant provided a kind of rhetorical punctuation for a musical composition, in that a half-cadence (a rise from tonic to dominant) could be used as a sort of colon or semi-colon specifying a movement to another topic or area of musical argument, and a full cadence (a fall from dominant to tonic) could provide an emphatic full stop.

The tonic was the locus of value: it was the Atlas whose shoulders bore the whole world of music. Musical analysis, even in the sophisticated form taught by Heinrich Schenker (still the basis of music theory in present-day conservatories), was essentially a method for precisely graduating value from the tonic to subsidiary notes by means of constructing a harmonic skeleton, a slow hidden under-melody guiding the deep surges of movement throughout a composition:

The whole of foreground, which men call chaos, God derives from His cosmos, the background. The eternal harmony of His eternal Being is grounded in this relationship.

The astronomer knows that every system is part of a higher system; the highest system of all is God himself, God the creator.

My concepts show that the art of music is much simpler than present-day teachings would have it appear. However, the fact that the simplicity does not lie on the surface makes it no less simple. Every surface, seen for itself alone, is of necessity confusing and always complex.

Specifically, my concepts demonstrate the following:

A firmly established linear progression can withstand even the most discordant friction of voices as they move contrapuntally.

A firmly established tonality can guide even a large number of chromatic phenomena securely back into the basic triad.[29]

I quote from Schenker's last work, published in the year of his death, 1935. It was perhaps not until the twentieth century, after the concept of tonality had been thoroughly attacked, that such an eloquent justification of tonality could have been written. Earlier writers no more needed to defend tonality than a fish needs to extol the virtues of water.

For Schenker, as for Augustine, all value is contingent upon God, whose infinite preciousness upholds the worth of every lesser thing. To confront the whole welter of notes in the score to a Beethoven symphony is to risk falling into utter confusion, but beneath the swirl of crotchets and quavers there are a few privileged notes, notes with gubernatorial force, special notes that analysis can properly isolate and arrange into a linear system, an orderly cosmos. And beneath the linear system there lies the tonic, God himself, or at least a potent metaphor for God.

But just as the atheist Nietzsche taught that God is dead—"Who gave us the sponge to wipe away the entire horizon? … Do we not smell anything yet of God's decomposition?"—so there were composers in the nineteenth century who tried to weaken the tonic, if not to destroy its power completely. Chief among them was the hero of Nietzsche's youth, Richard Wagner.[30] His opera *Tristan und Isolde* (1865) makes heavy use of a peculiar, half-diminished chord that makes no sense according to the old rules, a chord that can be resolved in any number of ways and is therefore capable of standing for irresolution itself, for a desire too great to permit of satisfaction, for a flamboyant delirium moving beyond the tonic of earthly fulfillment. The problem of finding the rules that govern the seeming anomie of weakly tonal or non-tonal music—the problem of discovering where value lay in these decentered tonal worlds—was to become a major research area for twentieth-century music.

Imitation of the Classics. Another source of value in traditional art has been adherence to the styles, the themes and the forms of the most successful examples of ancient art. In certain times and places—the France of Boileau, the England of Alexander Pope—reverence for the classics has been so great that the scope of artistic action has been limited, although where the need for conformity is strong, small deviations from the prototype are felt so intensely that great elegance and subtlety become possible.

Value: measure your standards of work by the lofty standards of antiquity.

The nineteenth century is famous for Romanticism, considered to be the opposite of Classicism. The term "Romanticism" was derived from the medieval romances, a literature written in the vulgar tongues (or Romance languages—French, Italian, Spanish), not Greek or Latin, a literature full of marvels and other undignified events, not polished or disciplined in the manner of Virgil's *Aeneid*. Hugo's fascination with the ugly and Berlioz's insistence on the gargantuan are among the countless signs of the Romantic movement. But the desire for classical standards remained. One manifestation of its endurance was Matthew Arnold's doctrine of the *touchstone*, a short passage memorized from Homer, Dante, Shakespeare, Milton:

> …which cost Ceres all that pain
> To seek her through the world.
> *These few lines, if we have tact and can use them, are enough even of themselves to keep clear and sound our judgments about poetry, to save us from fallacious estimates of it, to conduct us to a real estimate.*[31]

It should be noted that Arnold didn't want poets to model their work after the syntax or the diction or the metaphoric patterns of his touchstones: he simply hoped that poets, once in possession of the "higher truth" and "higher seriousness" of these passages, would be able to eliminate from their work the untrue, unserious parts—the labored, the flaccid, and the ornate. And the same could be said of all the arts: a painter should be able to paint with Titianesque bravura or with Chardin-like attention to detail, but no one expected a nineteenth-century painter to include in canvases for exhibition a copy of Titian's Magdalene or Chardin's ray. A composer should be able to write a fugue in the manner of Bach, but the public demand for brand-new sober fugues based on chorale tunes was fairly low (though Robert Schumann and Franz Liszt wrote impressive fugues on the German note-spelling B-A-C-H—that is, in our way of naming notes, B-flat–A–C–B—just as Bach himself had). The classics persisted in nineteenth-century art as a set of standards, a means of quality-control, not as a body of conspicuously quoted material.

In certain corners of nineteenth-century art we can see glimpses of an attitude toward the classics that would flourish in the twentieth century, making them a matter for parody and outright theft. Above all, Manet, in *Olympia* (1863), managed to give endless offense to connoisseurs of art by re-composing Titian's *Venus of Urbino* as a modern, sexually confrontational woman, staring at the viewer in a manner more characteristic of a prostitute than of a goddess (Fig. 5). In the next century, the classics would often be treated in this curiously intimate and impudent manner, sometimes verging on the greasily chummy. On the one hand, the new work asks to be taken as something as large-looming as the *Odyssey* or the *Divine Comedy*; on the other hand, if Odysseus finds himself masturbating on a Dublin beach, as he does in James Joyce's *Ulysses* (1922), there is a certain danger that the classics, instead of lending their

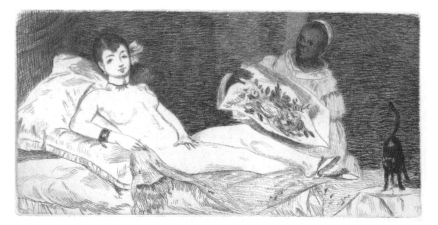

5) Edouard Manet, *L'Olympia*, original etching in Théodore Duret's *Histoire d'Edouard Manet et de son oeuvre* (1902).

prestige to the recent work, will lose all value themselves and grow as commonplace or inane as the art-work that apes them.

If the story of twentieth-century art is the story of a radical shift in value systems, then Nietzsche was a good prophet. In his late book *The Antichrist* (1888) he announced what he called "the transvaluation of all values": he was thinking specifically of a repudiation of the Christian ethos of pity—a morality fit only for slaves, Nietzsche thought—in favor of an assertion of a will to power. Many of the most significant figures in early twentieth-century art—the poets Yeats and Pound, the novelists Joyce and William Faulkner, the composer Arnold Schoenberg, the painter Picasso—fit exactly into Nietzsche's conception of the hero, throwing down a challenge to the audience by creating an art of almost unprecedented ambition, comprehensiveness, hardness, and asperity. Some of these artists (particularly Yeats) followed Nietzsche's call to action because they studied and admired Nietzsche's writings.

But a strange thing happened as the twentieth century came to an end. The author died, in the phrase of the French theorist Roland Barthes. Moreover, the art-work became not a reflex of ego on the largest scale but a semi-coordinated pile of signs, signs scrawled by no one in particular and addressed to no one in particular. Instead of possessing deep meaning, the art-work was considered to be a sort of machine for generating transient "signifieds" endlessly altering amid changing cultural contexts. This new understanding of art can be seen as a further development in the same process of disintegration that, in the nineteenth century, turned solid objects into tingles upon the nerve-endings. But now the value of the art-work, as well as the art-work itself, seemed to be losing all coherence. Late twentieth-century theory attacked value in many ways. Michel Foucault, perhaps the most influential theorist of all, redefined truth to mean not "the ensemble of truths which are to be discovered and accepted," but rather "the ensemble of rules according to which the true and

the false are separated and specific effects of power attached to the true."[32] In other words, truth does not exist except as a local construction that gratifies certain rulers' needs. Though Foucault was a historian, he believed that the study of history was useful chiefly in teaching us not to love the past. So instructed, we would understand that there is no essence, no miraculous origin, either to a society or to a form of life, for the people in the past were just as blundering and inept as we are.

This attack on value was continued by Jean-François Lyotard, who notes that there is a special class of story that establishes the value of other stories, and ultimately the value of value itself. Lyotard calls such a guarantee-story a *meta-narrative*: it seeks to "legitimate the rules of its own game," that is, to find some way of affirming its correctness, ascertaining its own valuableness.[33] Plato's story of the cave, where the watchers facing the rear wall stare at shadows generated by unseen forms passing in front of an unseen light, is a metanarrative, in that it confirms the truth-content of all sorts of stories we can tell about the superiority of ideal generalities to specific concretions. The experimental method, which requires those who pursue truth to follow a circle of hypothesis, test, and then modification of the hypothesis according to the results of the test, is a metanarrative in that it licenses every story that science tells, from Newton's laws of motion to the spooky action-at-a-distance of paired electrons in quantum mechanics. But Lyotard is fully aware of the fragility of every metanarrative, for he doubts that stories can possess truth: he defines the *postmodern* attitude as "incredulity toward metanarratives,"[34] because nowadays we are skeptical that there can exist self-validating stories. No appeal to certainty really convinces us any more.

The story of the arts has been full of metanarratives from the beginning. To understand Greek sculpture, the historian can tell a story about the passage from archaic conventionality to classical perfection to decadent imitation of boxers with cauliflower ears and so forth. The metanarrative is the story about value-assigning that underlies this simple tale: value arises through a lively imitation of an ideal (that is, symmetrical and strictly proportioned) human body. The archaic is too stiff, iconic, unreal-looking; the decadent is too fluent, too interested in the flaws of the body. It is probably impossible, and undesirable, to tell the story of the twentieth-century arts without recourse to some system of value. Every removal of value from one area necessitates a new value being erected somewhere else. There is exhilaration throughout twentieth-century art, in its endless transvaluations, devaluations, and reassertions of old values. This joy in the exploding of values perhaps constitutes a value of its own.

BAUDELAIRE AND THE RISE OF SYMBOLISM

The first stirring, perhaps, of a modern attitude toward value in art can be found in Charles Baudelaire's "The Painter of Modern Life" (1864). It is pleasing to think that Modernism should begin with (essentially) a defense of the word "modern"; and it is important to remember that for most of the history of Western civilization the word "modern" was not a term of praise–in Shakespeare's day "modern" could mean "commonplace," almost "trivial." The authority of Rome and the prestige of Greece were so great that "modern art," if it meant art cut off from imitation of the classics, often seemed contemptible. During the eighteenth century, the period of the "battle of the books" pitting the ancients against the moderns, almost all the authors we respect today, including Swift and Pope, were on the side of the ancients. Our present world is so informed by technology that this veneration for the archaic is almost incomprehensible—nobody wants to buy a computer built according to the grand, tried-and-true principles of last year, let alone the principles of the early Eniacs of the 1950s. But if you were a poet in the eighteenth century, you would be expected to ride Horace and Juvenal for twenty miles, then to walk the last six inches on your own feet.

The novelty of Baudelaire's argument was its elevation of the status of urban junk: the city, with all its random motions of passersby and discarded wind-blown paper, was the most appropriate subject of contemporary art; and the idler, the *flâneur*, savoring the faceless drift of things, was, if not the ideal artist, then at least a sort of precursor of him:

> *this solitary mortal endowed with an active imagination, always roaming the great desert of men… is looking for that indefinable something we may be allowed to call "modernity," for want of a better term to express the idea in question. The aim for him is to extract from fashion the poetry that resides in its historical envelope, to distil the eternal from the transitory…. Modernity is the transient, the fleeting, the contingent; it is one half of art, the other being the eternal and the immovable…. You have no right to despise this transitory fleeting element, the metamorphoses of which are so frequent, nor to dispense with it. If you do, you inevitably fall into the emptiness of an abstract and indefinable beauty.*[35]

Baudelaire was particularly angered by painters who (unlike Constantin Guys, the "painter of modern life" and main subject of the essay) dressed their subjects in the garments of antiquity, instead of the clothes of contemporary life. This impatience represents a striking divergence from the Romantic aesthetics of, say, Shelley, writing forty years earlier, a poet contemptuous of clothes:

> *a poet considers the vices of his contemporaries as the temporary dress in which his creation must be arrayed, and which cover without concealing the eternal proportions of their beauty…. Few poets of the highest class have chosen to exhibit the beauty of their conceptions in its naked truth and splendour; and it is doubtful whether the alloy of costume, habit, &c., be not necessary to temper this planetary music for mortal ears.*[36]

Value: look not to the ancient, but to the casual, the ephemeral, the drifting.

Shelley considered the swags and pranks of modern life a necessary evil, but for Baudelaire they were inextricable from modern life's value. In fifty years or so, Baudelaire's curiosity about the minutiae of the passing scene evolved into an astonishing appetite for self-documentation: photographs of the implosion of buildings no one ever thought attractive, posters for events no one attended, artifacts of transience more transient than the things they record, and lastly works of fiction in which brand names are so conspicuous that the twentieth century can seem the Age of Product Placement.

But Baudelaire's grasp of the ephemeral must not be confused with that of the naturalistic novelists. He did not value imitation for its own sake: if the artist recorded the details of fashion, it was for the sake of some poetic essence hidden within them. Baudelaire was not trying to make modern life more accessible, better known, to those who lived it; instead he was trying to defamiliarize it, to reveal the latent strangeness in it. The project of his essay "The Painter of Modern Life" was to be carried out during the twentieth century, where the shadow of the city looms, monstrous and uncanny. Béla Bartók, the Hungarian composer, turned the grinding dissonance of automobile horns in a traffic jam into music, in the opening of his ballet *The Miraculous Mandarin* (1926). Franz Kafka imagined New York street traffic as "an effect as palpable to the dazzled eye as if a glass roof stretched over the street were being violently smashed into fragments at every moment."[37] Perhaps the fullest of all defamiliarizations of the twentieth-century city was achieved by Vladimir Nabokov, in his early short story "A Guide to Berlin" (1925), which imagines a Berlin streetcar as it will appear in a museum in the year 2120:

Everything, every trifle, will be valuable and meaningful: the conductor's purse, the advertisement over the window, that peculiar jolting motion which our great-grandchildren will perhaps imagine—everything will be ennobled and justified by its age.

I think that here lies the sense of literary creation: to portray ordinary objects as they will be reflected in the kindly mirrors of future times; to find in the objects around us the fragrant tenderness that only posterity will discern and appreciate in the far-off times when every trifle of our plain everyday life will become exquisite and festive in its own right: the times when a man who might put on the most ordinary jacket of today will be dressed up for an elegant masquerade.[38]

Baudelaire and Nabokov were both aware that there exists some tincture to ordinary life to which we are for the most part completely blind. One reason for going to an exhibition of Modernism is that it helps us to place ourselves in that twenty-second century exhibition of early twenty-first century fashion, when our pre-torn bluejeans, spiked hair, and Manolo Blahniks will seem the faintly ludicrous appurtenances of a lost paradise.

There is a name for the sort of literature that tries to penetrate through the husk of physical appearance to the quick of things: Symbolism. Baudelaire was one of the founders of this school, for his sonnet "Correspondences" (1857) stated its means and hinted at its goals:

The pillars of Nature's temple are alive
and sometimes yield perplexing messages;
forests of symbols between us and the shrine
remark our passage with accustomed eyes.

Like long-held echoes, blending somewhere else
into one deep and shadowy unison
as limitless as darkness and as day,
the sounds, the scents, the colors correspond.

There are odors succulent as young flesh,
sweet as flutes, and green as any grass,
while others–rich, corrupt and masterful–

possess the power of such infinite things
as incense, amber, benjamin and musk,
to praise the senses' raptures and the mind's.[39]

A Symbolist artist is a detective hunting for treasure, living treasure. It is no accident that Baudelaire was much inspired by Edgar Allan Poe, the inventor of the detective story. The Symbolist finds most of existence to be a desert, blank and boring; but somewhere there lurks meaning, if the artist can respond fully enough to nature's subliminal urgencies. Baudelaire hoped to find at the edges of nature certain faint sensations provocative of beautiful feelings. Hovering at the verge of things is the sensational Eden of which the poet dreams, achieved by means of eerie combinations of sense data.

> **Value:** seek meaning only in sparsely distributed external objects— namely symbols.

Realism tends to celebrate the world as it is. Symbolism, on the other hand, concerns itself with the transcendental, the ideal; it dismisses the physical world as meaningless, except for a few precious occluded objects—symbols—phosphorescent with certain abstract potencies of meaning. As Jean Moréas wrote in the Symbolist manifesto (1886):

Symbolic poetry, the enemy of "instruction, declamation, false sensibility, and objective description," seeks to clothe the Idea in a tangible form which will not be that poetry's object but which, while serving to express the Idea, will remain subordinate. Nor must the Idea itself be seen stripped of the sumptuous

41

MAKE IT NEW: THE RISE OF MODERNISM

robes of external analogy; for the essential characteristic of symbolic art is never to go so far as the conception of the Idea in itself. Thus, in this art, neither scenes from nature nor human actions nor any other physical phenomena can be present in themselves: what we have instead are perceptible appearances designed to represent their esoteric affinities with primordial Ideas.

...Sometimes mythical phantasms, from ancient Demogorgon to Belial, from the Kabires to the Nigromans, appear elaborately decked out on Caliban's rock or in Titania's forest, to strains of the mixolydian modes of barbitons and eight-stringed lyres.[40]

Symbolism treated not exact appearances, the heft of physical objects, but the far reaches of imagination.

How can art skim above the physical world and enter the azure realm of the ideal? Ordinary language is poorly equipped to describe the delicate delirium that Symbolist writers wish to present. Wilde's praise of lying in "The Decay of Lying" is precisely validated by this philosophy of art. A more arcane method is the language of *synesthesia* (that is, the crossing-over from one sense to another): in Baudelaire's sonnet, perfumes are like flutes (actually oboes in the original French) or the feel of a child's flesh. Synesthesia is a technique for reconstruing commonplace nature into something fresh, for indicating intuitions of some indwelling transsensuous beauty, a beauty which (since it is beyond the usual range of our sensory apparatus) expresses itself through an unusual or "wrong" sense-organ. The phenomenon known as *audition colorée*—hearing in color—is not rare, but during the heyday of Symbolism it enjoyed particular prestige. Certain composers, especially, sought to induce their audiences to a state of synesthetic delirium: for example, Alexander Scriabin scored his *Prometheus* (1908-10) for a light organ as well as a conventional orchestral, and Arnold Schoenberg in his *Die glückliche Hand* (The Lucky Touch, 1913), carefully notated a storm of colored lights to accompany a sort of epileptic fit in the orchestra, when the protagonist is seized with creative fury. A late example of synesthesia can be found in the writings of Katherine Ruth Heyman, concert pianist, composer, friend of Ezra Pound, and enthusiast for Scriabin. She claimed in 1921 that the note E was colored chrome green, and had the flavor of chicken liver.[41]

The sensory stimuli that Baudelaire names in "Correspondences" are almost intolerably intense, and, since terror is a stronger feeling than pleasure, Baudelaire often evokes the repulsive in his quest to dismantle our common notions of reality and to thrust us into some Beyond. It is a strange idea, to create beauty by creating ugliness, but that is his goal. On rare occasions Baudelaire could present directly a vision of Eden, of supernatural beauty, as in the refrain of "Invitation to the Voyage," a passage gorgeously set by the composer Henri Duparc: "Là, tout n'est qu'ordre et beauté, / Luxe, calme et volupté" (There, all is order and beauty, luxury, calm, and voluptousness). But the typical emotion in a Baudelaire poem is yearning mixed with disgust:

The flies swarmed on the putrid vulva, then
A black tumbling rout would seethe
Of maggots, thick like a torrent in a glen,
Over those rags that lived and seemed to breathe,

They darted down and rose up like a wave
Or buzzed impetuously as before;
One would have thought the corpse was held a slave
To living by the life it bore!

This world had music, its own swift emotion
Like water and the wind running,
Or corn that a winnower in rhythmic motion
Fans with fiery cunning....

And even you will come to this foul shame,
This ultimate infection,
Star of my eyes, my being's inner flame,
My angel and my passion!

Yes: such shall you be, O queen of heavenly grace,
Beyond the last sacrament,
When through your bones the flowers and sucking grass
Weave their rank cerement.

Speak, then, my Beauty, to this dire putrescence,
To the worm that shall kiss your proud estate,
That I have kept the divine form and the essence
Of my festered loves inviolate![42]

Everything is calculated to revolt the reader: the intimately sexual nature of the carcass's posture, the odd voluptuousness of its stink, the reminder to reader and beloved that he and she will also attract the penetrating attention of worms and flies. But the point of this strategy is to induce recoil, from corrupt flesh to incorruptible beauty. It is a beauty approachable only in this negative fashion—as if, in some strange meeting of extremes of repulsion and attraction, beauty were constructed as the synesthesia of emotions themselves. The last two lines quoted above are ironic, but maybe there is a certain lack of irony too. Baudelaire does keep the essence of his festered love inviolate; indeed, he manages to define and isolate the essence by reversion from the putrefaction. The object of human love is infinitely violable—and yet *something* is there, something precious, that really cannot be violated. The manuscript of this poem, "La charogne" (published as "Une charogne," 1857) is an important text of the Ransom collection, for this poem is one of Modernism's founding documents (Fig. 6).

6) Charles Baudelaire, final strophe and signature from the manuscript of "La Charogne" (published as "Une Charogne" in *Les Fleurs du mal*, 1857).

Baudelaire's carrion, bad to smell, bad to look at, shows that the concept of *taboo* is near the heart of Symbolism. Symbolism's aesthetic is obviously constructed along religious lines, since such Christian concepts as incarnation and transubstantiation—the physical presence of God in flesh or eucharist—are extended into a secular and erotic domain, where metaphysical energies play around familiar, enticing objects. There is little distinction between symbol and fetish. In 1921 the Irish Symbolist Yeats enumerated his "main symbols" to the designer of his book covers: "Sun and Moon (in all phases), Tower, Mask, Tree."[43] In an earlier list he mentioned "a cross, a man preaching in the wilderness, a dancing Salome, a lily in a girl's hand, a flame leaping, a globe with wings, a pale sunset over still waters."[44] Of all biblical texts, the Symbolist movement found the story of Salome the most congenial, as in Gustave Moreau's various paintings on this theme, and a bewildering number of literary productions, including Flaubert's "Hérodias" (1877), Jules Massenet's opera *Hérodiade* (1881), Jules Laforgue's ironic "Salomé" (1887), Wilde's luscious drama *Salomé* (1893), with its dance of the seven veils, Strauss's opera *Salome* (1905), based on Wilde, and Yeats's stark imitation of a Japanese Noh play, *The King of the Great Clock Tower* (1935). For the Symbolists, the ultimate symbol is the unveiling of the human body, as if the pudenda themselves constitute a sinister sort of holy book—to read it is to die, as John the Baptist discovers. Baudelaire's "A Carrion" makes unusually explicit the thrill of the morbid found everywhere in the Symbolist movement, the linking of sex and death and transfiguration.

Sex, death and transfiguration come together most strikingly at the end of Wagner's *Tristan und Isolde* (1865), in an ecstatic deliquescence of musical language that Liszt, and soon everybody else, called Isolde's *Liebestod* or love-death. Wagner was important to the Symbolist movement: Baudelaire saw in the Paris revision of Wagner's *Tannhäuser* (1861) the theater of his dreams, and in some ways Wagner's *Parsifal* (1882) represents the climax of Symbolist art. Here the chief symbols are Spear and Grail—the spear that pierced the side of the crucified Christ, and the cup into which Christ's blood spilled. Wagner's drama of seduction and castration makes explicit the identification of Spear and Grail with phallus and vagina. The musical *Leitmotiv* associated with the Grail is, most unusually for Wagner, not a tune that he himself composed, but an old cadential formula called the Dresden Amen, as if Wagner could perfect the Grail's symbolic nature only by appealing to the verified sanctity of German church music.[45] It is instructive to compare *Parsifal* with a contemporary but non-Symbolist treatment of the same theme, Tennyson's idyll "The Holy Grail" (1869). In Tennyson's poem the Grail is a will-o'-the-wisp that dances out of the hands that try to grasp it, but Wagner's Grail at last sheds its salvific radiance over the ruined king and his knights. The extremely slow unveiling of the Grail, over the four hours of Wagner's music, is itself a fine striptease.

Of course *Parsifal*, an exercise in art-nouveau Gothic, has nothing of modern city life in it. The full realization of Baudelaire's wish for an art at once symbolic and ultra-contemporary would not come until another treatment of the Grail legend, T. S. Eliot's *The Waste Land* in 1922. Eliot's poem is crammed from beginning to end with urban scenery, urban knickknacks, and urban junk. Yet under the broken fingernails, the broken seals, the broken glass, the broken stories, and the broken voices, there is an allegation of meaning:

> *London, the swarming life you kill and breed,*
> *Huddled between the concrete and the sky;*
> *Responsive to the momentary need,*
> *Vibrates unconscious to its formal destiny,*
> *Knowing neither how to think, nor how to feel,*
> *But lives in the awareness of the observing eye.*
> *London, your people is bound upon the wheel!*
> *Phantasmal gnomes, burrowing in brick and stone and steel!*
> *Some minds, aberrant from the normal equipoise*
> *Record the motions of these pavement toys*
> *And trace the cryptogram that may be curled*
> *Within these faint perceptions of the noise,*
> *Of the movement, and the lights!*[46]

This stanza was deleted from the third part of the finished poem, but had it been retained, it would have been the poem's clearest statement that, beneath unreal London, there subsisted a design. The pedestrians scurry about at random, capable of neither thought nor feeling, but amid the buzz, the roar, the jerky motion there is a cryptogram or hidden pattern. The Grail legend is Eliot's attempt to solve the cryptogram, to elucidate the pattern: for, beneath every story of rapist and victim, of murderer and murdered, of actor and sufferer, there lies the great story of the replacement of a dying god with a living one, as enacted by the replacement of the wounded Grail-king Amfortas by the holy fool Parsifal.

43

MAKE IT NEW: THE RISE OF MODERNISM

Perhaps Eliot's poem announces its essentially Symbolist character most clearly at the end, when the Thunder speaks its huge syllable DA, possibly as a premonition of the rain that will bring new growth to the waste land, possibly as an omen of nothing at all. As Eliot construes DA as the first syllable of three worthy Sanskrit admonitions— *datta* (give), *dayadhvam* (sympathize), and *damyata* (control)—he encourages us to identify DA as the Word that authenticates the meaning of every word in every language, the prime vocable of God's voice. It is as if all the poetry that Eliot quotes (Dante, Shakespeare, Milton) had been seeking for centuries to uncover the buried sound-treasure that Eliot has at last found. This abracaDAbra may be only an illusion of meaning, but Eliot's city provides enough emptiness that, if the magic syllable can be pronounced, it will be heard.

The thunder-word, the word that can guarantee its own meaning, figured in the modernist vocabulary in many ways. In James Joyce's final book, *Finnegans Wake* (1939), it booms out, however ironically, on the very first page:

babadalgharaghtakamminarronnkonnbronntonnerronntuonnthunntrovar-rhounawnskawntoohoohoordenenthurnuk![47]

This great verbal blast is made up of words for thunder in various languages, including Japanese, Hindu, Greek, French, Italian, Swedish, Irish, Portuguese, Old Romanian, and Danish.

In music, the equivalent to the thunder-word is the chord composed of most or all of the twelve notes of the chromatic scale, the chord that sums up everything that music has to say. In Gustav Mahler's tenth symphony, left unfinished at his death in 1911, there is a huge shriek of a nine-note chord at the climax of the adagio, and in Schoenberg's *Die glückliche Hand* (1913) the hammer-blow that represents the moment of artistic inspiration is accompanied by a twelve-note chord. This fatal, hair-raising sound became a sort of ne plus ultra for the whole art of music.

Symbolism was a crucial component of modernist brio and self-confidence, for, if there were certain phenomena in art that were triumphantly meaningful in themselves, then these could provide a reliable foundation for artistic work. For the Symbolist, there is no such thing as invention, only discovery. Yeats even toyed with the idea that Keats's "Ode to a Nightingale" pre-existed in the general mind of the human race from the beginning of time, as if Keats were only the accidental vessel through which the poem was transmitted.[48] But as the twentieth century progressed, trust in symbols started to fail. At last there took hold a kind of literary theory which considered a text as a play of arbitrary signs, signs that have no root power in themselves, but which generate meaning only in their interaction. According to the linguistic philosophy of Ferdinand de Saussure, Ludwig Wittgenstein, and Jacques Derrida, the vocabulary of artistic value was systematically neutralized, evacuated of every sort of charge that establishes meaning.

A visual illustration of the change from modernist *symbol* to postmodernist *sign* can be found by comparing Joe Rosenthal's famous photograph of the raising of the American flag on Mount Suribachi in Iwo Jima to the several paintings of the American flag by Jasper Johns. The photograph is a documentary, but has many marks of artifice, such as the balanced diagonals of the flagpole and the soldiers' arms—the soldier at the farthest distance from the pole's base cannot actually touch the pole, and so seems to be gesturing hosanna to Old Glory. The superb linear composition works toward a consecration of the flag; indeed the photograph might be considered a sort of echo of and riposte to Théodore Géricault's Romantic painting *The Raft of the Medusa* (1819), a similar bold design of arms thrusting up toward a large diagonal shaft. The painting concerns the wreck of every human hope; the photograph concerns the passage from despair to triumph.

A flag can be called a symbol if there is a natural relation between its visual presence and the land or people that it stands for; it is a mere sign if this relation is not natural but conventional. Any account of the flag as a symbol will have to make its design into an occult map—not impossible to do in the case of the American flag, since the number of stars represents the number of states, and the number of stripes represents the thirteen original colonies. Furthermore, there is an official color symbolism: the red represents patriots' blood, and so forth. But these symbolic claims are fragile, since Americanness is only feebly imaged in the number-play of forty-eight or fifty versus thirteen, and red, white, and blue make up such a common combination that any moralizing feels somewhat incidental. To abolish any symbolic aspect to the flag, Johns had to do nothing more than to represent it as an obvious contrivance of paint, with visible brushstrokes and slightly infirm boundaries, and, sometimes, the wrong color—in the case of *White Flag* (1955), a dirty monochrome white, faintly littered with scraps of old newspapers, as if the flag were forever sullied by all the things written about it. Johns's flag flags, one might say; its meaning wavers and recedes, and it turns into an aesthetic object, albeit an extremely impure one, more like the corpse of a symbol. The patriots' blood is still there, in a sense, but it has been leached out by the heavy application of encaustic and become something leprous.

FUTURISM AND ITS DISCONTENTS

Symbolism was an aesthetic of transition between the characteristic art of the nineteenth century and that of the twentieth. At the beginning of the twentieth century, however, there arose a number of artistic movements that claimed to represent a radical rupture with all previous forms of art. One of the first and certainly the noisiest of these was Futurism.

The leader of the movement was Filippo Tommaso Marinetti, the "caffeine of Europe," a histrionic man who hated lethargy and rules of conduct, and adored speed and power. He exulted in war, wrote odes in praise of the machine gun, and hoped for destruction, for without destruction there would be

no room to build new things. His artistic principles are most clearly expressed in the "Technical Manifesto of Futurist Literature" of 1912 (Fig. 7):

> *One must destroy syntax and scatter one's nouns at random… the noun should be followed, with no conjunction, by the noun to which it is related by analogue. Example: man-torpedo-boat, woman-gulf, crowd-surf, piazza-funnel, door-faucet…. Abolish even the punctuation…. To accentuate certain movements and indicate their directions, mathematical symbols will be used: + - ¥ : = and the musical symbols…. Destroy the I in literature, that is, all psychology. The man sidetracked by the library and the museum, subjected to a logic and wisdom of fear, is of no interest…. To substitute for human psychology, now exhausted, the lyric obsession with matter…. The warmth of a piece of iron or wood is in our opinion more impassioned than the smile or tears of a woman.*[49]

If a piece of prose were to look like a machine, it would have to be spare, abrupt, efficient, and loud.

Value: make art as brutal, streamlined, and efficient as a speed-boat or a rifle.

In a sense, Futurism is simply Symbolism purged of its fascination with the archaic. Aldous Huxley in *Brave New World* (1932) noted that the Christian cross could easily be adapted to the cult of the Model-T Ford, simply by snipping off the tip of the vertical beam. If Wagner looked to the old myth of the Grail, Marinetti looked instead to the city, but he found a city much altered from Baudelaire's Paris, a new city in which the motor-car, the electric generator, and the telephone were beginning to catch on. In a city in which vehicles can approach thirty miles per hour, the passing scene starts to whiz by. There is no longer time to articulate the relations between man and torpedo-boat with a battery of carefully qualified similes. Instead, the man and the torpedo-boat must be slapped together into a single verbal dynamism.

There was also a "Technical Manifesto of Futurist Painting" (1910), written by some Futurist painters in collaboration with Marinetti:

> *All things move, all things run, all things are rapidly changing. A profile is never motionless before our eyes, but it constantly appears and disappears. On account of the persistency of an image on the retina, moving objects constantly*

7) F. Marinetti, *Supplément au manifeste technique de la littérature futuriste* (1912).

> *multiply themselves: their form changes, like rapid vibrations, in their mad career. Thus a running horse has not four legs but twenty… To paint a human figure you must not paint it: you must render the whole of its surrounding atmosphere…. Who can still believe in the opacity of bodies, since our sharpened and multiplied sensitivity has already penetrated the obscure manifestations of the medium? Why should we forget in our creations the doubled power of our sight, capable of giving results analogous to those of X-rays?… [T]he motor bus rushes into the house it passes, and in their turn the houses throw themselves upon the motor bus and are blended with it.*[50]

In Futurist art, matter behaved like energy, for the Futurists learned much from the motion-study photographs of Eadweard Muybridge and such Muybridgean paintings as Marcel Duchamp's 1911 *Nude Descending a Staircase*. Sometimes objects superimposed various states of themselves (as in the twenty-legged dachshund in Giacomo Balla's 1912 *Leash in Motion*). Sometimes objects decomposed into fields of force (as in Balla's 1909 *Street Lamp*). Sometimes they were generated from the vibration-patterns of sound (as in Luigi Russolo's 1912 *Music* or Balla's 1912 *Rhythms of a Bow*).

Futurist music was more problematic(Fig. 8). The Italian Futurists, rich in talented writers and painters, were poor in musicians. A painter, Luigi Russolo, decided to fill this almost empty ecological niche by devising a series of noise-makers called *intonarumori*, each enclosed in a black box, so that a concert of them would resemble a Cubist painting. These noise-makers had noisy names—*ululatori, rombatori, crepitatori, gorgogliatori,* and *sibilatori* (howlers, rumblers, cracklers, gurglers, hissers)—and Russolo devised concert-pieces for them, such as the 1913 *Risveglio di una città* (Awakening of a City), the score to which is a fine piece of Futurist graphic, with its normal bars, clefs, time signatures, and staves, all decorated with thick black lines, holding steadily horizontal, or ascending up and down in slow glides, or proceeding in fast jerks from one flat line to the next.

The look of Futurism is determined by the box and the ray. The ray (usually painted as squiggle or arrow) was one of the prime elements of Futurist speculation. Marinetti dreamed of radio receivers that could pick up not only human broadcasts but the general background radiation of the inanimate universe: "The reception amplification and transfiguration of vibrations emitted

45

MAKE IT NEW: THE RISE OF MODERNISM

by matter [sic] Just as today we listen to the song of the forest and the sea so tomorrow shall we be seduced by the vibrations of a diamond or a flower."[51] This vibratory aesthetic was an inheritance from Impressionism; indeed, Ezra Pound considered that there was, despite Marinetti's strident capricious urgency, something peculiarly passive about the "accelerated impressionism" of the Futurist movement.[52]

The boxiness of Futurism, the love of stacks of hard sharp angles, is, of course, an inheritance not from Impressionism but from Cubism. Beginning around 1907, Picasso and Georges Braque started to explore the possibilities for creating volume on a two-dimensional canvas, not by pretending (in the common fashion of painters) that the picture plane is a window looking onto a foreshortened scene, but by producing an effect of overall crinkle. It is as if the canvas imitated a piece of paper used for wrapping some object, whose bulk and heft left traces in the pattern of half-smoothed folds. Picasso himself suggested that his Cubist paintings were like flattened-out sculptures, or like instructions for folding paper into a three-dimensional shape: the spectator should feel able to "cut up" the canvas and put it back together and "find oneself confronted with a sculpture."[53] When the Futurist painters advocated a sort of painting in which the human figure and the atmosphere around it were fully integrated, they were repeating Braque's insistence on painting the "visual space" that "separates objects from each other." "This in-between space [entre-deux] seems to me," said Braque, "just as important as the objects themselves."[54] The distinction between figure and ground is challenged when a crumpled boat sails on a crumpled sea beneath a crumpled sky. Furthermore, Cubist portraiture could look aggressive and dehumanizing. What is a man if he is composed of a heap of shallow little gouges into the picture plane? Instead of a nose between two eyes above a mouth securely perched on top of a neck, the concept of face may disperse until stray nostrils, stray half-mustaches, poke out in odd corners of the canvas. Marinetti thought that the heat of iron was more passionate than the tears of a woman, and Cubist belligerence against the idea of the human figure was easily assimilated into Futurist art.

When the Futurists stared at the artifacts of modern technology, they felt elated. But other artists contemplated these same artifacts in a colder, more detached fashion, not as stimuli to a feeling of speed and power but simply as

8) Balilla Pratella, *Manifeste des musiciens futuristes* (1911). Pratella, who renounced the title of Maestro as a "stigma of mediocrity and ignorance," calls for the systematic destruction of conventional music and the dismissal of critics.

inert objects. Marcel Duchamp made a career out of decontextualizing mass-produced commodities. His most celebrated piece was a urinal, labeled *Fountain*, signed R. Mutt, and displayed in an art show in New York in 1917; but before that he had offered a shovel (*In Advance of a Broken Arm*, 1915) and a bicycle wheel mounted on top of a stool (*Bicycle Wheel*, 1913). The bicycle wheel in particular looks like an assault on Futurism, an "Up yours!" Stuck upside-down on a wooden base, it is obviously going nowhere. But it is also a challenge directed against art itself, for Duchamp insisted that he did not regard such an object as beautiful: "the choice of these 'readymades' was never dictated by esthetic delectation. The choice was based on a reaction of visual indifference," a "total absence of good or bad taste... in fact, a complete anesthesia."[55] Duchamp introduced technology—the flattest, most unobtrusively useful technology he could find—into art for the sake of vitiating the aesthetic experience in a way that anticipated the assaults against art to be carried out in Dada cabarets during the Great War, when (for example) Tristan Tzara composed poems by cutting up newsprint into individual words and drawing them at random from a hat. It is exactly the same thing to say that everything is art and that nothing is art: the word *art* loses all its power.

The Dadaists, dedicated to the annihilation of every artistic pretense except perhaps their own, went to special trouble to tweak the noses of the Futurists. As Francis Picabia wrote, "I would like to fabricate an 'artistic' automobile in rosewood, mixed with Pink pills. The tires would be of steel and the ball bearings in rubber, as a piece of FUTURISM it wouldn't be bad."[56] This gorgeous, castrated conveyance was designed as a sort of nightmare for Marinetti, all slack ornament without any motive power.

The Cubist reaction to Futurism was more complex. In 1945 Picasso made a sculpture entitled *Bull's Head* that consisted of the seat of a bicycle suspended vertex pointing down, with the bicycle's handlebars mounted above it, protruding like the horns of a bull. This seems like a response to the readymades

Value: let nothing have value.

...

Value: make an ostentatious show of the absence of value.

44

"A lady" said Murphy bitterly, "not a landlady. Thin
lips and a Doric pelvis. We are P.G.s."

"All the more reason to find work" said Celia.

Everything that happened became with Celia yet another
reason for Murphy's finding work. She exhibited a morbid
ingenuity in this matter. From such antagonistic occasions
as a new arrival at Pentonville and a fence sold out in
the Market she drew the same text. The antinomies of un-
married love can seldom have appeared to better advantage.
They persuaded Murphy that his engagement at even a small
salary could not fail to annihilate, for a time at least,
the visible universe for his beloved. She would have to
learn what it stood for all over again. And was she not
rather too old for such a feat of readaptation?

He kept these forebodings to himself, and indeed tried
to suppress them, so genuine was his anxiety that for him
henceforward there should be no willing and no nilling
but with her, or at least as little as possible. Also he
knew her retort in advance: "Then there will be nothing
to distract me from you." This was the kind of Joe Miller
revived.
that Murphy simply could not bear to hear ~~explain~~. It had
never been a good joke.

was
Not the least remarkable of Murphy's innumerable classif-
ications of experience/~~madness~~ that into jokes that had
once been good jokes and jokes that had never been good
jokes. What but an imperfect sense of humour could have
made such a mess of chaos. In the beginning was the pun.
And so on.

Celia was conscious of two equally important reasons
for insisting as she did. The first "as her desire to
make a man of Murphy! Yes, June to October, counting in
the blockade she had almost five months experience of
Murphy, yet the image of him as a man of the world con-
tinued to beckon her on. The second was her aversion
to resuming her own work, as would certainly be necessary

9) Samuel Beckett, *Murphy*, page from carbon copy typescript with author's emendations, c.1937.

of Duchamp, but by 1945 they were not recent news, and, in any case, Picasso's purpose seems remote from Duchamp's. Duchamp's bicycle is a dead thing, a spectacle of vehicular impotence; Picasso's bicycle hovers on the verge of organic form, as if it were about to assume the bull's impulsive strength. The machine is rearranged into an abstraction of animal thrust. Just as the visual delight of the Cubist style often lies in the ambiguity between two and three dimensions, so a great deal of Picasso's work is based on puns and riddles. A pun is a method for obtaining an overload of meaning; as such, it is the exact opposite of Dadaist art, which attempts to drain away any meaning at all.

The modernist movement is full of attempts to promote the concept of the pun into a large-scale artistic method. The most famous such attempt is Joyce's *Finnegans Wake* (1939), of which the following is a specimen: "To stir up love's young fizz I tilt with this bridle's cup champagne, dimming douce from her peepair of hide-seeks tight squeezed on my snowybreasted and while my pearlies in their sparkling wisdom are nippling her bubblets."[57] Here are superimposed two distinct planes of meaning, one concerning the nuzzling of lovers and the other concerning drunkenness: "nippling" contains "nipping," "nibbling" and "nipple"; "bubblets" contains "bubbles" (from the champagne) and "bubby" (a dialect word for a woman's breast, preserved in our modern "boob"); and from the little thicket of hair teased out in "peepair of hide-seeks" there peeks a bottle of Piper-Heidsieck, a brand of champagne. When Joyce's disciple Samuel Beckett wrote, "In the beginning was the pun," he might have been speaking of the origins of Modernism itself (Fig. 10).[58]

Not only could Picasso see the bull's head lurking in the bicycle, he could see the fertility goddess lurking in the gas burner. His *Vénus du gaz* is one of the many fascinating objects in the Ransom exhibition (see color plates below). It consists of a metal ring detached from a stove, mounted vertically on two small rods, with a third rod sticking straight up from the top of the ring. Picasso often found inspiration in prehistoric art, and possibly this sculpture is a riposte to the Venus of Willendorf, the famous little paleolithic idol of a woman so great-dugged, great-buttocked, that she is almost a sphere; it is not known when Picasso made the *Vénus du gaz*, but I doubt that it was before 1908, the date of the discovery of the Venus of Willendorf. The idol approximates a simple geometric form; Picasso's sculpture is a simple geometric form, a readymade annulus, outfitted with the sparest possible allusions to head and legs. The sculpture is an obscene pun, but perhaps retaining some vestiges of the sacred. Picasso abstracts the concept of Woman until she is nothing but a hole—a hole fringed with fire, if we remember the gas burner "she" comes from.

This discovery of something savage and archaic within the domain of technology is one of the most characteristic features of Modernism. The best pun is the pun in which one meaning is futuristic, the other meaning barbaric.

Value: double the value-content of your art by saying two things at once.

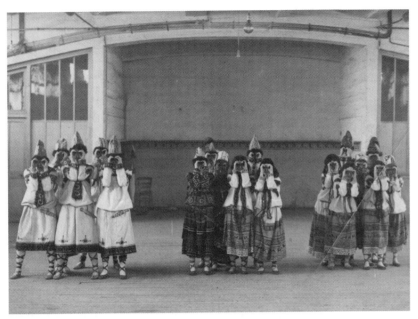

10) Photograph of performers from the original performance of Igor Stravinsky's *Le Sacre du printemps* (1913).

of emotion (Expressionism); stability and inexpressiveness (the New Objectivity); accuracy of representation (Hyperrealism); absence of representation (Abstractionism); purity of form (Neoclassicism); formless energy (Neobarbarism); cultivation of the technological present (Futurism); cultivation of the prehistoric past (the Mythic Method). These extremes, of course, have been arranged in pairs, because aesthetic heresies, like theological ones, come in binary sets: each limit-point presupposes an opposite limit-point, a counter-extreme toward which the artist can push. Much of the strangeness, the stridency, and the exhilaration of modernist art can be explained by this strong thrust toward the verges of the aesthetic experience. After the nineteenth century had established a remarkably safe, intimate center where the artist and the audience could dwell, the modernist age reached out to the freakish circumferences of art. The extremes of the aesthetic experience tend to converge: in the modernist movement, the most barbaric art tends to be the most up-to-date and sophisticated.

Not only is Modernism a Manichean sort of movement in that it contains opposites as stark as black and white, but it is also a domain where black and white can be strangely hard to distinguish. This convergence of extremes can best be seen in Stravinsky's evocation of pagan Russia, *The Rite of Spring*. Its première, on 29 May 1913, a hot day in Paris, led to a riot, and established the riot as the *de rigueur* response to modernist theater. Many subsequent artists were disappointed if they could not stir up quite the same fury of rejection; some were willing to go to some trouble to contrive a riot if the audience seemed capable of sufficient disgruntling. At the première of Apollinaire's skit *The Dugs of Tiresias* (1917) an angry audience found itself confronted by a man waving a pistol and threatening to shoot. It was Jacques Vaché, a fellow Surrealist.

The law of parity: let every value presuppose an exactly equal countervalue.

It is now thought that *The Rite of Spring* riot was a response less to Stravinsky's music, which could scarcely be heard amid the uproar, than to Nijinsky's choreography, which inverted most of the conventions of ballet (Fig. 10). The movements of classical ballet are expansive, poised, pigeon-toed, and turned out; the movements of the dancers in *The Rite of Spring* were huddled, hunched, knee-buckled, and turned in. Classical dancers seem on the brink of escaping the pull of gravity; Nijinsky's dancers seemed to live on a planet like Jupiter: they stooped under the weight of their own bodies. They found it physically painful to jump in the air and land flat-footed, as Nijinsky commanded; and yet these mathematically calculated awkwardnesses seemed to possess a sort of grace.

Those who saw the early performances of *The Rite of Spring* found radically different things. One reviewer was struck by Nijinsky's "use of the human body to realize arbitrary conceptions of movement, to devise a scale of gesture just as abstract as a scale of musical notes," and compared the ballet to

Those who listened to early radio broadcasts felt that they were simultaneously experiencing something never experienced before and participating in some prehistoric rite. In 1927, for example, Otto Alfred Palitzsch deplored radio's habit of broadcasting old plays by Ibsen and Shakespeare, and he asked for a new kind of program: a "pure radio play that is not somehow carried by a choir or geared to voices and music but is integrated into an acoustical atmosphere in which the hooting of the automobile and the bray of a donkey are able to find their place, just like the whistle of the wind and the chiming of devotional bells in a village church. In the place of colored sets come tonal ones."[59] The notion of an acoustic collage comparable to the Cubist collages in the visual arts was indeed soon realized, as in Walter Ruttman's remarkable film-without-pictures *Weekend* (1930), a soundtrack played in a movie theatre with an empty screen, full of train and car noises, whistles, sawings, a singer's practice scales, cuckoo-clocks, sirens, laughter, distant hullabaloo, footsteps, church bells, and snatches of dialogue. But Palitzsch, gazing at the future of a brand-new artistic medium, also invoked the most distant past: he imagined that the radio would promote an oral culture of new minnesingers, new Homers, a restoration of "that lost epoch when the people's hunger for fables was stilled by itinerant singers and chroniclers."[60] If Modernism always strains toward the horizon, the horizon of the future may look curiously like the horizon of the past.

Modernism always generates such paradoxes because Modernism is a *testing of the limits of aesthetic construction*. According to this perspective, the modernists tried to find the ultimate bounds of certain artistic possibilities: volatility

non-representational painting.[61] Another spoke of "the fallacy of Nijinsky's exacerbated 'cerebralism'" and went on to ask, "What is there cerebral and intellectual in Stravinsky's superhuman force, in the athleticism of his brutal art that continually parries direct hits to the stomach and right hooks to the chin?"[62] The ballet seemed extraordinarily abstract and concrete at the same time, at once a pure play of arbitrary forms and a punch in the gut.

The plot of the ballet concerns the sacrifice of a virgin to the god Yarilo, and Nicholas Roerich designed the costumes and sets with a certain attention to the scholarship of the paleolithic, although the archaism has false notes. When we look now at the old drawings of the costumes and poses, we are often bemused by their Hollywood-Indian aspect, and, in fact, the young Nijinsky's first theatrical experience was a visit to an American Indian show. Stravinsky's music, with its yawps and asymmetric thuds, might be said to convey a certain primeval blood lust, but its range of suggestion goes as much to the technological present or future as to the savage past. As T. S. Eliot wrote in 1921, the music seems to "transform the rhythm of the steppes into the scream of the motor-horn, the rattle of machinery, the grind of wheels, the beating of iron and steel, the roar of the underground railway, and the other barbaric noises of modern life."[63] In the domain of Modernism, *The Flintstones* and *The Jetsons* are always the same show.

Modernist literature was often fascinated with the ecology and anthropology of the future. This fascination had marked earlier novels, such as Mary Shelley's *The Last Man* (1826), but H. G. Wells, Karel Čapek, Aldous Huxley, and others were to "precognize," we might say, the future in far more extravagant detail. Sometimes the future looked like a regression to the past, according to the same paradoxical equivalence that bemused Eliot in *The Rite of Spring*. In Wells's *The Time Machine* (1895), the narrator accelerates chronology until he arrives in A.D. 802,701—here, again, time turns into space (Fig. 11). Wells's fable is profoundly cinematic, in that it was perhaps difficult to conceive such a thing as a time machine until the invention of movies, where a continuous time-segment attains spatial definition in a reversible strip. When the narrator of *The Time Machine* starts to move forward in time, he sees a sort of stroboscope effect of day blinking into night, as if he were watching a poorly-projected film. In the distant future he finds an ape-like race of troglodytes, the Morlocks, as if the human race had been busy devolving over several hundred millennia. It seems to matter little whether the unspooling reel of human history is played backward or forward: the future and the past look rather similar.

And sometimes the future looked like a regression, not to the past as presented in history books, but to a sort of metallic analogue of the pre-feudal past, in which the concept of the brute slave slides into the concept of the robot. The word "robot," based on a Slavic word for "worker," comes from Čapek's play *R.U.R.* (1923), and for many years the modernist imagination was beguiled by the notion of a blunt race capable only of labor, whether confected from steel (the quickening of a metal woman, zapped with rings of electricity, is

11) Unidentified photographer, H.G.Wells, author of *The Time Machine* (1895).

among the most memorable images in Fritz Lang's movie *Metropolis*, 1926) or synthesized in artificial wombs (as in Huxley's *Brave New World*, 1932).

But some aspects of the *passé* futures of Modernism were genuinely futuristic, in that they were generated not by regression but by extrapolation. If you take a gorilla as the first term of a series, and a man as the second term, what does the third term look like? Small in torso and jaw, large in cranium and eye, spindly, hairless, delicately flexible—the caricature of an extraterrestrial, familiar from Steven Spielberg's *Close Encounters of the Third Kind* (1977) and innumerable other sources in popular culture. Such beings started populating modernist fiction and drama quite early. In Wells's *The Time Machine*, there are in fact two races, the savage Morlocks and the dainty Eloi, who seem to spend their vapid lives giggling and playing with rhododendrons. The narrator speaks of their "Dresden-china type of prettiness" and compares their arms to "soft little tentacles"; later, he finds himself "dreaming most disagreeably that I was drowned, and that sea-anemones were feeling over my face with their soft palps."[64] These tactile, sensitive imbeciles are one of two strands of human evolution. The narrator discovers that the human race

> had not remained one species, but had differentiated into two distinct animals: that my graceful children of the Upper-world were not the sole descendants of our generation, but that this bleached, obscene, nocturnal Thing [a Morlock], which had flashed before me, was also heir to all the ages.... So, in the end [after capitalists and workers stop intermarrying], above ground you must have the Haves, pursuing pleasure and comfort and beauty, and below ground the Have-nots, the Workers getting continually adapted to the conditions of their labour.[65]

But *The Time Machine* is a horror story as well as a bio-economic theory. It turns out that the Eloi are "cultivated" in two senses of the word, for the Morlocks raise them for food. Decadence begins by running "to art and to eroticism, and then come languor and decay."[66] Wells imagines a future in which white chimpanzees feast on the corpse of Oscar Wilde. This sort of abutting of the too-coarse and the too-refined is common in modernist art. For example, in Leoš Janáček's opera *The Excursion of Mr. Brouček to the Moon* (1917), with a libretto by the Czech satirist Viktor Dyk, the beer-guzzling landlord Mr.

Brouček is transported in a drunken frenzy to the moon, where he flirts with a pixilated poetical lunar native named Etherea, to the annoyance of her boyfriend Azurean.

The Morlocks and the Eloi seem as remote from one another as two sorts of human beings can possibly be. And yet once again extremes converge, for in the artistic movement called Expressionism the exquisite and the brutal are combined.

EXPRESSIONISM

The earliest distinctly Expressionist school of painting arose in Germany in 1905: the Dresden group called *Die Brücke* (The Bridge), soon followed by the *Neue Sezession* in Berlin and *Der Blaue Reiter* (The Blue Rider) in Munich. Die Brücke took its name from Nietzsche's comparison of mankind to a rope connecting the beast to the *Übermensch*, the over-man, and part of the character of Expressionist art can be understood from another aphorism of Nietzsche's: "Whoever struggles with monsters must see to it that he doesn't turn into a monster. And when you stare for a long time into an abyss, the abyss also stares back into you."[67] Expressionist art depicts the patient gaze of the abyss into the deformed gibbering thing at the core of your being, the Morlock within.

And yet Expressionism, for all its Frankensteinian look of faces and bodies stitched together at unnatural angles, was a spiritualizing art movement based in Symbolist dematerialization. The term Expressionism was coined in 1910 by a Czech art historian, Antonin Matějček, who saw the movement as the opposite of Impressionism: "An Expressionist wishes, above all, to express himself…. [He rejects] immediate perception and builds on more complex psychic structures."[68] A still clearer sense of the anti-naturalistic quality of the movement can be found in the preface to the catalogue of the 1911 Neue Sezession exhibition: "Each and every object is only the channel of a colour, a colour composition, and the work as a whole aims, not at an impression of nature, but at the expression of feelings. Science and imitation disappear once more in favour of original creation."[69] The object vanishes into the colors it emits and becomes a reflex of the tumult of the subject. Also in 1911 Vassily Kandinsky, the Russian painter settled in Munich, argued that a non-representational style was an advance in the art of painting, in that it liberated art from its dependence on the coarse and corrupt external world and sensitized its medium to spiritual vibrations in the ether:

The more abstract the form, the more clear and direct is its appeal. In any composition the material side may be more or less omitted in proportion as the forms used are more or less material, and for them substituted pure abstractions, or largely dematerialized objects. The more an artist uses these abstracted forms, the deeper and more confidently will he advance into the kingdom of the abstract.[70]

Expressionism continued the general evacuation of objects found in the works of the aesthetes of late nineteenth century. Kandinsky was influenced by the plays of Maurice Maeterlinck, in which wispy characters grope for some fragile definition of themselves amid the wisp of a world. Yeats, following the Symbolist poet Stéphane Mallarmé, considered that there had arisen "a new poetry, which is always contracting its limits":

Man has wooed and won the world, and has fallen weary… with a weariness that will not end until the last autumn, when the stars shall be blown away like withered leaves. He grew weary when he said, "These things that I touch and see and hear are alone real," for he saw them without illusion at last, and found them but air and dust and moisture….The arts are, I believe, about to take upon their shoulders the burdens that have fallen from the shoulders of priests, and to lead us back upon our journey by filling our thoughts with the essences of things, and not with things.[71]

This fascination with quintessences and immaterial intensities would form an important part of the rhetoric of the Expressionists, especially of such theosophists as Kandinsky. It might be called the Eloi strain.

But the Expressionists, especially the artists of Die Brücke, sought their quintessences and immaterial intensities not in the transcendental forms of Plato, not in the fleeting shudder when the scent of a violet coincides with an augmented triad in A–flat and not in the slight dilation of an iris at beholding a veiled object of desire, but in something raw, abrupt, and sickening. The favorite poet of Ludwig Kirchner, one of the most gifted painters of the school, was not Mallarmé but Walt Whitman, and Kirchner's works, like Egon Schiele's, sometimes show a harsh eroticism—an outthrust of vehement breasts and erect penises. The world of Expressionism was violently up-to-date, taking its idea of sex from Freud and the misogynist Otto Weininger and taking its style of dematerialization from the most recent developments in physics, such as Rutherford's picture of the atom. As Kandinsky noted in 1911, "professional men of learning… finally cast doubt on that very *matter* which was yesterday the foundation of everything, so that the whole universe rocks. The theory of the electrons, that is, of waves in motion, designed to replace matter completely, finds at this moment bold champions."[72] Expressionism was garishly reductionist in character: the object was reduced to a thick sort of standing wave, and the subject reduced to various compulsions or vectors of appetite. Kirchner even considered that the incidental furniture in his art was purely sexual in its nature and function: "The love which the painter brought to the girl who was his mate and partner was transmitted to the carved figure, was refined in the environment of the picture, and in turn mediated

Value: cut to the interior—human truth lies in the electroencephalogram.

the particular chair- or table-form out of the lifelong pattern of the human figure."[73] Even Kirchner's chairs and street-lamps and trees are only the enchanted transpositions of male and female shapes, for our desires are tangled up in the whole world. The outer world, strictly speaking, does not exist, for everything around us is an occult hieroglyph—"hieroglyph" was a favorite word of Kirchner's—of our wishes and fears.

The Expressionists found a number of tools for tracing the contours of the hidden feelings deep within us. The painful elongations and cavings-in of the painted figure—as if the human subject had been amputated or pulled apart on a rack—become a measure of psychic authenticity, visible signs of the internal stresses that bent it out of shape. A certain ghoulish pleasure in depicting skeletons or other over-simplified human forms is often manifest. Oskar Kokoschka used anorexic models "because you can see their joints, sinew and muscles so clearly, and because the effect of each movement is modeled more emphatically with them."[74] One of the most famous of all modernist images is the screamer in Edvard Munch's *The Scream* (1895), a painting that helped to summon the Expressionist movement into being. Munch's figure is an odd cross between a fetus and a corpse. Munch commented, "I felt a loud, unending scream piercing nature," and he may have thought that a hollow stillborn thing was the best icon of the terror of existence.[75] Kokoschka, on the other hand, evidently considered the painter's gaze as something like an X-ray, as if naked feeling was best depicted through images of flayed flesh and bone. Wilhelm Röntgen's invention of the X-ray created a certain coenesthetic anxiety: in Thomas Mann's novel *The Magic Mountain* (1924), set in a tuberculosis sanitarium, the young hero sees an X-ray of his hand and shivers: he is staring into his own grave. In 1907 Kokoschka wrote the first Expressionist play—*Murderer, Hope of Women*, a fable about sexual love as a form of general massacre—and later illustrated it with an X-ray-like drawing. A man stands on a fallen woman, his foot half covered by her fat breast, his hand clenching a dagger; the woman's hand, more lobster claw than hand, seems to be groping for the man's groin. Both large figures, and the scrawny dog behind them, are drawn with vehement cross-hatchings, as if the musculature and nerve-structure were popping through the skin. In Expressionist art, the skin may seem a sort of prevarication, hiding the truth about the human subject; the artist must peel it off with a scalpel.

The Expressionist everywhere promoted the idea of the knife. Sometimes the knife, as in Kokoschka's drawing, appears as a theme; other times it appears as a technique. The Expressionists liked woodcuts, and few woodcuts stress the gash of the artist's knife quite so strongly as Kirchner's *Women at Potsdamer Platz* (1914), in which the women, moving like blades, seem to cut the city into chunks. The Expressionist artist can seem to be a sort of hothouse simulation of a psychotic, flailing with knife or brush against the lies of bourgeois existence. One of the typical subjects of Expressionist art was Jack the Ripper, a prominent figure in Frank Wedekind's play *Lulu* (1913, but based on earlier

12) Arnold Schoenberg's painting, *Vision*, reproduced in *Der Blau Reiter*, edited by Wassily Kandinsky and Franz Marc (Munich: R. Piper & Co. Verlag, 1914).

plays from 1895 and 1902), and in Georg Grosz's painting *Jack the Ripper* (1918), in which Jack comically scuttles away, through an urban space full of bad angles, from a body as luscious and sexually inviting as a nearly decapitated and armless woman can be.

Because Expressionism always tended toward sensory overload, it often sought a sort of multimedia overwhelm through opera and cinema. Wedekind's Lulu, the world-deranging prostitute stabbed by Jack the Ripper, would become the subject not only of a silent film starring Louise Brooks but also of an opera by Alban Berg (1935), in which her murder would be musically depicted by one of those shrieking chords with far too many notes. Berg learned the vocabulary of Expressionism from his teacher Schoenberg, perhaps the most uncompromising of all the Expressionists.

Schoenberg was involved with Kandinsky's Blue Rider school both as a

13) Arnold Schoenberg's "Herrgewäsche (M. Maeterlinck)," for soprano, celesta, harmonium, and harp, reproduced in *Der Blau Reiter* (1914).

14) Film still from *The Cabinet of Dr. Caligari* (1921).

composer and as a painter. In one of his most famous paintings, Schoenberg depicted the back of his own head, as if the painting itself must avert its gaze from the thing that the painter broods upon (Fig. 12). Schoenberg's non-tonal compositions also seemed to find musical equivalents for Symbolist transcendence (as in "Herrgewäsche" a spare and eerie setting for celesta, harp, harmonium, and ultra-high soprano of a poem by Maeterlinck) or for registers of feeling never before reached: the sound-keys that induced the listener to convulsions of the brain (Fig. 13). As Theodor Adorno brilliantly put it,

> *Passions are no longer simulated, but rather genuine emotions of the unconscious—of shock, of trauma—are registered without disguise through the medium of music.… The first atonal works are case studies in the sense of psychoanalytical dream case studies. In the very first publication on Schoenberg,[76] Vassily Kandinsky called the composer's paintings "acts of the mind" [Gehirnakte, or brain-acts]. The scars of this revolution of expression, however, are the blotches which have become fixed in his music as well as in his pictures, as the heralds of the id against the compositional will. They destroy the surface and are as little to be removed by subsequent correction as are the traces of blood in a fairy tale. Authentic suffering has implanted these in the work of art.[77]*

Adorno was particularly struck by Schoenberg's *Erwartung* (Expectation, 1909), an opera for one singer, a madwoman who, stumbling through a forest, comes across the corpse of the faithless lover whom she may have murdered; but it is equally possible that all is hallucination—the corpse, the lover, the forest, the woman herself. Adorno felt that the disturbances in the woman's brain—the electrical stimulations that produce slow dread, quick horror, epileptic fury—found an exact embodiment in the music. The music was not an image of feeling, but feeling itself, made audible. The absence of a tonic corresponded to the absence of conscious mental control, the forbidden intervals in the chords and melodies corresponded to the naked confrontation with taboo, and the emancipation of dissonance corresponded to a filling out of the full spectrum of human emotion. The text of *Erwartung*, a tissue of ellipsis like the free association of a psychoanalyst's patient, was written by a medical student, Marie Pappenheim, a relative of the woman known to history as "Anna O.," the hysteric whom Breuer and Freud described in a famous case history. And, finally, *Erwartung* can be understood as a prolonged teasing-out of music's id, the huge shifting sound-blot that lurks under all the rules and regulations that govern polite discourse.

Expressionism aims to be one of the most therapeutic of artistic movements. Underneath all its hoo-ha's and creepy-crawlies there is finally the message: "Be not

afraid." After all the queasy tilts of floor and ceiling in Robert Wiene's great cinema-study of psychotic murder, *The Cabinet of Dr. Caligari* (1921), the somnambulist wakes up, and sunlight and terra firma are restored (Fig. 14). Perhaps still more revealing is a moment in Fritz Lang's *M* (1931), when Peter Lorre, playing a child killer, walks by a toy store and sees a dancing skeleton and a spiral whirligig spinning away. The tricks of Expressionism, its devices for making the heart skip and the hair stand on end, are at last, no matter what Adorno says, only tricks. It is an artistic movement founded on a toy chest. When Jimmy Stewart is caught on a spiral whirligig in Alfred Hitchcock's *Vertigo* (1958), it is a potent image of his giddy terror of high places, but Lang had long since exposed it for the storefront novelty item it is.

According to Freudian theory, the exposure of the repressed areas of the psyche is the first step toward mental health; so Expressionist art, by rubbing our faces in the body's muck and gore, by making us too dizzy to sustain our careful false pictures of things, brings us closer to confrontation with the truths of ourselves.

But some Expressionists did not subscribe to Freudian theory and therefore hoped to lead us to health by a somewhat different route. D. H. Lawrence,

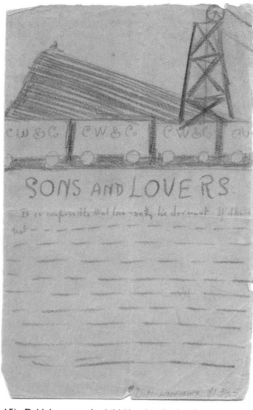

15) D. H. Lawrence's child-like doodle for *Sons and Lovers* (1913).

for example, was an Expressionist in that he hoped to find in subsurface torsions and distortions of form the wellsprings of life-energy. The painter-hero of his early novel *Sons and Lovers* (1913) says that he paints "the shimmering protoplasm in the leaves and everywhere, and not the stiffness of the shape."[78] Elsewhere Lawrence claimed that children's drawings (Fig. 15) are the best drawings of all:

When a boy of eight sees a horse, he doesn't see the correct biological object we intend him to see. He sees a big living presence of no particular shape with hair dangling from its neck and four legs. If he puts two eyes in the profile, he is quite right. Because he does not see with optical, photographic vision…. If a huge eye sits in the middle of the cheek, in a child's drawing, this shows that the deep dynamic consciousness of the eye, its relative exaggeration, is the life-truth, even if it is a scientific falsehood.[79]

For Lawrence, what the child captures is not a photograph or an X-ray, but a sort of radiation-image of the aura of the horse's nervous system, its deep being. The horses in Lawrence's novels are somewhat like these child's drawings of horses:

"She was aware of a great flash of hoofs," he wrote in *The Rainbow*, "a bluish, iridescent flash of the hoof-iron, large as a halo of lightning round the knotted darkness of the flanks. Like circles of lightning came the flash of hoofs from out of the powerful flanks."[80]

Lawrence's opposition to Freud stems from his rejection of the theory of the Oedipus complex. Lawrence considered that incestuous desires were not innate but artificial, carefully coached in male children by depraved mothers, and he (like the devil in Blake's *Proverbs of Hell*) thought that the id, the locus of instinct, was naturally healthy, clean, and trustworthy:

What was there in the cave? Alas that we ever looked! Nothing but a huge slimy serpent of sex, and heaps of excrement, and a myriad repulsive little horrors spawned between sex and excrement.

Is it true? Does the great unknown of sleep contain nothing else? No lovely spirits in the anterior regions of our being?[81]

When, toward the end of his life, Lawrence took up painting, he often devised images of the "lovely spirits" of the deep unconscious, what he called "the very body's body."[82] The Ransom Center contains a particularly telling example, *Boccaccio Story* (1929), illustrating the old tale in Boccaccio's *Decameron* (third day, first story) in which Masetto pretends to be a deaf mute in order to get a job as a gardener in a convent (Fig. 16). Of course the services he provides are as much sexual as horticultural. Lawrence shows the nuns comically discombobulated by the sight of the powerful sleeping man—a figure so exaggerated that he seems to be all thigh. His thighs taper down to fine small toes; his left arm, more ham than arm, seems to extend into a handless stump, as if all his articulateness were in the center of his body, not his extremities. Lawrence repudiates the Freudian model of sex as slithery, snaky, and spidery, in favor of something forthright and beautiful, delicate in its casual strength. For his trouble Lawrence found his paintings confiscated by the police during a public exhibition—once again suggesting how scandal, if not riot, was the proper response to the outrages of Modernism.

TO THE NEW OBJECTIVITY

Like the other extreme "-isms" embraced within Modernism, and just as surely as the north-seeking pole of a magnet presupposes the existence of a south-seeking pole, Expressionism presupposed the existence of an exact contrary. At the

53

MAKE IT NEW: THE RISE OF MODERNISM

16) D H. Lawrence, painting based on a story in Boccaccio's *Decamaron* (1929).

end of the 1910s, symptoms of a revolt against Expressionism were apparent. In 1919 Stravinsky composed for Diaghilev the ballet *Pulcinella*, the first Neoclassical composition (or so Stravinsky claimed), for all the material was stolen from eighteenth-century compositions by (or falsely attributed to) Pergolesi. The year before, Cocteau wrote *Cock and Harlequin*, a call to a new aesthetic of the spare, the simple, the linear, the sturdy, and even the ordinary—traits he found in the music of Erik Satie, with whom he had just collaborated in the ballet *Parade* (1917), also written for Diaghilev's *Ballets Russes*:

> *Art is science in the flesh.*
>
> *The musician opens the cage-door to arithmetic; the draughtsman gives geometry its freedom....*
>
> *With us there is a house, a lamp, a plate of soup, a fire, wine and pipes at the back of every important work of art....*
>
> *The nightingale sings badly....*
>
> A POET ALWAYS HAS TOO MANY WORDS IN HIS VOCABULARY, A PAINTER TOO MANY COLORS ON HIS PALETTE, AND A MUSICIAN TOO MANY NOTES ON HIS KEYBOARD....
>
> SMALL WORKS. *There are certain small works of art whose whole importance lies in their depth; the size of their orifice is of small account.*
>
> *In music, line is melody. The return to design will necessarily involve a return to melody.... Wagner, Stravinsky, and even Debussy are first-rate octopuses. Whoever goes near them is sore put to it to escape from their tentacles; Satie leaves a clear road open...*
>
> *Not music one swims in, nor music one dances on;* MUSIC ON WHICH ONE WALKS....

> *Enough of clouds, waves, aquariums, water-sprites, and nocturnal scents;* [83] *what we need is a music of the earth, everyday music.*
>
> *Enough of hammocks, garlands, and gondolas; I want someone to build me music I can live in, like a house....*
>
> *Music is not all the time a gondola, or a racehorse, or a tightrope. It is sometimes a chair as well.*
>
> *A Holy Family is not necessarily a holy family; it may also consist of a pipe, a pint of beer, a pack of cards and a pouch of tobacco.* [84]

The ostentatiously modest, reticent sort of art which Cocteau calls for here is as far from Expressionism as one can get. Satie once gave a concert of "furniture music," and was angry that people paid attention to the music, instead of talking to one another and going about their business. The music was supposed to be an environment, more like wallpaper (one piece was in fact called *Wallpaper in Forged Iron*) than an outpouring of emotions.

This anti-Expressionist aesthetic may have first appeared in England. T. E. Hulme, the philosopher and poet killed in the Great War, wrote in his 1911 essay "Romanticism and Classicism" that Romanticism had shown itself to be messy, gassy, always burbling off into the infinite; he advocated instead a Classical art, hard and dry: "To the one party man's nature is like a well, to the other a bucket. The view which regards man as a well, a reservoir full of possibilities, I call the romantic; the one which regards him as a very finite and fixed creature, I call the classical." [85] Similarly, Bertrand Russell tried hard to liberate the objective world from entanglement with the human psyche by postulating phantom perceivers to fill in all the gaps between real ones, thus safeguarding the continuity and reliability of physical objects in time and space. The object seemed about to become truly respectable in itself.

The Germans managed to give a name to the artistic movement proper to such a philosophy: the New Objectivity (*Neue Sachlichkeit*). The German word "Sache" means "thing," and "sachlich" means "matter-of-fact"; and there arose during the 1920s an artistic movement that understood the artwork, not as an expression, not as the mere vessel of an intimate psychic state, but as a self-standing non-contingent object, equal in dignity to other phenomena in the world. In literature, this program entailed a desire to understand a poem as a verbal icon, a well-wrought urn, not connected to the poet's biography or to the political culture around it—a doctrine that followed from T. S. Eliot's "Tradition and the Individual Talent" (1919). In painting, it entailed a rejection of what Wilhelm Hausenstein called the "objectlessness of expressionism"—its preoccupation with "intestinal convolutions, nerves, and blood vessels," all that is "horribly deformed, cross-eyed, loutish, mangled"—in favor of cool colors, unstrenuous facture, and clear outlines. [86] In 1925 Franz Roh compiled a useful table of the differences between Expressionism and its successor movement:

Value: consider the art work as a physical object, not as a pseudoperson.

Expressionism	Post-Expressionism
ecstatic objects	*plain objects*
many religious themes	*few religious themes*
the stifled object	*the explanatory object…*
dynamic	*static*
loud	*quiet*
summary	*sustained…*
monumental	*miniature*
warm	*cool to cold*
thick coloration	*thin layer of color*
roughened	*smooth, dislodged*
like uncut stone	*like polished metal*
work process preserved	*work process effaced*
leaving traces	*pure objectification*
expressive deformation of objects	*harmonic cleansing of objects*
rich in diagonals	*rectangular to the frame*
often acute-angled	*parallel*
working against the edges of image	*fixed within edges of image*
primitive	*civilized*[87]

An Expressionist work of art often seems unfinished, because it shows on the outside the inner processes of its coming-into-being; it is less an object than a tracing of psychic activity. But a New Objectivist work of art tends toward a certain anonymity and arbitrariness, a canceling-out of creative process. An Expressionist work of art is symbolic in the sense that it is charged with a visible burden of flagrant meaning; a New Objectivist work of art is symbolic in that it conceals its meaning despite leaving every surface open for inspection. As Roh says, it is "obvious and enigmatic," disturbingly impervious to interpretation.

Five years after Roh compiled his table, Bertolt Brecht and Peter Suhrkamp published a similar table in order to differentiate the old theater that engrossed feelings from the new theater that roused critical attention:

Old: Dramatic theater	**New**: Epic theater
plot	*narrative*
implicates the spectator in a stage situation	*turns the spectator into an observer, but*
wears down his capacity for action	*arouses his capacity for action*
provides him with sensations	*forces him to make decisions*
experience	*picture of the world*
the spectator is involved in something	*he is made to face something*
suggestion	*argument…*
the spectator is in the thick of it, shares	*the spectator stands outside, studies…*
feeling	*reason*[88]

The epic theater, according to this definition, is not cathartic; it is not a sort of brothel for working-up and discharging emotions; it is instead a hard thing, a representation of the hard choices of being. Brecht wanted what he called a smoker's theater, a theater that cultivated a canny, critical, and detached estimation of the virtues and deficiencies presented—an attitude more commonly found among spectators at a boxing match, Brecht thought, than among visitors to playhouses. To some extent this is simply the New Objectivist painting turned into drama, a drama in which nothing is sloppy, nothing leaks out of the edges of the proscenium into the spectator's lap, nothing is deep, arcane, or hidden, everything is spruce and tight, available for evaluation. If you see on stage a representation of a woman's life ruined by a plutocrat's contempt for the lower classes, Brecht does not invite you to weep, to resign yourself to the tears of things; he invites you to ask yourself, "What could I do to change the economic system?"

There seems no possibility for a convergence of opposites between Expressionism and the New Objectivity, and yet, as with all the extremes of the modernist aesthetic experience, such a convergence did take place. It is easiest to illustrate this convergence in the world of music, where Schoenberg in the 1920s abandoned, or half-abandoned, the arch-Expressionist style of "free-atonalism" for a tight, disciplined manner of composition, the twelve-tone system, in which all musical material is based on a pre-determined sequence of the twelve notes of the chromatic scale, called the "tone row." In this system no note can be repeated until the whole row has been heard. This rule abolishes any possibility for a tonic, since every note is of equal value, and it guarantees a certain degree of compositional unity, since every passage is stamped, sometimes overtly, sometimes inaudibly, with its genetic code. Furthermore, some of Schoenberg's early twelve-tone compositions, such as his 1923 piano suite, were divided into movements with eighteenth-century dance titles such as gavotte, musette, and gigue—as if Schoenberg had completely surrendered to the Neoclassicists. But a gavotte written in the twelve-tone system, even if it obeys all the rhythmical protocols of Bach's age, does not sound like Bach; its very urbanity and simplicity makes the lack of a tonal center all the more disorienting. The gavotte in Schoenberg's piano suite, a sort of music-box for mechanical insects, feels like an exercise in the Freudian uncanny, for the displacements of the *almost*-familiar feel stranger than the blatant incomprehensibilities of *Erwartung*.

This mad oscillation between extremes could be seen in other composers, too. Paul Hindemith in 1921 wrote an Expressionist opera, *Sancta Susanna*, about a mad nun who presses her naked body against a large statue of Jesus, but by 1928 Hindemith was writing an opera, *Neues vom Tage*, about the casual affairs of businessmen and their wives, normal people who go to art museums or sing in the bathtub. After prolonged arousals of psychotic states of consciousness, composers may have found the

Value: use the work of art as a teaching aid, not as a promoter of acquiescence.

MAKE IT NEW: THE RISE OF MODERNISM

17) Jean Cocteau, pencil drawing, no date. The *musiciens* or composers—Auric, Durey, Honegger, Milhaud, Poulenc, and Tailleferre—came together as the group, *Les Six*, under Erik Satie and were later adopted and promoted by Cocteau.

world of newspaper headlines and bureaucrats at the Marriage License Office to be the last refuge of weirdness. Both Expressionism and the New Objectivity were simply part of a large cultural rhythm of familiarization and defamiliarization; perhaps neither was possible without the other. In the Ransom Center is a pen-and-ink drawing by Cocteau (Fig. 17) in which a dove-like bird, hovering in the upper left-hand corner, carries in its beak a scroll of paper that unfurls like a ribbon across the length of the paper and bears the message: "arnold schoenberg les six musiciens vous saluent" (arnold schoenberg the six musicians greet you). The French composers called *Les Six* were mostly disciples of Satie: they included Francis Poulenc, Darius Milhaud, and Arthur Honegger. Their aesthetic was, to a large extent, that of Cocteau's *Cock and Harlequin*: an art devoted to the agreeable, not to the shocking. This greeting-card from Cocteau and *Les Six* to Schoenberg suggests just how narrow even the widest fissure within Modernism in fact is. The grand canyon between elegant Parisian hijinks and Schoenberg's confrontation with the monsters in the id seems little more than a crack in the sidewalk, easily bridged by the ribbon on a casual drawing.

• • •

We began this tour of modernist art with Wagner's declaration that under certain boundary conditions time turns into space. Expressionist music inflicts terrible gashes onto time itself. Schoenberg said that "In *Erwartung* the aim is to represent in *slow motion* everything that occurs during a single second of maximum spiritual excitement, stretching it out to half an hour."[89] Furthermore, he praised the *Six Bagatelles* (each only a few seconds long) of his pupil Anton Webern by saying, "Think what self-denial it takes to cut a long story so short.… To convey a novel through a single gesture, or felicity by a single catch of the

breath: such concentration.…"[90] Psychic or aesthetic time and clock time seem to have nothing to do with one another. The motto of such art is **out of synch**. According to the physicist Lorentz's theory, one spatial dimension of an object starts to contract at speeds approaching the speed of light; according to Einstein's famous thought-experiment, if one were a photon, one would be hurling through a freeze-frame universe in which nothing at all seems to happen. Expressionism is an artistic movement appropriate to this sort of taffy-pulled temporality. Its spatial forms, often elongated along one axis and contracted along another, also seem to follow the rules of physics concerning dimensional changes near the speed of light. In a sense we could, by comparing the ratio of height vs. width in an Expressionist image to the ratio of a normal figure, measure its presumed psychic velocity.

But Expressionism is only the most obvious modernist artistic movement to challenge traditional concepts of time and space. The melting watches in Salvador Dalí's Surrealistic *The Persistence of Memory* (1931), resigned to utter loss of temporal rigor, seem to be indicating the hour in some time-frame remote from earth. Even Neoclassicism and the New Objectivity are not so conventional and normative as they first seem. It is true that their propriety seemed like a relief after Expressionist art: here, it seems, space is easily measured with a yardstick and time with a clock. But the graceful severities of Constantin Brancusi's sculptures, or Piet Mondrian's early paintings of waves as stark grids (almost indistinguishable from his paintings of trees as stark grids) suggest a certain defiance of time itself. An abstraction, if it is abstract enough, attains immunity from temporal process. Even the temporal arts, such as music, seem to strive for an atemporal quality, as if a musical composition could hover in space like a painting. For example, a work such as Stravinsky's burlesque

Renard (1922) is pasted together from terse, endlessly recycled pattern-units, as if it were a collage in time. Adorno intensely deplored Stravinsky's way of turning time into space: "the spatialization of music is.… on the innermost level an abdication," he asserts, going on to claim that "the trick that defines all of Stravinsky's organizings of form" is "to let time stand in, as in a circus tableau, and to present time complexes as if spatial."[91] But Stravinsky was not a traitor to his artistic medium; he was simply a twentieth-century artist, pushing at the medium's limits. And the circus is no better and no worse a venue for great art than the Louvre or the Amsterdam Concertgebouw or the Berliner Ensemble's playhouse.

Very early in the twentieth century, artists of many different schools came to understand one central characteristic of Modernism to be the convergence of time and space in ways that would have been unimaginable previously. Here is the Expressionist painter August Macke making this point in 1913, as he contemplates the fact that real raindrops fall through the air as almost perfect little spheres:

> *Cubism, Futurism, Expressionism, abstract painting, are only names given to a change which our artistic thinking wants to make and is making. Nobody has ever painted falling raindrops suspended in the air, they've always been depicted as streaks (even the cave-men drew herds of reindeer in the same way). Now people are painting cabs rattling along, lights flickering, people dancing, all in the same way (this is how we all see movement). That is the whole frightfully simple secret of Futurism. It's very easy to prove its artistic feasibility, for all the philosophizing that has been raised against it. Space, surface and time are different things, which ought not to be mixed together, is the continuous cry. If only it were possible to separate them. I can't do it. Time has a large part to play in looking at a picture.… The eye jumps from blue to red, to green (even if it is only a change of form), to a black line, suddenly comes upon a sharp white eruption, follows it, floats onto a delicate yellow patch.… It is impossible to take it all in at once. Time is inseparable from surface.*[92]

A painting unfurls itself slowly, energetically; a piece of music can be apprehended in a single instant. In a thousand ways Modernism tells us, "You are not what you think you are"; or, "What seems to be still is in fact moving"; or, "What seems to move is in fact still." Even a statue can point an accusing finger, like the torso of Apollo (in Rainer Maria Rilke's poem of 1908) that tells us, through the very twist of its body, "You must change your life."[93]

NOTES

1. Richard Wagner, *Wagner on Music and Drama*, tr. H. Ashton Ellis, ed. Albert Goldman and Evert Sprinchorn, New York: Da Capo Press, 1964, p. 181.

2. W. B. Yeats, *Essays and Introductions*, New York: Macmillan, 1961, p. 190; T. S. Eliot, *The Use of Poetry and the Use of Criticism*, London: Faber and Faber, 1964, p. 113.

3. Virginia Woolf, *Orlando*, New York: Harvest, 1956, pp. 227-28.

4. *Norton Anthology of English Literature*, ed. M. H. Abrams et al., New York: Norton, 1974, third edition, vol. 2, p. 1004.

5. William Wordsworth, *Prose Works*, ed. W. J. B. Owen and Jane Worthington Smyser, Oxford: Clarendon Press, 1974, 2:79.

6. George Eliot, *Adam Bede*, Book 2, Chapter 17.

7. Émile Zola, *The Experimental Novel and Other Essays*, tr. Belle M. Sherman, New York, 1893, p. 54.

8. Robert Browning, *The Poems*, ed. John Pettigrew, New Haven: Yale University Press, 1981,1: 646 (ll. 97-98; 111-17).

9. Gustave Flaubert, *Madame Bovary*, tr. Paul de Man et al., New York: W. W. Norton, 1965, p. 2.

10. Friedrich Nietzsche, *The Portable Nietzsche*, tr. Walter Kaufmann, New York: Viking, 1968, p. 45.

11. Oscar Wilde, *Complete Works*, ed. Vyvyan Holland, London: Collins, 1973, pp. 990-91.

12. Ibid, p. 17.

13. William Shakespeare, *Hamlet* 3.2.20-22

14. W. B. Yeats, *Mythologies*, New York: Macmillan, 1959, p. 276.

15. D. H. Lawrence, *The Complete Poems of D. H. Lawrence*, ed. Vivian de Sola Pinto and F. Warren Roberts, New York: Viking, 1971, p. 477.

16. Arthur Schopenhauer, *The World as Will and Idea*, tr. R. B. Haldane and J. Kemp, New York: Charles Scribner's Sons, 1950, 1:341.

17. Hector Berlioz, *À travers chants: études musicales, adorations, boutades et critiques*, Paris: Michel Levy, 1862, p. 31.

18. Translated from Victor Hugo, *La préface de Cromwell*, ed. Souriau, pp. 22-23.

19. Flaubert, letter to Louise Colet, 15 July 1853.

20. D. H. Lawrence, *Etruscan Places*, New York: Viking, 1970, p. 112.

21. *The Impressionists at First Hand*, ed. Bernard Denvir, New York: Thames and Hudson, 1987, p. 36.

22. Phoebe Pool, *Impressionism*, New York: Thames and Hudson, 1991, p. 228.

23. Ibid, p. 224.

24. *The Impressionists at First Hand*, p. 147.

25. *The Portable Nietzsche*, p. 46.

26. *Impressionism*, pp. 243-44.

27. Walter Pater, *The Renaissance: Studies in Art and Poetry*, ed. Donald L. Hill, Berkeley: University of California Press, 1980, pp. 185, 187-88.

28. Joseph Conrad, *Heart of Darkness*, ed. Robert Kimbrough, New York: Norton, 1971.

29. Heinrich Schenker, *Free Composition: Volume III of New Musical Theories and Fantasies*, New York: Longman, 1979.

30. *The Portable Nietzsche*, p. 95.

31. Matthew Arnold, *Poetry and criticism of Matthew Arnold*, ed. A. Dwight Culler, New York: Riverside, 1961, p. 313.

32. Michel Foucault, *The Foucault Reader*, ed. Paul Rabinow, New York: Pantheon, 1984, p. 74.

33. Jean-François Lyotard, *The Postmodern Condition: A Report on Knowledge*, tr. Geoff Bennington and Brian Massumi, Minneapolis: University of Minnesota Press, 1984, p. xxiii.

34. Ibid, p. xxiv.

35. *Modernism: An Anthology of Sources and Documents*, ed. Vassiliki Kolocontroni et. al., Chicago: University of Chicago Press, 1998, pp. 106-7. The translator here is P. E. Charvet.

36. P. B. Shelley, *A Defence of Poetry*, and T. L. Peacock, *The Four Ages of Poetry*, ed. John L. Jordan, Indianapolis: Bobbs-Merrill, 1965, p. 39.

37. Franz Kafka, *Amerika*, tr. Willa and Edwin Muir, New York: Schocken, 1974, p. 39.

38. Vladimir Nabokov, *Details of a Sunset and Other Stories*, New York: McGraw-Hill, 1976, p. 94.

39. Charles Baudelaire, *Les fleurs du mal*, tr. Richard Howard, Boston: David R. Godine, 1985, pp. 193, 15.

40. Cited in Robert L. Delevoy, *Symbolists and Symbolism*, New York: Rizzoli, 1982, p . 71.

41. Katherine Ruth Heyman, *The Relation of Ultramodern to Archaic Music*, Boston: Small, Maynard, 1921, p. 7.

42. Allen Tate, *Collected Poems 1919-1976*, New York: Farrar Straus & Giroux, 1977.

43. *W. B. Yeats and T. Sturge Moore: Their Correspondence 1901-37*, ed. Ursula Bridge,New York: Oxford University Press, 1953, p. 38.

44. W. B. Yeats, *The Variorum Edition of the Poems of W. B. Yeats*, ed. Peter Allt and Russell K. Alspach, New York: Macmillan, 1957, p. 807.

45. Composed by J.G. Naumann (1741-1801).

46. T. S. Eliot, *The Waste Land: A Facsimile and Transcript of the Original Drafts Including the Annotations of Ezra Pound*, ed. Valerie Eliot, New York: Harcourt Brace Jovanovich, 1971, p. 43, with some canceled material omitted.

47. Joyce, *Finnegans Wake*, New York: Viking Press, 1966, p. 5.

48. Harper, George Mills Harper, *The Making of Yeats's 'A Vision': A Study of the Automatic Script*, Carbondale: Southern Illinois University Press, 1987, vol. 2, p. 356.

49. *Marinetti: Selected Writings*, tr. R. W. Flint and Arthur A. Coppotelli, New York: Farrar, Straus and Giroux, 1972, pp. 84-85, 87.

50. Caroline Tisdall and Angelo Bozzolla, *Futurism*, New York: Thames and Hudson, 1989, pp. 33, 35.

51. Filippo Tommaso Marinetti and Pino Masnata, "La radia," tr. Stephen Sartarelli, in *Wireless Imagination*, ed. Douglas Kahn and Gregory Whitehead, Cambridge: MIT Press, 1992, p. 267.

52. Ezra Pound, *Ezra Pound and the Visual Arts*, ed. Harriet Zinnes, New York: New Directions, 1980, p. 199.

53. Cited in Douglas Cooper, *The Cubist Epoch*, London: Phaidon Press, 1970, p. 33.

54. Cited by William Rubin in *Cézanne: The Late Work*, ed. William Rubin, New York: The Museum of Modern Art, 1977, pp. 169, 198.

55. Marcel Duchamp, *The Writings of Marcel Duchamp*, ed. Sanouillet and Peterson, p. 141, quoted in Jeffrey Weiss, *The Popular Culture of Modern Art*, New Haven: Yale University Press, p. 126.

56. Francis Picabia, *Écrits 1913-1920*, ed. d'Allonnes, p. 251.

57. Joyce, *Finnegans Wake*, p. 462.

58. Samuel Beckett, *Murphy*, New York: New Directions, 1957, p. 65.

59. Anton Kaes et al., ed. *The Weimar Republic Sourcebook*, Berkeley: University of California Press, 1994, p. 602.

60. *Weimar Sourcebook*, p. 602.

61. O. Raymond Drey in the *New Weekly* (May 1914), cited in Jann Pasler, ed., *Confronting Stravinsky*, Berkeley: University of California Press, 1986, p. 80.

62. Émile Vuillermoz in *La Revue Musicale*, 15 June 1913, cited in Minna Lederman, ed., *Stravinsky in the Theatre*, New York: Pellegrini & Cudahy, 1949, p. 21.

63. T. S. Eliot, "London Letter," The Dial, September 1921.

64. H. G. Wells, *The Time Machine*, ed. H.M. Geduld, Bloomington: Indiana University Press, 1987, p. 45; Ibid., p. 59.

65. Ibid., pp. 61, 63.

66. Ibid., p. 52.

67. From the Prologue to *Also Sprach Zarathustra*, in *The Portable Nietzsche*, p. 126; *Beyond Good and Evil* §146, from Friedrich Nietzsche, *Werke in Drei Bänden*, München: Carl Hanser Verlag, 1966, vol. 2, p. 636.

68. Cited in Donald E. Gordon, *Expressionism: Art and Idea*, New Haven: Yale University Press, 1987, p. 175.

69. Cited in Wolf-Dieter Dube, *The*

Expressionists, London: Thames and Hudson, 1972, p. 159.

70. Kandinsky, *Concerning the Spiritual in Art*, tr. M. T. H. Sadler, New York: Dover, 1977, p. 32.

71. W. B. Yeats, *Essays and Introductions*, New York: Macmillan, 1968, pp. 190, 192-93.

72. Cited in Gordon, *Expressionism: Art and Idea*, p. 23.

73. Ibid., p. 14.

74. Dube, *The Expressionists*, p. 181.

75. Elizabeth Prelinger and Michael Parke-Taylor, *The Symbolist Prints of Edward Munch*, New Haven: Yale University Press, 1996, p. 98.

76. *Arnold Schönberg*, ed. Berg et al.–Kandinsky's essay is reproduced in *Arnold Schoenberg / Wassily Kandinsky / Letters, Pictures, and Documents*, ed. Jelena Hahl-Koch, tr. John C. Crawford, London: Faber and Faber, 1984, pp. 125-28. Kandinsky there remarks that Schoenberg paints "in order to give expressions to those motions of the spirit [Gehirnakte] that are not couched in musical form."

77. Theodor Adorno, *Philosophy of Modern Music*, tr. Anne G. Mitchell and Wesley V. Blomster, New York: Seabury, 1973, p. 39.

78. D. H. Lawrence, *Sons and Lovers*, New York: Viking, 1970, p. 152.

79. D. H. Lawrence, *Psychoanalysis and the Unconscious and Fantasia of the Unconscious*, New York: Viking, 1971, pp. 125-26.

80. D. H. Lawrence, *The Rainbow*, New York: Viking, 1969, p. 487.

81. Lawrence, *Psychoanalysis and the Unconscious*, p. 5.

82. D. H. Lawrence, *The Complete Poems of D. H. Lawrence*, ed. Vivian de Sola Pinto and F. Warren Roberts, New York: 1971, p. 264.

83. Each item in this catalog seems derived from an Impressionist composition: the clouds from Debussy's *Nuages* (from *Nocturnes*, 1899), the waves from his *La mer* (1905), the aquarium from his *Poissons d'or* (*Images* 2.3, 1907), the water-sprite from Ravel's *Ondine* (from *Gaspard de la nuit*, 1908), the nocturnal scent from Debussy's *Ibéria* (1909).

84. From *Cocteau's World: An Anthology of Writings by Jean Cocteau*, ed. Margaret Crosland, New York: Dodd, Mead, 1972, pp. 304-14 passim.

85. *Modernism: An Anthology*, ed. Kolocotroni et al, pp. 179-80.

86. *Weimar Sourcebook*, p. 481.

87. Ibid., p. 493.

88. *Brecht on Theatre*, tr. John Willett, New York: Hill and Wang, 1991, p. 37.

89. Arnold Schoenberg, *Style and Idea*, ed. Leonard Stein, tr. Leo Black,

Berkeley: University of California Press, 1984, p. 105.

90. Ibid., pp. 483-84.

91. Theodor W. Adorno, *Philosophie der neuen Musik*, Frankfurt: Europäische Verlagsanstalt, 1966, pp. 176, 180.

92. Dube, *The Expressionists*, pp. 144-45.

93. Rainer Maria Rilke, *New Poems*, tr. J. B. Leishman, London: Hogarth Press, 1964, p. 164.

Unknown manufacturer, Zoetrope, 1868. William Horner invented the Zoetrope in 1834. It was the most sophisticated motion machine of its day. The cylinder is spun, and as it is spinning, the viewer looks through the small slots on the outside. With the illusion of motion, the drawings inside appear as a continuous movement. The birth of film in 1895 combined these elements, and more, to create the illusion of moving images that could be viewed on a large screen at 24 frames per second.

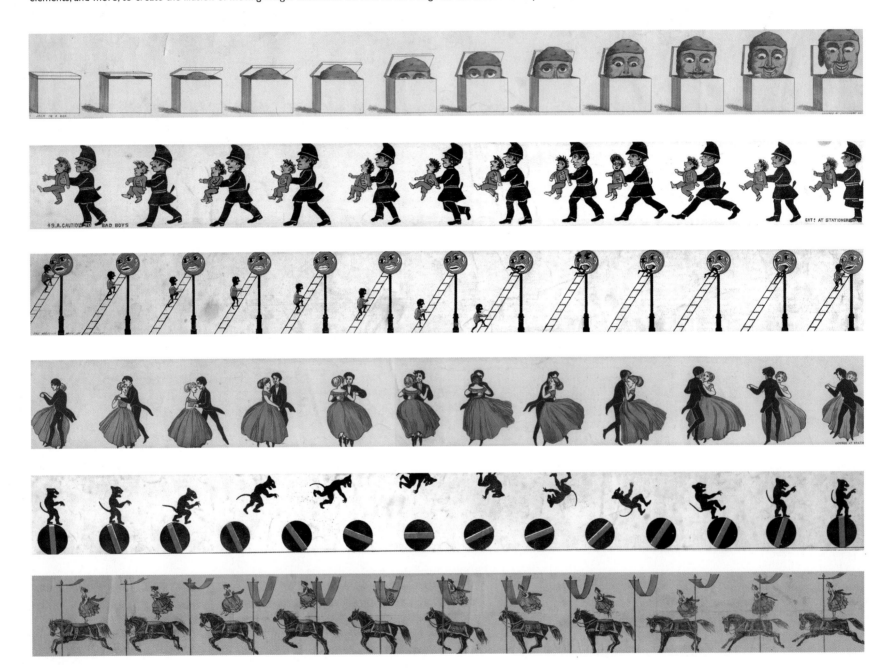

PORTALS OF DISCOVERY

"A man of genius," Stephen Dedalus asserts in James Joyce's *Ulysses* (1922), "makes no mistakes." Even his errors are "portals of discovery." What is discovered through these portals, the shock of the new, is sometimes fully recognizable only in retrospect. Kurtz's discovery of "The horror! The horror!" in Joseph Conrad's *Heart of Darkness* (1898-9) would have been understood at the time in the context of the Boer War, but the monstrosity is only felt fully after the slaughters of the First World War; the debacles of Algeria, the Belgian Congo, and Indochina; and the tragedies of the Holocaust and Hiroshima. Now that the twentieth century is history, one can better see how the horror of the modern was rooted in expansions and contractions of empire.

Similarly, contemporaries of the French poet Charles Baudelaire knew that *Les Fleurs du mal* (1857) was a shocking book, but the lasting importance of poems such as "Une Charogne" ("Carrion") was not so much the subject, a dead animal, as the tone or perspective, the portal through which this subject was made shockingly important. Writing in 1907, the German poet Rainer Maria Rilke dubbed this the first modern poem because of its "development toward objective expression," a phenomenon that Rilke associated visually with Cézanne. In this poem, Rilke says, the poet makes a new discovery, as if in error. He goes "far enough to see even in the horrible and apparently merely repulsive that which is and which, with everything else that is, is valid."

To extend the grounds of what is valid: that may be the germinal action of modernist art. "Some of the flowers of fiction have the odour of [reality]," Henry James said in "The Art of Fiction" (1894), "and others have not." But, as he wrote in the preface to his novel *Roderick Hudson*, "Everything counts, nothing is superfluous…." For us, James's image may point toward the premise of chaos theory, that everything is interconnected, the movement of butterfly wings in China and the wind currents half a globe away. We now see James's remark as a portal, even as he discovered the purpose of his novel in a "preface" he wrote to it over thirty years later.

T. S. Eliot explained in a letter from the summer of 1919, the first summer after the war, that he had discovered portals. To see what "comprises modern culture," he told his correspondent, look at Byzantine, Polynesian, African, Hebridean, and Chinese art; then look at Stendahl, Mozart, Bach; look at Flaubert; look at Russian ballet, Russian novels; look at Laforgue (though he's "really inferior to Corbière at his best"). There it is. But "it" might take several lifetimes of study—study that ironically would take the student of the modern back to the deep past, to the primitive, to cultures before "culture."

Ezra Pound spent his whole life writing a curriculum for becoming modern (and the modern age has been called "The Pound Era"). His point, and the point of many like him in the early twentieth century, was that the modern arts were subjects of study equal in importance to what you could find in a university. And sometimes easier of access. As Louis Armstrong said of his curriculum, jazz, "If you gotta ask [what it is], you ain't never gonna know."

GEOGRAPHY

1) Portrait of Joseph Conrad (1857-1924) by Walter Tittle, oil on canvas, 1924, painted the year Conrad died.

2) Joseph Conrad's *The Heart of Darkness* was published in book form in *Youth: A Narrative and Two Other Stories* (Edinburgh and London, 1902). The novella was previously serialized in *Blackwood's Magazine*, February-April 1899.

3) This copy of *Youth* is inscribed by Conrad to Henry James: "Au cher Maître / affectueusement / J.C. / 20 Nov 1902". James (1843-1916) was an important transitional figure in the development of the modern novel; he also represented, through his dual nationality (American/British), the international focus that the Polish-born and widely traveled Conrad valued.

1)

THE HEART OF DARKNESS.

BY JOSEPH CONRAD.

THE " Nellie," a cruising yawl, swung to her anchor without a flutter of the sails, and was at rest. The flood had made, the wind was nearly calm, and being bound down the river, the only thing for us was to come to and wait for the turn of the tide.

The sea-reach of the Thames stretched before us like the beginning of an interminable waterway. In the offing the sea and the sky were welded together without a joint, and in the luminous space the tanned sails of the barges drifting up with the tide seemed to stand still in red clusters of canvas sharply peaked, with gleams of varnished sprits. A haze rested on the low shores that ran out to sea in vanishing flatness. The air was dark above Gravesend, and farther back still seemed condensed into a mournful gloom, brooding motionless over the biggest, and the greatest, town on earth.

The Director of Companies was our captain and our host. We four affectionately watched his back as he stood in the bows looking to seaward. On the whole river there was nothing that looked half so nautical. He resembled a pilot, which to a seaman is trustworthiness personified. It was difficult to realise his work was not out there in the luminous estuary, but behind him, within the brooding gloom.

Between us there was, as I have already said somewhere, the bond of the sea. Besides holding our hearts together through long periods of separation, it had the effect of making us tolerant of each other's yarns—and even convictions. The Lawyer—the best of old fellows—had, because of his many years and many virtues, the only cushion on deck, and was lying on the only rug. The Accountant had brought out already a box of dominoes, and was toying architecturally with the bones. Marlow sat cross-legged right aft, leaning against the mizzen-mast. He had sunken cheeks, a yellow complexion, a straight back, an ascetic aspect, and, with his arms dropped, the palms of hands outwards, resembled an idol. The Director, satisfied the anchor had good hold, made his way aft and sat down amongst us. We exchanged a few words lazily. Afterwards there was silence on board the yacht. For some reason or other we did not begin that game of dominoes. We felt meditative, and fit for nothing but placid staring. The day was ending in a serenity that had a still and exquisite brilliance. The water

2)

3)

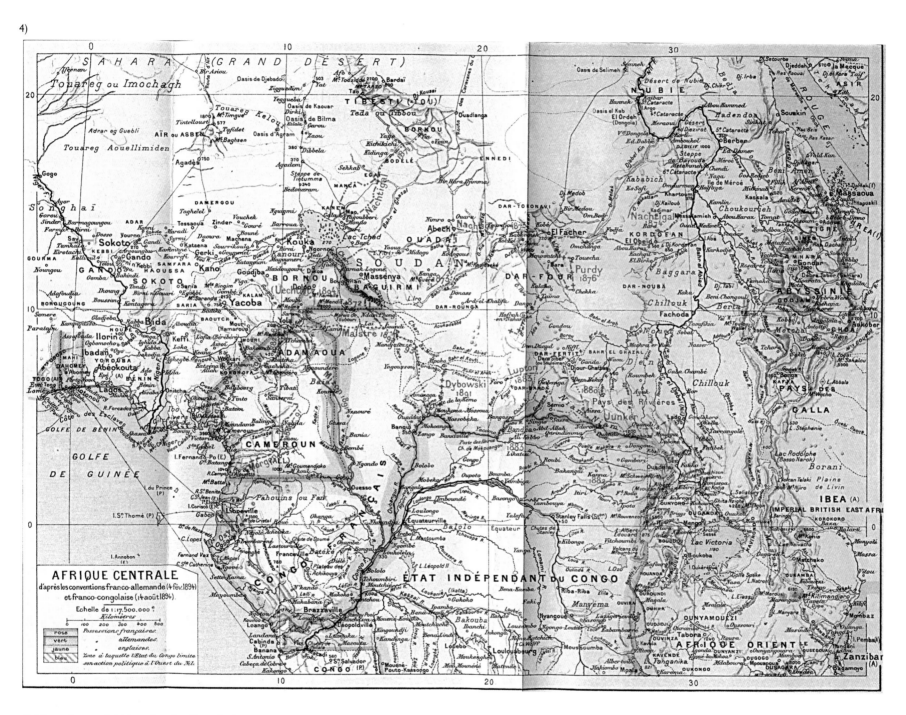

4) Map of central Africa after the French-German convention of 4 February 1894 and the French-Congolese convention of 14 August 1894. Courtesy of The University of Texas at Austin General Libraries Map Collection.

"Now when I was a little chap I had a passion for maps.... At that time there were many blank spaces on the earth, and when I saw one that looked particularly inviting on a map (but they all look that) I would put my finger on it and say, 'When I grow up I will go there.'... [But] it had got filled since my boyhood with rivers and lakes and names. It had ceased to be a blank space of delightful mystery—a white patch for a boy to dream gloriously over. It had become a place of darkness." – *Heart of Darkness*

5)

PASSION

5) First edition of *The Good Soldier: A Tale of Passion* (London and New York, 1915) by Ford Madox Hueffer (1873-1939), who later changed his name to Ford Madox Ford. His unsuccessful attempts to divorce his first wife are reflected in this book. Ford originally titled the book, "The Saddest Story," here inked in on the title page, but he was persuaded by John Lane, his publisher, to change it. The novel was published in wartime, and Lane was afraid its original title would hurt sales.

6) Portrait of Ford Madox Ford by George T. Hartmann, oil on canvas, 1926. After collaborating with Joseph Conrad on two novels, Ford founded the *English Review* in which he also published Henry James and Thomas Hardy. Later, Ford successfully bridged the generations by publishing, as editor of the *Transatlantic Review*, Hemingway, Joyce, and Pound.

6)

7)

8)

9)

LEGITIMACY

7) Photograph of Verlaine (1844-1896) in the Café François I by Dornac, c. 1890. The glass probably holds the intoxicating—and toxic—drink, absinthe. This photograph is still in its original frame and comes from Adrienne Monnier's bookshop La Maison des Amis des Livres, on the rue de l'Odéon in Paris.

8 and 9) Autograph manuscript (in another hand) of Paul Verlaine's, "Ballade pour les décadents," September 1887. Verlaine too was a transitional figure. Born in an era of High Romanticism, he espoused attitudes, such as the *esprit décadent*, later associated with Modernism. In the repeating phrase "bons écrivains" Verlaine is claiming that poets like him are "good," in the sense of expert, writers, and also morally "good," despite their openly rude disdain for bourgeois manners and authority. The refrain could be translated: "However many bankers try to cheat us, / Divine and sweet, let's laugh like princes; / Forget what anybody said or meant, / We are the writers who are pretty decent."

65

A LIVE TRADITION

10) E.F. Shipley, photograph, "The Modern Poets," taken on 18 January 1914 at a dinner in honor of Wilfred Scawn Blunt. Pictured from left to right are Victor Plarr, Sturge Moore, W. B. Yeats, Blunt, Ezra Pound, Richard Aldington, and F. S. Flint. This event was a self-conscious effort by the younger poets to link themselves with an exemplar of the previous generation. While interred thirty years later at Pisa on the charge of treason, Pound remembered:

> *To have, with decency, knocked*
> *That a Blunt should open*
> > *To have gathered from the air a*
> > *live tradition*
> *or from a fine old eye the uncon-*
> > *quered flame*
> *This is not vanity.*

11) Signed autograph manuscript of William Butler Yeats's "King Goll," c. 1887. Written when Yeats was 22 years old, it was his first poem published in England, a kind of folk ballad showing marked Celtic and Symbolist tendencies.

12) First edition of Yeats's *The Wind Among the Reeds* (London: Elkin Mathews, 1899), gilt-vellum binding attributed to Althea Gyles. The cover's Celtic design explicitly links the poet's work to nationalist Irish themes.

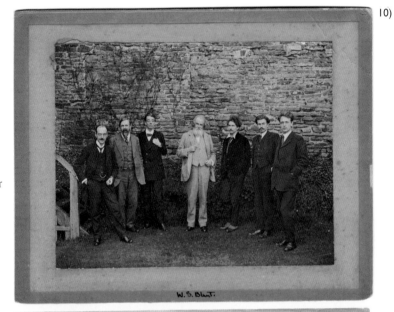

10)

12)

11)

13)

Rough note for Eliot painting in Durban 1938

14)

15)

© Valerie Eliot, reproduced by permission of the Eliot estate.

THE PRIMITIVE

13) Wyndham Lewis, "Rough note for [T. S.] Eliot painting in Durban, 1938." Litho crayon on paper. The completed portrait was rejected by the Royal Academy.

14) Letter from T. S. Eliot to Mary Hutchinson, (11?) July 1919, in which Eliot lists what he thinks "comprises modern culture," including such archaic and primitive societies as Polynesian, African, and Hebridean—indeed, "savage and Oriental art in general."

15) Easter Island Man, wood, probably late 18th century. Private collection. At the turn of the twentieth century, Oceanic, African, and other tribal art was making its way into art galleries, museums, and private collection. The "magical" qualities imbued in these idols and masks is what Picasso and others incorporated in the lines and geometry of their own art, to create Cubism. Is the Lewis portrait gesturing toward this primitivism?

67

MAKE IT NEW: THE RISE OF MODERNISM

THE PRIMITIVE

16) Photograph of Benin head and bracelets, from Nancy Cunard's African art collection, c. 1930, silver gelatin print. This photograph was used in the cover montage for *Henry Music* published by Cunard in 1930 at her Hours Press. Ransom Center visiting scholar Wendy Grossman recently reattributed this work to Man Ray (1890-1976) and not to Raoul Ubach as is stated on the reverse of the photo. Cunard herself commented on her choice of Man Ray as documentarian: "His vision in taking and placing and, as it were, in 'mating' various objects, was often supreme."

17) Pablo Picasso (1881-1973), *La Vénus du gaz*, an *objet trouvé* or found object (here a burner from a gas stove), no date. Daniel Albright suggests that Picasso may have seen the so-called Venus of Willendorf (c. 15,000-10,000 B.C.), which was discovered early in the twentieth century.

68

16)

17)

2

FORMS AND TECHNOLOGIES

Although the year 1890 may sound like an arbitrary starting point for the modern era, it was the year in which the first entirely steel-framed building was erected in Chicago, rubber gloves were first used in surgery in Baltimore, and the first moving pictures were shown in New York. These different technologies marked significant changes in architectural design, hygiene and medical technique, and the nature of visual (and ultimately aural) representation.

In a similar manner, the airplane transformed the transportation of goods and people, the way war was waged, and how space and time were conceived. At the Aviation Exhibition in Paris in 1912 Marcel Duchamp inspected a propeller and declared to his companion Constantin Brancusi, "Painting is finished. Who can do anything better than this propeller? Can you?" The challenge presages Robert Frost's assertion that if design governs in large things it must also govern in small things—in things as fine, say, as image, line, color, tone, inflection, scale, beat, and instrumentation. Fewer than two decades after Duchamp's remark, the Museum of Modern Art opened in New York City. In due course, it would have a design wing to celebrate the aesthetics of practical objects like rubber gloves and propellers.

Certainly the creation of new material technologies affected the kinds of artistic representation that were possible. Artists were not content to do what they had always done in the past, and they drew inspiration and techniques from each other. The interdisciplinary nature of Modernism exposed new modes of artistic invention, operating through both high and popular cultures.

"Make it new," Ezra Pound proclaimed. One way of doing so was to deface or derange or disfigure the old aesthetic product. Words were set free of syntax, grammar, and meter. Notes were set free of octaves and traditional harmonies going back to Pythagoras. Color and line were set free of perspective and realistic representation. Dramatic works became musical (Strindberg's *Ghost Sonata*). Music became visual (Matisse's *Jazz*). Writings became sculptural (Mallarmé's *Un Coup de dés*, Blaise Cendrars's monumental "accordian book," E. E. Cummings's little poem that phonetically resembles the leap of the grasshopper that it describes). Gertrude Stein tried to "paint" Picasso and Matisse using words in the same manner that the artists had used line and color. On the one hand, Claude Debussy's grand opera, *Pelléas and Mélisande*, aspired to the condition of conversational fluidity without bursting operatically into song—there is too much singing in opera, Debussy said. On the other hand, George Antheil's *Ballet Méchanique* aspired to the condition of machinery—indeed, it was scored for player pianos. The most hybrid of all media, jazz, may itself be considered the center of modernist technologies; it gave its name to the central decades of the modern period—the "jazz age." Because of the enormous influx and absorption of energy between the arts, many artists tried to work in two or more media. It was a culture of media transgressions.

TYPOGRAPHY

18) Stéphane Mallarmé (1842-1898), *Un Coup de dés jamais n'abolira le hasard*. Poème. Paris, 1914. First published in the journal *Cosmopolis* in 1897, the poem was not published on its own and in the format intended by the poet until the posthumous edition shown here. The poet Paul Valéry (1871-1945) said when he first saw the poem's layout, "It seemed to me that I was looking at the form and pattern of a thought, placed for the first time in finite space. Here space itself truly spoke, dreamed, and gave birth to temporal forms.... *[Mallarmé] has undertaken,* I thought, *finally to raise a printed page to the power of the midnight sky.*"

19) Paul Gauguin (1848-1903), portrait of Stéphane Mallarmé [18]91, signed "P Go" and dated "91" in the plate. This is the only etching known to have been made by Gauguin. Private collection.

20) Under the influence of Gauguin's exoticism and the colorful, decorative Japanese prints that were the rage in Paris at the turn of the century, Henri Matisse (1869-1954) helped inaugurate the first art revolution of the twentieth century: Fauvism or "wild beast-ism," referring to the intense color of the new painting. Although this linocut, the only use Matisse ever made of this technique, dates from the late 1930s, it alludes to the Fauvism of his youth with its simple and sinuous lines and its decorative touch, the leaf hinting at a tropical setting. Color is absent but strongly implied.

COMME SI

Une insinuation
au silence

dans quelque proche

voltige

simple
enroulée avec ironie
ou
le mystère
précipité
hurlé

tourbillon d'hilarité et d'horreur

autour du gouffre
sans le joncher
ni fuir
et en berce le vierge indice

COMME SI

18)

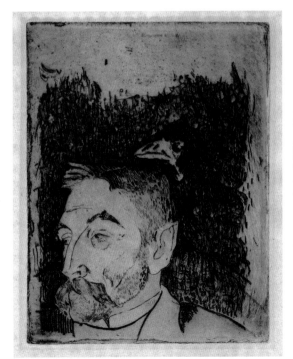

19)

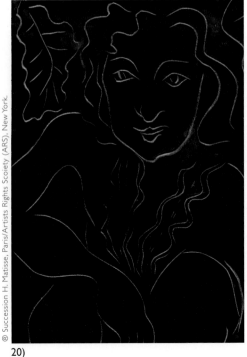

20)

domestic articles to have about the house-- like patent f

Fire extinguishers. They are no use: but you can go and

look at them and twiddle the taps from time to time. And

with two creatures like myself and your Office ... Well,

possibly , a Fire Extinguisher...

 To recapitulate: If , in the nature of things, 700

lines is too long for your July number, get the gentleman

who sends out slips to send me another slip with the

code-word "Bumph!" on it and I will take it to mean that

you want somethingless than 150 lines and you shall have

that by the 18/6/20 . See? I have got something in my

head, but I like a month or so to fiddle away at things

and make them look really careless . Nevertheless, by the

18/6/20, it will have reached the stage of looking really

Tolllol, with the five word sparklers of old Time not

taken out, and balanced, singularly blank verse. Tout

comme les poemes de M. notre confrere.... But that would

be invidious..

 Excuse these misplaced flippancies: I have just got

a new typewriter and it carries me away... but it does not

seem to possess any accents)) at least, I have not found

them yet"/@£_&'()⅛⅜:!%?. No, they aren't there.

 Yours

21)

fl

a

tt

ene

d d

reaml

essn

esse

s wa

it

sp

i

t)(t

he

s

e

f

ooli

sh sh

apes

ccocoucougcougcoughi

ng with me

n more o

n than in the

m

22)

TYPEWRITER

21) Last page of a typed letter from Ford Madox Ford to Harold Monro of The Poetry Bookshop, 9 June 1920, complaining of the difficulty of using a typewriter.

"[The typewriter fuses] composition and publication, causing an entirely new attitude to the written and printed word....Seated at the typewriter, the poet, much in the manner of the jazz musician, has the experience of performance as composition, ... [doing] Nijinsky leaps or Chaplin-like shuffles and wiggles....Composing on the typewriter is like flying a kite."
 —*Marshall McLuhan* (1964).

22) Typescript of a poem by E. E. Cummings (1894-1962) from *Fifty Poems* (1940) illustrating the distinctive typographic arrangement characteristic of Cummings' poetry.

IMAGE

23) Man Ray (1890-1975), H.D. (*Hilda Doolittle*), undated, silver gelatin print. H. D. (1886-1961) was championed early as an exemplar of Imagism, a self-consciously created movement in poetry that valued brevity, precise diction, concreteness, and organic rhythms. The movement flourished between 1912 and 1917.

24) First page of a typed letter (late 1920s) from Hilda Doolittle to Glenn Hughes referring to her literary apprenticeship with her childhood friend Ezra Pound, her first publication by him under the name "H.D. Imagiste," and her dislike of literary movements and the controversies caused by them.

72

23)

Tuesday. Riant Chateau
 Territet.

Dear Mr.Hughes,

 Yes ... I will do my best to stop off for a day or so, end May or early June. In the meantime, let me know of any other obscure points ... of course, I scribbled a bit, adolescent stuff. My first real serious (and I think, in a way, successful verses) were some translations I did of Heine (before I was seriously dubbed " Imagist. ") I think they were probably very lyrical in their small way, but of course, I destroyed everything. I did a little verse-translation of the lyric Latin poets at Bryn Mawr, vaguely but nothing came of them. I do not think I even submitted them to the college paper. I do recall however, how somewhat shocked I was at Bryn Mawn to be flunked quite frankly in English. I don't know how or why this shocked me. I really did love the things even when they were rather depleted of their beauty, Beowolf and such like. I suppose that was one of the spurs toward a determination to self-expression. I do know that in some way, I was rather stunned at the time. (I just jot down impression this way. Do not take them seriously but I am trying to answer your question ... in a rambling manner .)

later, just before coming " abroad ",
 I scribbled a half dozen rather free verses that might have been vers libre, but I had never heard of vers libre till I was " discouvered " later by Ezra Pound. Ezra Pound was very kind and use

24)

22

IN THE TUBE

The electric car jerks ;
I stumble on the slats of the floor,
Fall into a leather seat
And look up.

A row of advertisements,
A row of windows,
Set in brown woodwork pitted with brass nails,
A row of hard faces,
Immobile,
In the swaying train,
Rush across the flickering background of fluted dingy
 tunnel ;
A row of eyes,
Eyes of greed, of pitiful blankness, of plethoric
 complacency,
Immobile,
Gaze, stare at one point,
At my eyes.

Antagonism,
Disgust,
Immediate antipathy,
Cut my brain, as a sharp dry reed
Cuts a finger.

I surprise the same thought
In the brasslike eyes :

" What right have you to live ?"

23

CINEMA EXIT

After the click and whirr
Of the glimmering pictures,
The dry feeling in the eyes
As the sight follows the electric flickerings,
The banal sentimentality of the films,
The hushed concentration of the people,
The tinkling piano—
Suddenly
A vast avalanch of greenish yellow light
Pours over the threshold ;
White globes darting vertical rays
Spot the sombre buildings ;
The violent gloom of the night
Battles with the radiance ;
Swift figures, legs, skirts, white cheeks, hats
Flicker in oblique rays of dark and light.

Millions of human vermin
Swarm sweating
Along the night-arched cavernous roads.

(Happily rapid chemical processes
Will disintegrate them all.)

25)

26)

27)

28)

IMAGE

25) "In the Tube" and "Cinema Exit," two poems in Richard Aldington's book *Images*, both referring to modern technologies, film and the subway, in the spare haiku-like Imagist style.

26) Des Imagistes: An Anthology. The Glebe, edited by Alfred Kreymborg (1883-1966). Published by A. & C. Boni in New York and distributed in England by the Poetry Bookshop (London, 1914). An anthology of Imagist poems.

27) Anne Knish and Emanuel Morgan, *Spectra: New Poems* (New York, 1916). Knish and Morgan were actually two young American poets, A. D. Ficke (1883-1945) and Witter Bynner (1881-1968), who set out to satirize the high seriousness of Imagism and the pretentiousness of literary movements in general. To the authors' surprise the hoax was taken seriously, and the authors' own reputations never quite recovered.

28) Cover of *Images 1910-1915*, published by Poetry Bookshop in London. Aldington married H.D. in 1913.

73

IMAGE

29) Farmer Studio, Waco, Texas, *Robert Frost* (1874-1963), signed by Frost, undated, silver gelatin print. Frost lived in San Antonio during the winter of 1936-37 (and the portrait probably dates from this period). The Texas Hill Country reminded him of the landscape of New England but without the winters.

30) Autograph manuscript of Robert Frost's poem "Poets are Born Not Made," 1913. Frost included this poem in a letter to F. S. Flint, the Imagist, asking that he type it and show it to Ezra Pound. It is a free-verse parody of such Imagists as H. D. and Richard Aldington.

Robert Frost

29)

Poets are Born Not Made

My nose is out of joint
For my father-in-letters —
My father mind you —
Has been brought to bed of another poet,
And I not nine months old.
It is twins this time
And they came into the world prodigiously
 united in wedlock
(Dont try to visualise this.)
Already they have written their first poem in
 vers libre
And sold it within twenty-four hours.
My father-in-letters was the affluent American
 buyer —
There was no one to bid against him.
The merit of the poem is the new convention
That definitely locates an emotion in the belly,
Instead of scientifically in the viscera at large,
Or mid-Victorianly in the heart.
It voices a desire to grin
With the grin of a beast more scared than frightened
 For why?
Because it is a cinch that twins so well born
 will be able to sell almost anything they write.
 R. F.

30)

31)

CUBISM

31) Juan Gris (1887-1927), *Still Life*, silkscreen, no date. Inscribed "A Mlle Gertrude Stein / Bien amicallment." Private collection. "I work with the elements of the intellect, with the imagination. I try to make concrete that which is abstract. I proceed from the general to the particular, by which I mean that I start with an abstraction in order to arrive at a true fact. Mine is an art of synthesis, of deduction…" (Gris, 1921). Gertrude Stein was collecting Gris well before his style came to be known as Synthetic Cubism.

75

33)

32) Jean Cocteau (1889-1963), "Mais oui, mais oui...Picasso." Ink on paper, [c. 1916]. Drawing of Cocteau in uniform with a rendition of Picasso's signature below it. The sketch most likely makes reference to the "Ingres-like" portrait of Cocteau, in uniform, that Picasso did in 1916, later published as a frontispiece to the poet's book *Le Coq et l'arlequin* in 1918. A Cubist rendering in the upper right corner is reminiscent of the drawings Cocteau did for *Le Potomak* (1914) and *Le Mot*, the periodical he founded with Paul Iribe in 1915. A smaller sketch in the lower left could be interpreted as Cocteau's uniform cap.

33) Georges Braque (1882-1963), *Still Life*, c. mid-1920s. Private collection. @Artists Rights Society (ARS), New York/ADAGP, Paris. "I couldn't portray a woman in all her natural loveliness. I haven't the skill. No one has. I must, therefore, create a new sort of beauty, the beauty that appears to me in terms of volume of line, of mass, of weight, and through that beauty interpret my subjective impression. Nature is a mere pretext for a decorative composition, plus sentiment" (Braque as quoted by Gelett Burgess in 1910). Whereas Picasso claimed tribal art as an influence on his kind of Cubism, Braque looked back to the techniques of Cézanne.

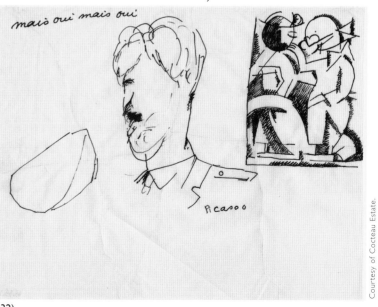

mais oui mais oui

Picasso

Courtesy of Cocteau Estate.

32)

MAKE IT NEW: THE RISE OF MODERNISM

34) Wassily Kandinsky (1866-1944), *Komposition Nr. 4*, c. 1914, published in *Der Blau Reiter* (Munich, 1914). One of the leading proponents of abstraction in modern art, Kandinsky created "a kind of painting that completely eliminates the reproduction of any object or any connection with the world of things" (Albert Schug).

35)

ABSTRACTION

35) Pablo Picasso (1881-1973), "Tableau Abstrait" (Abstract Painting), pencil drawing on a post-card sent to H. Roché from Hôtel des Terrasses in Dinard, 18 July 1922. The only image in the elaborate, window-like frame is a dot. "I deal with painting as I deal with things, I paint a window just as I look out of a window. An open window looks wrong in a picture, I draw the curtain and shut it, just as I would in my own room. In painting, as if life, you must act directly" (Picasso, 1935).

36) Jacques Villon (1875-1963), untitled work, lithograph, c. 1922. Private collection. Villon was one of Marcel Duchamp's two brothers. Assigned to the camouflage service in World War I, Villon tried a new kind of abstract art after the war (1919-22), using overlapping planes to express a thing's essence rather than its figural reality.

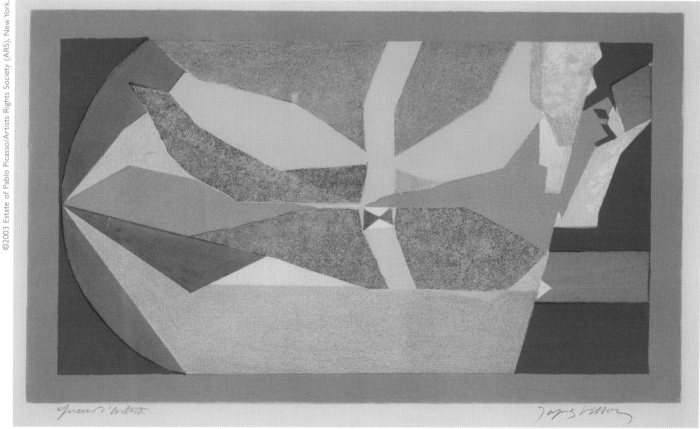

36)

PHOTOGRAPH VS. PAINTING

37) Paul Strand (1890-1976), *Photograph*, photogravure, 1917. This image appeared in the final issue of *Camera Work*, devoted entirely to Strand's work, in which he wrote, "Objectivity is of the very essence of photography, its contribution and at the very same time its limitation: honesty no less than intensity of vision is the prerequisite of a living expression. The fullest realization of this is accomplished without tricks or processes of manipulation, through the use of straight photographic methods."

38) Marsden Hartley (1877-1943), *White Cyclamen*, oil on canvas, no date. "All the 'isms,' from Impressionism down to the present moment, have had their inestimable value and have clarified the mind and the scene of all superfluous emotionalism.... I can hardly bear the sound of the words 'expressionism,' 'emotionalism,' 'personality,' and such, because they imply the wish to express personal life, and I prefer to have no personal life. Personal art is for me a matter of spiritual indelicacy" (Hartley, 1928).

78

37)

38)

39)

40)

PHOTOGRAPH VS. PAINTING

39) Still from *The Cabinet of Dr. Caligari*, 1919, a watershed film employing set design and unusual camera angles to create the effect of Expressionist paintings.

40) Alvin Langdon Coburn (1882-1966), *Vortograph*, silver gelatin print, 1917 (but printed later). An early practitioner of Pictorialism, the premodern attempt to make photographs look like paintings, Coburn was also a pioneer in new methods for his medium. In an attempt to photograph in a Cubist manner, he fitted his camera lens with a kaleidoscopic array of mirrors. Pound dubbed these fragmented images vortographs, after the Vorticist movement in literature.

79

MAKE IT NEW: THE RISE OF MODERNISM

PHOTOGRAPH VS. PAINTING

41) Albert Renger-Patzsch (1897-1966), *Sempervivium*, 1922, silver gelatin print. As part of the New Objectivity, an art movement in Germany in the 1920s, Renger-Patzsch's photographs often featured extreme close-ups. As he explained, "Let us leave art to the artist, and let us try—with photographic means—to create photographs which can stand alone because of their very photographic character—without borrowing from art."

80

The rose is obsolete
but each petal ends in
an edge, the double facet
cementing the grooved
columns of air…

so that to engage roses
becomes a geometry—

…

It is at the edge of the
petal that love waits

…

From the petal's edge a line starts
that being of steel
infinitely fine, infinitely
rigid penetrates
the Milky Way.…

—William Carlos Williams,
"The Rose" (1923)

41)

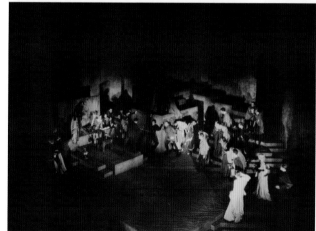

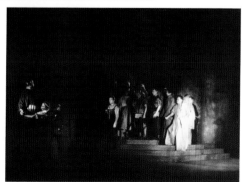

42)

MOVEMENT

42) Norman Bel Geddes (1893-1958), photomontage of rehearsals, light and set designs for *Hamlet*, Broadhurst Theatre, New York, November 5, 1931. Bel Geddes believed that movement was the essential attribute of drama. His "New Stagecraft" was a coordinated enterprise: the lighting used multi-colored directional flood lamps; the sound was stereophonic; the stage was flexible with minimal scenery; the players spoke and acted "naturally"; and the tempo was fast, faster than the movies.

MOVEMENT

43) Valentine Hugo (1887-1968), portrait of Isadora Duncan (1877-1927), pastel on colored paper, no date. Duncan changed the shape of modern dance with her belief that all movement originated from the solar plexus and that dances should yield to the force of gravity.

44) Nicholas Roerich (1874-1947), hat and robe from the original production of Igor Stravinsky's *Le Sacre du printemps*, May 29, 1913. Everything about the ballet was shocking: the costumes, the story of pagan sacrifice, the music, but especially the physically unnatural, anti-classical dancing. Said one performer, of Nijinsky's choreography: "With every leap we landed heavily enough to jar every organ in us."

44)

43)

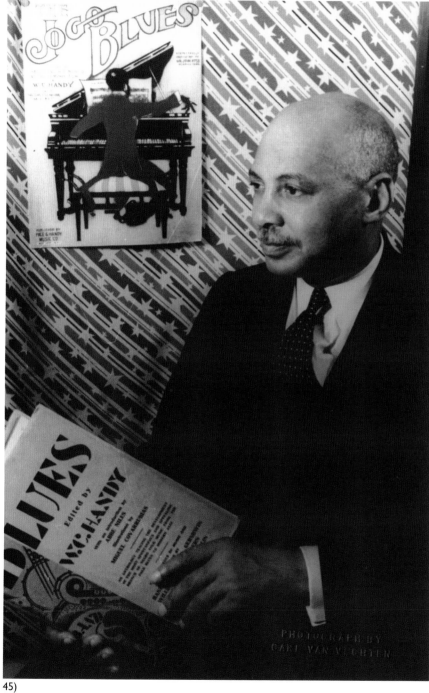

45)

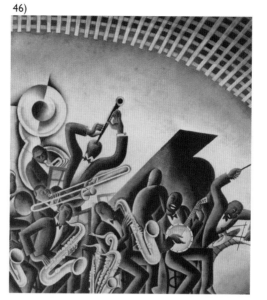

46)

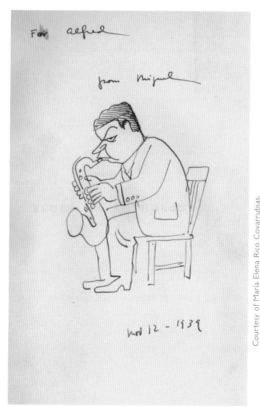

47)

JAZZ AND BLUES

45) Carl Van Vechten (1880-1964), photograph of W. C. Handy (1873-1958), the "Father of the Blues," holding a copy of his *Blues: An Anthology*, 24 May 1932.

46) Miguel Covarrubias, frontispiece for Handy's *Blues: An Anthology* (New York: A. & C. Boni, 1926). The Mexican-born Covarrubias (1904-1957) was the most famous caricaturist of the period, a studio-mate of Al Hirschfeld who would later assume his mantle. He was especially renowned for his depiction of African American culture, particularly of Harlem in the 1920s and 30s.

47) Original drawing of a saxophone player, by Covarrubias, on the flyleaf of Handy's *Blues: An Anthology*, inscribed by the artist to Alfred [Knopf], Nov. 12, 1939.

83

MAKE IT NEW: THE RISE OF MODERNISM

JAZZ AND BLUES

48) Flyer from The Vogue, Grand Avenue at Ninth Street, Los Angeles, announcing the appearance of Louis Armstrong and his orchestra, November, 1937.

50) Letter from Ross Russell, dated 11-15-37, describing the Armstrong opening at The Vogue. "[T]he unforgettable Satchemo...started in at 8:00 o'clock with a fine Sleepy Time Down South with a trumpet finale that goes inside you and from then on the man did not stop once all evening. He jived, blew, vocalized, yelled, wept, exhorted straight through until two a.m., we having stayed until the last with Mother refusing to go.... Even for the elaborate floor show with its large creole dancing chorus Louis, instead of taking a rest, was blowing his brains out...." Russell (1909-2000) was to become the legendary owner of the Tempo Music Shop on Hollywood Boulevard, the founder of the Dial recording label, and the author of *Bird Lives!*, the first biography of Charlie Parker.

84

48)

49) Snapshot of Louis Armstrong and the Luis Russell Orchestra, U.S. Highway 99 above San Luis Obispo, December 1937, after leaving LA, on their way to San José. Standing left to right: Wilbur de Paris (1st trombone), Ross Russell, Armstrong, Stuart Seymour (asst. manager), Henry Allen Jr. (3rd trumpet & vocals), Robert Smiley (Armstrong's valet), Luis Russell (piano & leader). Squatting: Charlie Holmes (tenor & alto sax), Scad Hemphill (2nd trumpet).

50)

LETTER TO TONI WATER, 11-15-37, followingopening of Louis Armstrong at THE VOGUE, 9th and Grand, Los Angeles, backed by Luis Russell's orchestra (Higginbotham,Barbarin,Allen,&c)

Dear Toni:-

As I postcarded I went to Armstrong's opening Saturday night, my date being mother. The opening was a last minute affair, the Sebastian Cafe International having been cancelled apparently, in favor of the Vogue, a revamped danceland that has been a fixture in downtown Los Angeles for some time. About the size of Wolohans in San Francisco, or possibly Sweets.

It is quite impossible to describe the effect the whole affair. Whereas the Mosby-L.L. Burke band was hot and Fats Waller is no doubt stupendous, such words fail completely. The only manner of describing the show is that it is a fine excess of everything --- very much like a large circus where more can be seen from any one point than can be readily observed.

Louis of course is tremendous. He would be worth a trip south in his own right. But the band itself is an incredibly fine organization. Instead of having just two or three good men it is actually the old Lou Russell band which has been together for SEVEN years. The combination made countless fine records under Russell's name, under King Oliver, McKinney's Cotton Pickers, the Burning Eight, J.C. Higginboth's Six Hicks, Red Allen and his orchestra, and the Hawkins-Allen orchestra.

I was completely bowled over to discover swingmen like Paul Barbarin on drums, Bass Foster on bass, Willie Johnson on git box, George Washington on second trombone, Bingie Madison on alto, and Charley Holmes on tenor, J.C. Higginbotham is without question one of the two greatest living trombonists, with only Tegarden to dispute his complete supremacy. Red Allen would be sufficient front and solo for the orchestra himself, all without Louis. There is Lou Russell's fine, intelligent piano which he plays as a percussion instrument. Finally I would rate the rhythm section one of the four or five best in all-time swing history.

In addition to all this there is the unforgettable Satchemo. He started in at 8:00 o'clock with a fine Sleepy Time Down South with a trumpet finale that got inside you the man did not stop once all evening. He jived, blew, vocalized, yelled, wept, exhorted straight through until two a.m., we having stayed until the last with Mother refusing to go. Poeple were packed six deep around the band stand yelling on the hot ones, close to tears on the blues numbers. Even for the elaborate floor show with its large creole dancing chorus Louis, instead of taking a rest, was blowing his brains out with colossal solos.

I called Marvin long distance and he was perfectly sick, Hig, Red, and Louis all got off during the intermittent

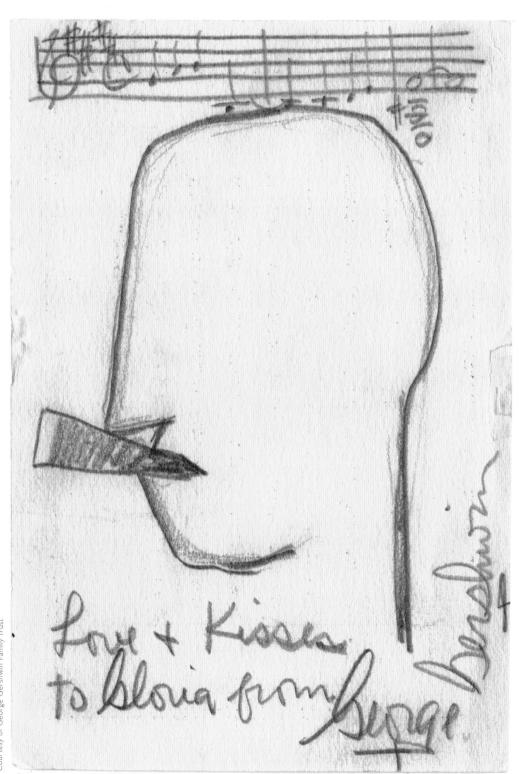

51)

JAZZ AND BLUES

52)

85

51) Restaurant card with self-portrait caricature of George Gershwin, inscribed to Gloria [Swanson] with the opening bars of Gershwin's *Rhapsody in Blue*, February 1924, a light-hearted example of modernist collage.

52) Signed autograph letter from F. Scott Fitzgerald to Blanche Knopf, 1928, in which he conjugates the word "cocktail." Through works such as *The Great Gatsby* and *Tales of the Jazz Age* as well as through his marriage to Zelda, Fitzgerald would become synonymous with the alcohol prohibited in the U.S.

MAKE IT NEW: THE RISE OF MODERNISM

THE CAPTAIN'S TOWER

53) T.S. Eliot, *The Waste Land*, inscribed by Eliot to Ezra Pound, January 1923. Eliot calls Pound *migglior fabbro*, the "better maker," the term applied to Arnaut Daniel in Dante's *Divine Comedy*, who, writing in Provençal, was the father of literature in the vernacular languages. Vernacular artist Bob Dylan talks of Eliot and Pound "fighting in the captain's tower," presumably because Pound edited Eliot's poem extensively (see fig. 56).

54) Ezra Pound (1885-1977), *A Draft of XVI. Cantos* (Paris: Three Mountains Press, 1925). One of the beautiful editions that often introduced difficult modern works. This 65-page edition of 90 copies, various versions using different papers, started at 400 francs.

55) Emil Otto Hoppé (1878-1972), photograph of Ezra Pound, c. 1918. An elegant photo of Pound, seated, facing left, with his legs crossed. This image, used as the frontispiece of Pound's *Pavannes and Divisions* (1918), is seldom reproduced.

56) T. S. Eliot (1888-1965), fair copy manuscript of *The Waste Land*, 1922, often called, along with Joyce's *Ulysses* and Picasso's *Guernica*, a germinal work of the century.

53)

54)

55)

56)

X-rays were discovered by Wilhelm Röntgen in 1895, allowing researchers literally to look inside our physical being. Five years later, in *The Interpretation of Dreams*, Sigmund Freud, claiming that dreams were not accidental or incidental to our existence, looked inside the psychological being:

> *Dreams are not to be likened to the unregulated sounds that rise from a musical instrument struck by the blow of some external force instead of by a player's hand…they are not meaningless, they are not absurd; they do not imply that one portion of our store of ideas is asleep while another portion is beginning to wake. On the contrary, they are psychical phenomena of complete validity— fulfillments of wishes.*

Freud would refine the metaphor later on, saying that dreams were not fragments but the whole manuscript of a text that arrives to our analysis in mutilated form. X-rays show bones and organs, but dreams indicate the material presence of another invisible part of physical bodies—the libido. It was these invisible worlds—of desire, of corporeal mystery—which stream-of-consciousness writing was intended to illumine, even as airy, almost skeletal structures of steel like the new Eiffel Tower were used to send and receive wireless telegraphy, messages passing invisibly in the air.

"It is a new century," wrote Henry Adams about the World Exposition in Paris in 1900, "and what we used to call electricity is its God." If electricity was God, then surely photography was a deity also. In 1920, for the first time, Max Wolf was able to use photography of asteroids to demonstrate accurately the structure of the Milky Way. In 1925 Leica's introduction of a fast-action camera allowed one to see motion that was invisible to the eye, even the photographer's. In scientific terms, there was a search for a fourth dimension to physical materiality, even as various kinds of spiritualism pursued realms outside dimensionality altogether. Still others sought not a super- or supra-reality but a reality on top of, or at least topping, the reality in which we think we live, a surreal world where the unconscious could be accessed in waking life as it was accessed in sleeping life by means of dreams. "The greatest poverty is not to live in a physical world," wrote the poet Wallace Stevens, adding: "It is not in the premise that reality/Is a solid. It may be a shade that traverses/A dust, a force that traverses a shade." The physical worlds of inner and outer space, the conjunctions of space and matter, space and time, proved far more complex than anyone had ever imagined.

RADIOACTIVITY

57) *Le Radium*, January 1904 issue, illustrating the spinthariscope, a device with which one could actually watch radioactive decay happening—therefore, a way of rendering the invisible visible.

58) *My Radium Girl*, sheet music from Ziegfeld's Follies of 1915. Music by Louis A. Hirsch, lyrics by Gene Buck.

Every girl is more or less a mystery,
Every night there's one I look for
 wistfully,
'Cause her vi'let ray
Stole my heart away…,
My Radium Girl.

58)

57)

60)

ELECTRICITY

59) Man Ray (1890-1976), "Le Monde," one of ten rayograms from a portfolio entitled *Electricité* commissioned by *La Compagnie parisienne de distribution d'électricité*, photogravure, 1931. The portfolio was given by the Paris electric company to its best customers. Man Ray juxtaposed abstractions with recognizable objects so as to "evoke, not imitate, these forces, these movements, these secrets of the electric world" (Pierre Bost).

60) Cover, Georges Dary's *Tout par l'electricité* (Tours, 1883), a book discussing the myriad new uses for electricity, industrial and domestic. Note Benjamin Franklin's kite.

89

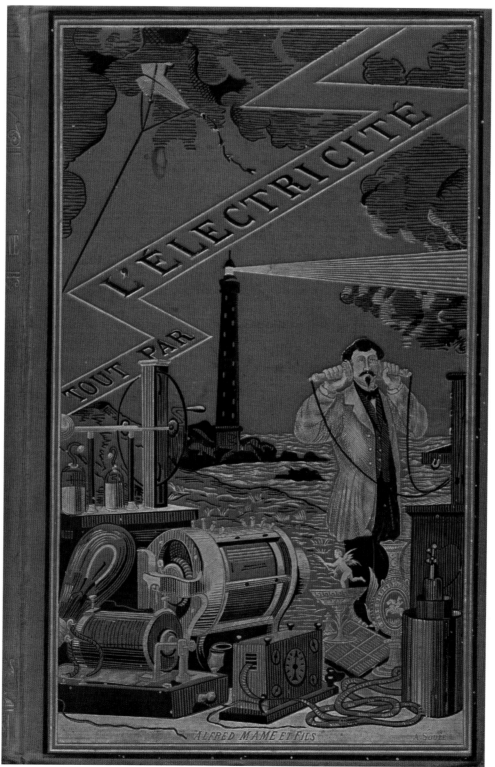

59)

ELECTRICITY

61a and b) Guillaume Apollinaire (1880-1918), "Lettre-Océan" from proof copy of *Calligrammes. Lithos de Chirico* (Paris, 1930). The lines of the poem represent waves radiating outward, illustrating the impact of wireless technology. The Eiffel Tower was used to transmit radiowaves, and this poem may be, in effect, a bird's-eye view of the tower.

90

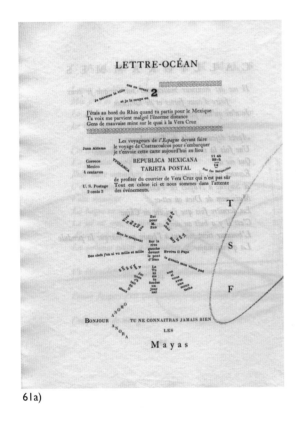

61a)

61b)

62)

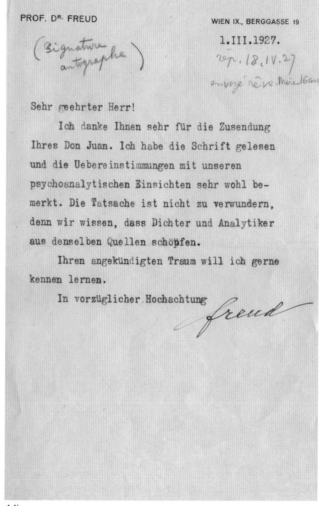

64)

63)

SPIRIT AND MIND

62) Annie Besant and C. W. Leadbeater, *Thought-Forms* (New York, 1905). This volume and the photograph below *(63)* are from the library of Sir Arthur Conan Doyle who began collecting instances of spiritualism after the death of his son in World War I.

63) Unidentified photographer, *Image of a séance*, undated, silver gelatin print. Text on the reverse of the image reads: "The teleplasmic mass is now on the table, but obviously arises from the right ear. We are allowed to examine it and find it to be about 40 degrees Fahrenheit, resilient and clammy. The Psychic is examined by Doctors before and after the sitting, and is nude save for the one garment."

64) Letter from Sigmund Freud (1856-1939) to Henri Pierre Roché (1879-1959), 1 March 1927: "Thank you for sending me your Don Juan. I have read the book and noticed the correspondences with our psychoanalytical insights. That is not unusual since the poet and the analyst draw from same sources." Roché indicates in pencil in the upper right corner of the letter that he replied to Freud on 18 April and sent with his letter an account of a dream he had about his mother when he was 16 years old.

SPIRIT AND MIND

65) Marcel Proust (1871-1922), *A l'ombre des jeunes filles en fleurs* [section of *Remembrance of Things Past*], 1914. Composite manuscripts and corrected proofs with autograph emendations. Proust's manuscripts of his masterpiece reveal "the conscious attempt to elucidate an unconscious design" (John Gross).

66) Autograph manuscript of Dorothy Richardson's novel *Dimple Hill*, 1 November 1935. The book was not published, however, until late 1938 in the 4-volume "omnibus" edition of *Pilgrimage*. Richardson is regarded as a precursor of the "stream-of-consciousness" style, a term she despised.

67) Adrian Allinson (1890-1959), *The Odles at Tea*, oil on canvas, c. 1940. Private collection. Mrs. Odle is Dorothy Richardson (1873-1957). Allinson was one of an influential group of artists associated with the Slade School of Art in London, including Stanley Spencer, Mark Gertler, and C. R. W. Nevinson.

92

Courtesy of the Proust Estate.

67)

65)

66)

68)

SPIRIT AND MIND

68) *Le Cadavre exquis [The Exquisite Corpse]*, autograph manuscript, no date. A Surrealist word game in which one person would write a phrase, fold the paper so that a part of the phrase was concealed, and pass it to the next player who would write down a second phrase, and so on.

The manuscript gives evidence of the participation of Paul Eluard and the three men standing in the photograph below—Aragon, Tual, and Morise.

69) Man Ray, *The Surrealists*, 1925. Standing left to right: André Breton, Louis Aragon, Max Morise, Roland Tual. Seated left to right: Simone Kahn [Mme. Breton], Man Ray, Colette Jéramec [Mme. Tual]. Breton was the self-appointed leader of the Surrealists, a movement in both poetry and painting to bring the unconscious or the anti-rational mind into play in the act of composition. Apollinaire coined the term in 1917: "When man wanted to imitate walking, he invented the wheel, which doesn't resemble a leg. He thus produced surrealism without knowing it."

69)

93

SPIRIT AND MIND

70) Max Ernst (1891-1976), *Rébus*, pencil on paper, no date. Inscribed to Mlle Jeannine [sic] Kahn, the sister of Simone Kahn who is pictured in Fig. 69 above. Janine (as her name is usually spelled) later married the Surrealist Raymond Queneau. The inscription is puzzling, as befits a piece called "Puzzle" or "Conundrum." "Sabre," a kind of sword, is also slang for penis, and "de na poloon" could be construed as "belonging to Napoleon."

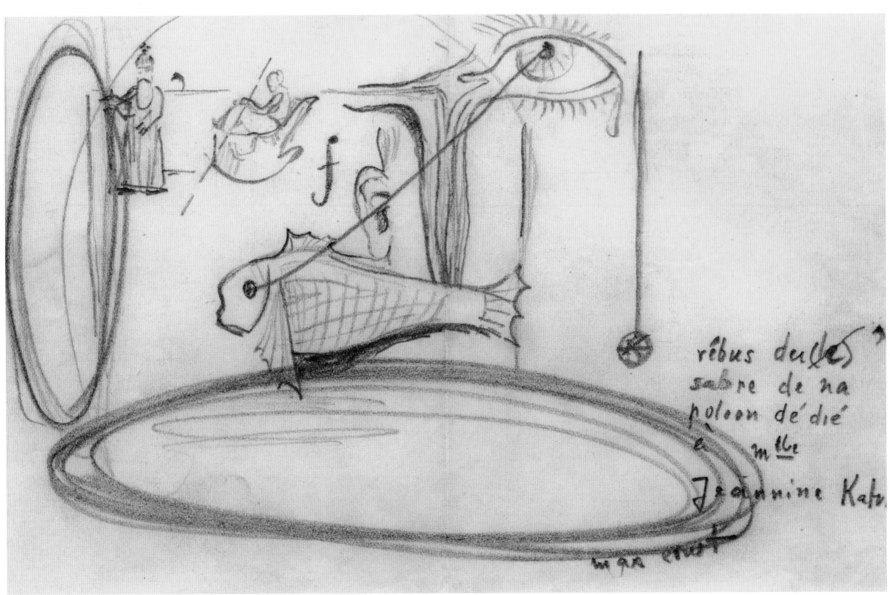

70)

4

THE CITY

If one of the recurring themes of Modernism is monumentality, then the most obvious symbol of this is the city, such as the fictitious one created by Fritz Lang in his 1926 movie *Metropolis*. The city itself is filled with monuments such as those the Ohio-born poet Hart Crane called, in the title of his first book, "White Buildings"—that is, the skyscrapers. "I have looked down across the city from high windows," Ezra Pound wrote of New York in 1912: "It is then that the great buildings lose reality and take on their magical powers. They are immaterial; that is to say one sees but the lighted windows. Squares after squares of flame, set and cut into the ether. Here is our poetry, for we have pulled down the stars to our will."

In *The American Scene*, the book Henry James wrote about returning to America in 1904 after years of exile, James denigrated the monumentality of the New York skyline. From the water, he declared, the tall buildings seemed "like extravagant pins in a cushion already overplanted, and stuck in as in the dark, anywhere and anyhow." Even thus trivialized, however, the skyscrapers "tak[e] the sun and the shade in the manner of towers of marble." But, James quickly added, "they are not all of marble, I believe, by any means, even if some may be, but they are impudently new and still more impudently 'novel'—this in common with so many other terrible things in America."

New York was not the only terrible and sublime metropolis. T.S. Eliot's poem *The Waste Land* (1922) was centered in London, but it just as easily could have been Paris or Vienna or Chicago—or any "unreal city," to use Baudelaire's earlier term: "Unreal City,/ Under the brown fog of a winter dawn,/ A crowd flowed over London Bridge, so many,/ I had not thought death had undone so many./Sighs, short and infrequent, were exhaled,/And each man fixed his eyes before his feet." In language derived from both nursery rhyme and Dante's depiction of hell, Eliot unmasks a landscape of spiritual aridity and inarticulate isolation.

It is not an accident that another of the most famous poems of the modern era, Ezra Pound's "In a Station of the Metro," takes the reader into the underworld by means of that new urban technology, opened for the first time in Paris in 1900: the subway. It is a place of "apparitions," to use Pound's word, where only classical heroes heretofore had gone—Orpheus, Ulysses, Aeneas, Tiresias, Christ. Now "the descent beckons" (in W.C. Williams's phrase) to any and every city dweller. Neither is it an accident that the arguably most famous novel of the modern era, James Joyce's *Ulysses*, takes place in a single city, Dublin, one of the oldest and oddest cities in Europe, or that its central character is a Jew, for Jews have an ancient history of maintaining a sense of community within the dehumanizing forces of city life. It was Yiddish and Spanish that Henry James heard in the cafés of New York's East Side, an "Accent of the Future" that "may be destined to become the most beautiful on the globe and the very music of humanity (here the 'ethnic' synthesis shrouds itself thicker than ever); but whatever we shall know it for, certainly, we shall not know it for English—in any sense for which there is an existing literary measure."

Whether it was a city of celebration or a city of condemnation varied with the observer, who often changed his or her mind even while moving at the new modern pace from site to site.Gertrude Stein: "Paris was where the twentieth century was."; Ezra Pound: "There was more going on in London and what went on went on sooner than in New York."; Mabel Dodge: "Life in New York is one long-protracted thrill. You must spend next winter here and be in fashion."

These unreal cities, with their peculiar mixture of languages, architecture, machines, and customs, were the very cornucopia of modernity. You just had to be there.

THE CITY

71) Blaise Cendrars (1887-1961) and Sonia Delaunay (1885-1979), *La Prose du transsibérien et de la Petite Jehanne de France*, pochoir on paper with multiple typefaces, Paris: Editions des Hommes Nouveaux, 1913. The text describes a trip on the Transsiberian Express across Russia, from Moscow to Manchuria, during the 1905 Revolution and Sino-Russian War, far from Paris's Montmartre in the poem's refrain. But in some sense Paris is never far away. The image of the Eiffel Tower starts at the bottom left and continues to rise to the top in unfolding levels of abstraction. Known as an "accordion book," the work fits into an envelope. Unfolded, it is about six and a half feet tall. Ron Padgett calls it the first book illustrated with abstract art and the first book to function as an art object.

72) Detail of *La Prose du transsibérien et de la Petite Jehanne de France*.

73) Unidentified photographer, *Eiffel Tower*, c. 1900, albumen stereograph. Stereoviews were an important form of popular entertainment and were useful for disseminating images on a mass level to the public. This particular view of the Eiffel Tower, which opened at the Paris World Exposition in 1889, is compelling for its "modern" cropping and viewpoint, putting the viewer at the base of the 984-foot tower gazing upward.

96

71)

73)

72)

THE CITY

74) Typed letter signed, from Hart Crane to his mother, 23 March 1926, in which he writes, "I am back on The Bridge scaffolding again. Temporarily I am Christopher Columbus in mid-channel. The poem as a whole, looks more exciting than ever to me."

75) E. O. Hoppé (1878-1972), *Brooklyn Bridge*, New York, 1917, silver gelatin print. What made the construction of the Bridge revolutionary were the suspension cables which, in this view, seem a harp-like instrument through which emerges that other symbol of modernity, the skyline of the City itself. Hoppé has written on the reverse: "It is little 'weak' and its quality is not up to what I think it would be—however I do think it should be reproduced as it did start a 'fashion.'"

76) Title page from the first limited edition of Crane's *The Bridge* (Paris: Black Sun Press, 1930).

77) Walker Evans (1903-1975), *Hart Crane*, 1929, silver gelatin print. It is a jaunty, urbane image of a young writer, sitting astride a chair smoking a cigar. Evans helped Crane in the late 1920s find work at a brokerage house where Evans was a stock clerk. The first edition of *The Bridge* (see above) was illustrated with Evans's photographs, his first published images.

97

March 23rd, 1926
Patterson, New York

Dear Grace:

Bein' that I'm gonna' kinda gotta sorta write to you I might as well state that everythin' is well here among the hay-stacks, that I had a hectic day and night in New York on my way - and was damned glad to get back.

I tried to get you a couple nice Jap prints in that store I rave about in Brooklyn, but nothing could be had short of ten bucks and I didn't have any extra cash on hand at the time. However, you can plan on two daisies sometime when "we", Otto and I, can afford it. Of course I caught a cold and sore throat in your city with its steam-pipes and such appurtenances of civilization. I hope it leaves me soon. Yesterday was very summery, indeed,- but today it looks bleak again and shakes a wicked wind.

I'm back on The Bridge scaffolding again. Temporarily am Cristopher Columbus in mid-channel. The poem, as a whole, looks more exciting than ever to me. I wrote Otto a long letter as soon as I got back - describing details of my plan, etc. and expect an answer any day now.

I'll write Grandma again soon. Give her my love. Charles, too. I'm ordering Laukhuff to send you out a copy of Frank's "Virgin Spain" - charged to me, of course, and I hope you'll give it a careful reading.

Yours devotedly,
Hart

74)

STREET SCENES

78) E. E. Cummings (1894-1962),
Porte St. Denis, watercolor on paper,
no date.

79) Alfred Stieglitz (1864-1946),
Old and New York, photogravure,
in *Camera Work,* no. 35,
October, 1911.

78)

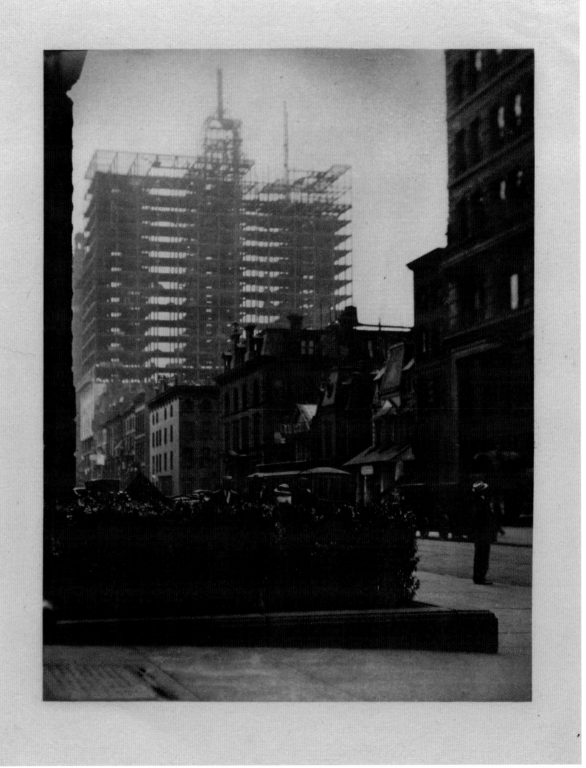

79)

STREET SCENES

80) Paul Martin (1864-1944), *A Weatherproof Lion, Trafalgar Square,* 1895, carbon print. Martin was a pioneer in the field of night photography. This particular image caused a brief uproar in the press because the London bobby (who is barely visible) would have had to remain stationary in the drizzly London twilight for thirty minutes, the time Martin needed to expose his plate.

STREET SCENES

81) *Map of Dublin.* One of the oldest cities in Europe, Dublin was also one of the most modern, having opened an electric train line in 1905, just a few years after the installation of the Métro subway system in Paris. Although James Joyce derided the provincialism of the Irish city, he makes Dublin the center of his modern reworking of epic and myth, *Ulysses* (1922), depicting it in that novel with cartographic precision.

82)

83)

STREET SCENES

82) Christina Broom (1863-1939), *Suffragettes' March*, 1907, silver gelatin print. A city happening that occurred with greater frequency as the century went on. From left to right: Mrs. Pethwick Laurence, Miss Christabel Pankhurst, Miss Sylvia Pankhurst, Dr. Garrett Anderson.

83) *That Ragtime Suffragette*, sheet music from Ziegfeld's Follies of 1913. Music by Nat. D. Ayer, lyrics by Harry Williams.

"That Ragtime Suffragette,
 She's no household pet!
 While her husband's waiting
 home to dine,
 She is ragging up and down
 the line,
 Shouting votes, votes, votes, votes
 for women...."

101

MAKE IT NEW: THE RISE OF MODERNISM

BLOOMSBURY

84a and b) Dora Carrington, pages from an illustrated letter to her brother Noel, with self-portraits, probably early 1917. Dora depicts herself "thinking of him" tearfully but also imagining that in "Reality" her soldier-brother may be having a grand time in France. Lytton Strachey, one of the eminent literary men of the time, was quite tall, but Carrington also often depicts herself in a diminuitive way. Many of the Bloomsbury circle were pacifists. When Strachey was asked during the First World War why he was not fighting for civilization, he replied, "I am, Madam, the civilization for which they are fighting."

85) Letter from Dora Carrington (1893-1932) to Mark Gertler, no date. Carrington entered the Slade School of Art in 1910 where she met Gertler and eventually the Bloomsbury group. In this illustrated letter, Carrington teases Gertler for his raucous behavior at a party. Carrington depicts Gertler dancing wildly, to the consternation of those in attendance. On another occasion Gertler quarreled violently with Strachey, the man with whom Carrington lived. Other figures in this drawing are not identified, but two of them closely resemble Virginia Woolf and Roger Fry.

86) Roger Fry (1866-1934), *Portrait of Lytton Strachey* (1880-1932), oil on canvas, no date. Fry was an intimate of the Bloomsbury group and the man who first brought modern art to England through his organizing of the Post-Impressionist show in 1910, the year, according to Virginia Woolf, when human character changed. Strachey revolutionized the genre of biography by trying to imagine it as a form of portrait painting.

84a)

85)

84b)

86)

WAR

World War I Posters

WAR

87) Siegfried Sassoon (1886-1967), signed autograph manuscript of "The General," written on Reform Club stationery, 1917. Sassoon has drawn an ink sketch of the General saluting his troops. The last lines read: "'He's a cheery old bloke'— grunted Johnny to Jack / As they slogged up to Arras with rifle & pack / But he murdered them both by his plan of attack." Sassoon was one of the few poets of the Great War to survive it.

88) Ezra Pound, corrected type-script of the second section of *Hugh Selwyn Mauberley* subtitled "Mauberley" (London: Ovid Press, 1920). The poet describes himself as adrift, overwhelmed by ANANGKE (Necessity) in the postwar world of sexual "bewilder-ment" and "final estrangement."

89) Unidentified photographer. Alice B. Toklas and Gertrude Stein with a group of French relief work-ers, 1917. Toklas is at the far left of the middle row, Stein at the far right. The two women distributed hospital supplies from their Ford van, "Auntie."

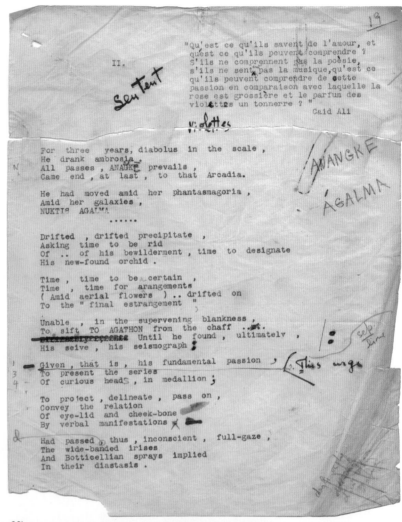

87)

88)

89)

90)

91)

92)

WAR

90) Wilfred Owen (1893-1918), postcard, [1918]. Owen arrived in the Ripon Army Camp, from which this card is sent, in March 1918 to begin his journey back to the Western Front after nearly a year recuperating from shellshock. In the coming months he would compose some of his most famous poems. The card, however, laments everything he is missing: "Books, Sonnets, Letters, friends, fries, oysters, antique shops."

91) *Wheels*, 1919, cover by William Roberts. This was the fourth volume of an annual verse anthology edited by Edith Sitwell (1887-1964) and is "dedicated to the memory of Wilfred Owen, M.C." Owen, who had seven poems in this volume, received the Military Cross for gallantry under fire.

92) Wilfred Owen, last page of his last letter, written from France to his mother, 15 October 1918. He was killed two weeks later, on 4 November, one week before the Armistice.

105

WAR

93) George Nathaniel Nash Scrapbook, photographs of Bolshevik marchers in St. Petersburg, 1917. Little is known of Lt. Nash except that he was an English army officer assigned to Russia just as the civil war was unfolding. His scrapbook covers the period 18 January 1917 to 10 December 1919. England was officially neutral, so Nash was able to tour both sides of the conflict—dining with the Czar, for example, as well as fraternizing with the Bolshevik troops in the field. One of the few "objective" records, in both words and pictures, of the war within the [Great] War—the Russian Revolution.

94) Anna Akhmatova (1889-1966), signed autograph manuscript, partly damaged, with drawings of flowers, 22-23 February 1911. Akhmatova was an early example of what came to be called the poetry of witness against the horrors of genocide and political persecution. This poem, though, is a landscape scene—a rust-colored pond, once wide but now shallow, a quivering aspen, a slip of a moon. There is even a flower, a withered morning-glory. "Here," the speaker says, "one could be silent for years," as she goes in the poem from seeing herself as "an idler" to making herself "ready / To join you once again, my earth."

106

93)

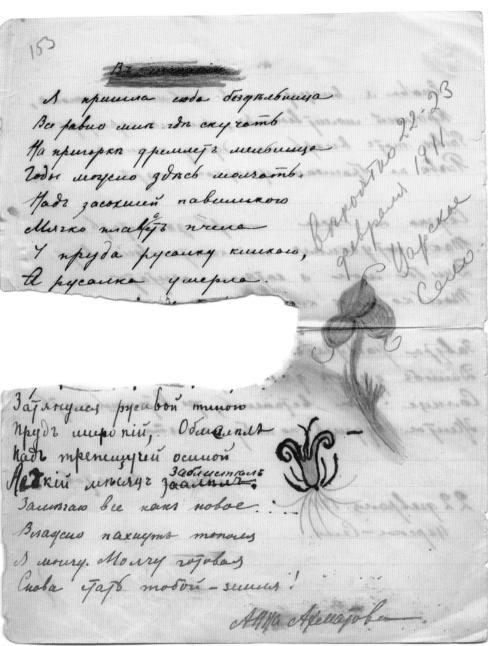

94)

5

MARKETING THE NEW

What is one to make of an era that would give its name—the twentieth century—to its fastest railroad train? This very train would, in turn, become the subject of a relatively new art form—the motion picture—this one featuring the blond bombshell Carole Lombard, who was herself a new phenomenon—a film star—the epitome of sexuality and good-natured fun and the first in a long train of such stars. The new twentieth century thus arrived, again and again, in forms which could be speedily marketed, imitated, and reproduced.

Some events were predictable causes for celebration, such as the Columbian Exposition of 1892 marking 400 years of Anglo presence in the Western Hemisphere. But others were manufactured. When you publish a "great" book, Valery Larbaud told James Joyce, you need to make a mighty noise—that is, you need to create a sensation, a spectacle. The publication of *Ulysses* in 1922 was so arranged to create a market for limited-edition books. Blaise Cendrars was not joking in his café poem "At the Five Corners," when he equated making a splash to being a smash. "Poetry," he concluded, "is at stake."

There was a veritable explosion of publishing opportunities in the first decades of the new century in such journals as *The Dial, Poetry, English Review, The Freewoman, The Egoist, The Little Review, The Criterion, The Fugitive, Others*—and then, later, *Commerce, Botteghe Oscure, Contempo*, and *transition*. These were both mainstream and avant-garde in their critical taste and in their marketing strategies. There was also a vigorous cottage industry for book publishing, including the Ovid and Hogarth Presses in London, Dun Emer and Cuala Press in Dublin, and Contact Publishing and Three Mountains Press in Paris. Sometimes the publications were financially backed as well as distributed and promoted by bookstores, such as Shakespeare and Co. in Paris, the Poetry Book Shop in London, or the Sunwise Turn in New York, which called itself "The Modern Bookshop." Many of the more avant-garde publications were not done cheaply but were sumptuous productions intended as much for connoisseurs and collectors as for general readers. To look at how modern art was published leads one to ask who paid for Modernism—who produced it, who consumed it, how was it distributed, and how did it find its various (and often contradictory) publics.

On many occasions, modernist artists had to create their own opportunities for dissemination of their work. These artists were often quite adept at identifying marketing occasions, such as the Post-Impressionist exhibition in London, first staged in 1910 and mounted again in 1912, the precursor to the famous Armory Show of contemporary art in New York in 1913. The movement called Futurism depended entirely on manufacturing "events," and Dadaism followed suit with "anti-events." The aim was not necessarily to make money but to gain celebrity (or notoriety), to draw attention to the artists and to the new ideas that they promulgated. The assassination of the Crown Prince of Austria in Sarajevo in 1914 was just such a kind of notorious, bizarre, Dadaist "happening," although one with more disastrous consequences than those with a strictly aesthetic purpose.

The openings of *Ubu Roi, Parade, Façade, Pelléas and Mélisande*, and *The Rite of Spring* may not have been intended as spectacles but they attained legendary notoriety, thanks to the displeasure of their audiences. Modernist art-events were often squibs and flashes, not the pyrotechnic "blasts" from the Vortex (Wyndham Lewis) or the emanations spun out of "widening gyres" (William Butler Yeats) or the "radiant gists" (William Carlos Williams) bursting from split atoms which their creators longed for. If intended for the marketplace, modernist art often had to find its true life in the marketplace of ideas alone. If intended to be explosive, what was most explosive was not art but the Great War and the Dadaist scourge of Spanish influenza that followed on its heels and killed far more people than the war itself. A decade later, every market would collapse.

ARMORY SHOW

Modern art came to the United States on March 13th, 1913 when 1100 art works were displayed at the armory of the 69th Cavalry Regiment in New York City. The lawyer and art collector John Quinn was a major contributor to this exhibition. His Brancusis were ridiculed by many critics as "too comical for commentary." Of the five sculptures exhibited, *The Sleeping Muse* was called most enigmatic.

95) Constantin Brancusi (1876-1957), photograph (by Brancusi) of his sculpture *The Sleeping Muse*, included, in marble, in the Armory Show. "Direct cutting [of stone] is the true way to sculpture…. Polishing is a necessity which demands the almost absolute forms of certain materials" (Brancusi, aphorisms, collected by Irene Codreame).

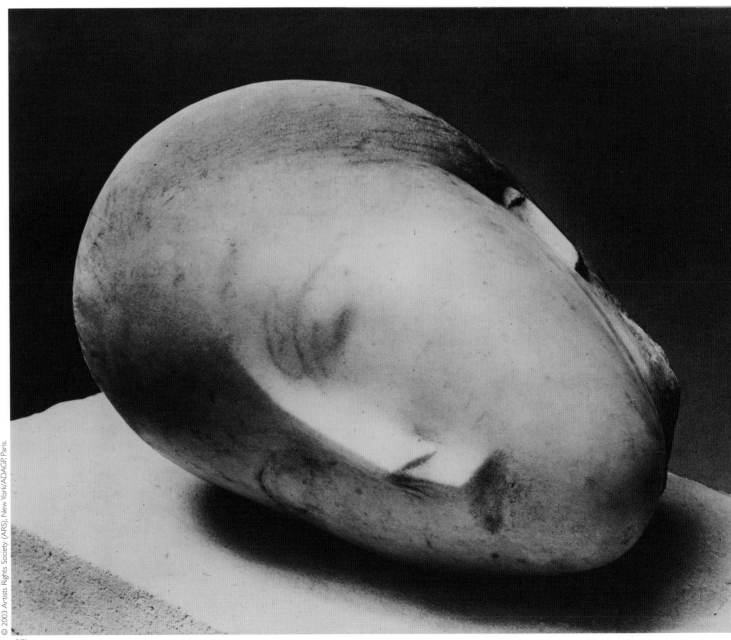

95)

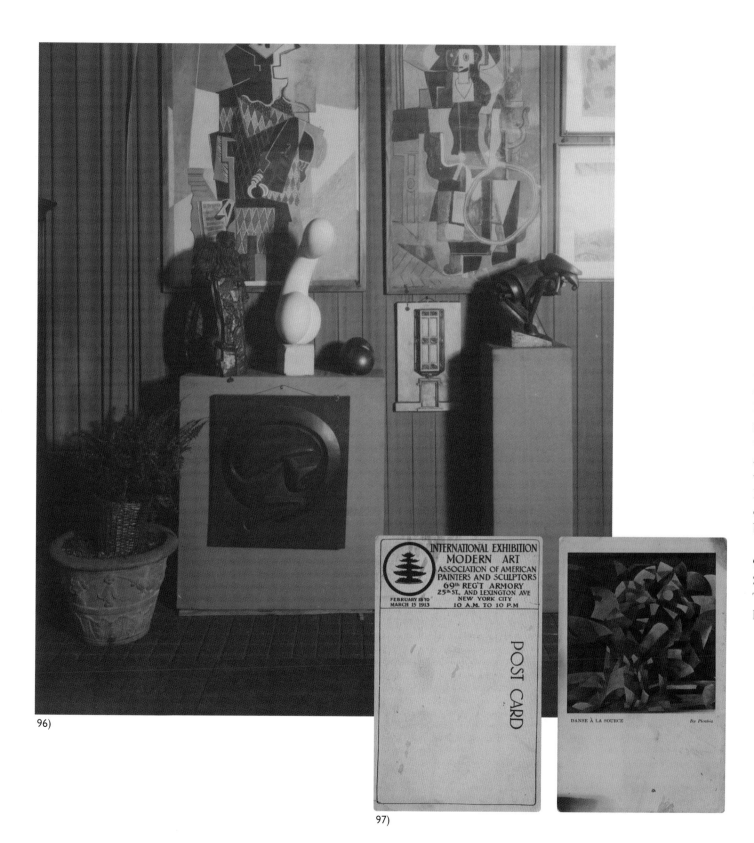

97)

ARMORY SHOW

96) V. Sakayan. Image of Brancusi's *Princess* X by and other items in John Quinn's art collection. After the coalition responsible for the Armory Show fell apart, several groups of artists got together in 1916 to form the Society of Independent American Artists, taking as their model the Salon des Indépendants in Paris, with a policy of "no jury, no prizes." In 1917 the "Indep" held their first exhibition, spearheaded by Marcel Duchamp. At twice the size of the Armory Show, the exhibition was the largest America had seen—more than two miles of art, Duchamp claimed after pacing off the aisles of New York City's Grand Central Palace, where the show was held. Quinn, dismayed by Duchamp's unorthodox method of hanging the art, complained that the process was "Democracy run riot." *Princess* X was lambasted by one critic as a "shining example of bulby mistification [sic]...."

97) Postcard for sale at the Armory Show, 1913. Private Collection. The image is *Dance à la source* by Francis Picabia.

109

MAKE IT NEW: THE RISE OF MODERNISM

LITTLE MAGAZINES

Small magazines provided modernist authors and artists an important outlet in which to publish their work. By one estimate, the period between 1900 and 1940 saw the publication of over 600 "little magazines." Called "little" because their circulation numbers were often small, these publications could be very expensive or of notoriously poor quality. Some ran for only a few issues; others for years. A couple are still in business.

98) *The Exile*, edited by Ezra Pound, published by Pascal Covici, Chicago, Spring 1928.

99) *Little Review, Final Number*, edited by Margaret Anderson and Jane Heap, New York and Paris, May 1929.

100) *The Little Review, Exiles' Number*, edited by Margaret Anderson and Ezra Pound, New York and London, Spring 1923.

101) *Hound & Horn*, edited by Bernard Bandler II, Lincoln Kirstein, and A. Hyatt

102) *Colossevm*, edited by Bernard Wall, London, September 1935.

103) *The Soil*, A Magazine of Art, New York, July 1917.

104) *Poetry: A Magazine of Verse*, edited by Harriet Monroe, Chicago, vol. x, no. 3, June 1917.

105) *Others*, edited by Alfred Kreymborg, New York, February 1919.

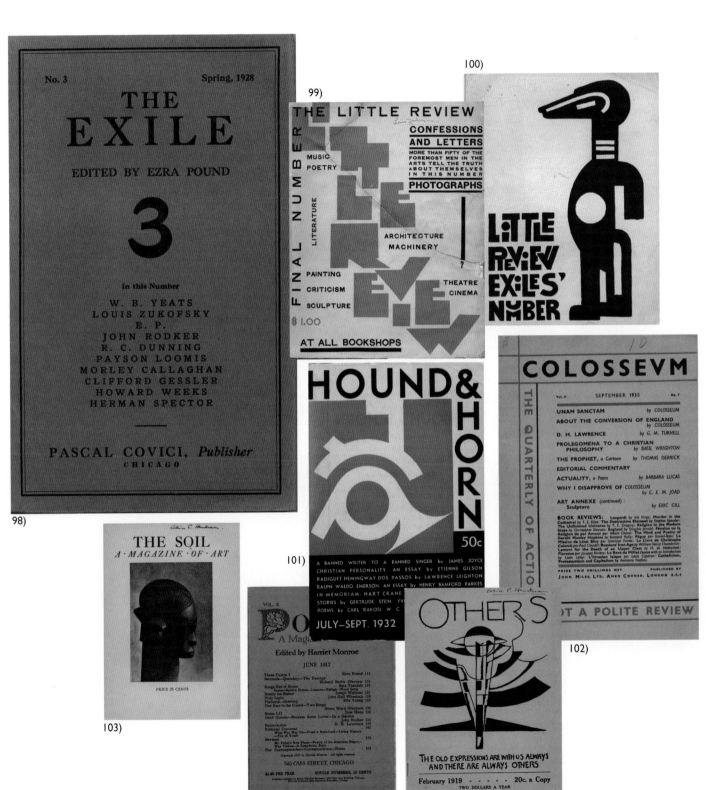

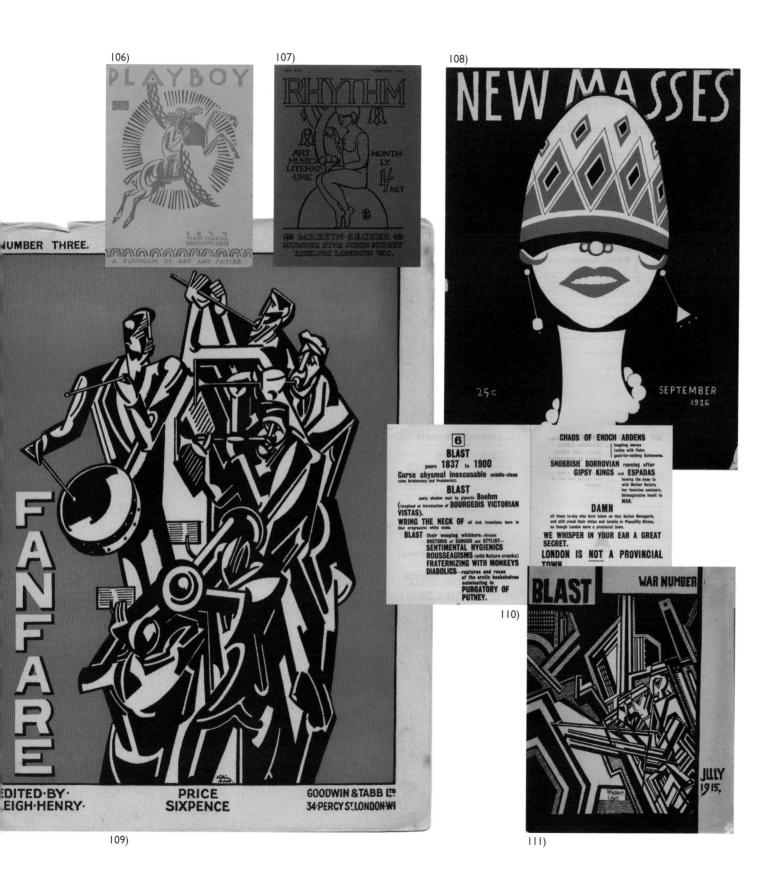

LITTLE MAGAZINES

106) Playboy: A Portfolio of Art and Satire, edited by Egmon Arens, New York, First Quarter 1923.

107) Rhythm, edited by John Middleton Murry and Katherine Mansfield, London, no. 13, February 1913.

108) New Masses, edited by Mike Gold, New York, vol. 1, no. 5, September 1926.

109) Fanfare, edited by Leigh Henry (London: Goodwin & Tabb, Ltd), vol. 1, no. 3, November 1, 1921. The cover is by William Roberts (1895-1980).

110) Blast: Review of the Great English Vortex, ed. by Wyndham Lewis (London: John Lane, The Bodley Head), Issue no. 1, 20 June 1914, interior lay-out.

111) Blast: War Number, July, 1915.

PERFORMANCE EVENTS

112) Invitation to the premiere of *Les Mamelles de Tirésias* (24 June 1917), written by Guillaume Apollinaire (1880-1918) and produced by Pierre Albert-Birot. Thérèse, the main character, renounces her breasts and abandons her husband in order to become Tirésias and saddles him with all reproductive duties. The invitation includes the announcement of a *conférence contradictoire*, entitled "*L'esprit d'avant-garde,*" dedicated to "cubism, futurism, and nunism." Nunism, from the Greek word for "now," was officially a one-person movement (applying to Pierre Albert-Birot's refusal to be boxed into any one artistic movement), but "Now-ism" could define, in its general sense of heightened contemporaneity, all the -isms that made up Modernism.

113) Jean Hugo (1894-1984, great-grandson of Victor Hugo), portrait of Apollinaire with his head bandaged from war wound, pen-and-ink on paper. Wearing his sky-blue lieutenant's uniform, with the Croix de Guerre around his neck, Apollinaire rushed onstage during the intermission of *Mamelles* and shouted to the riotous opening night audience to come to order. An officer seated in the front row waved his pistol and threatened to fire on the crowd.

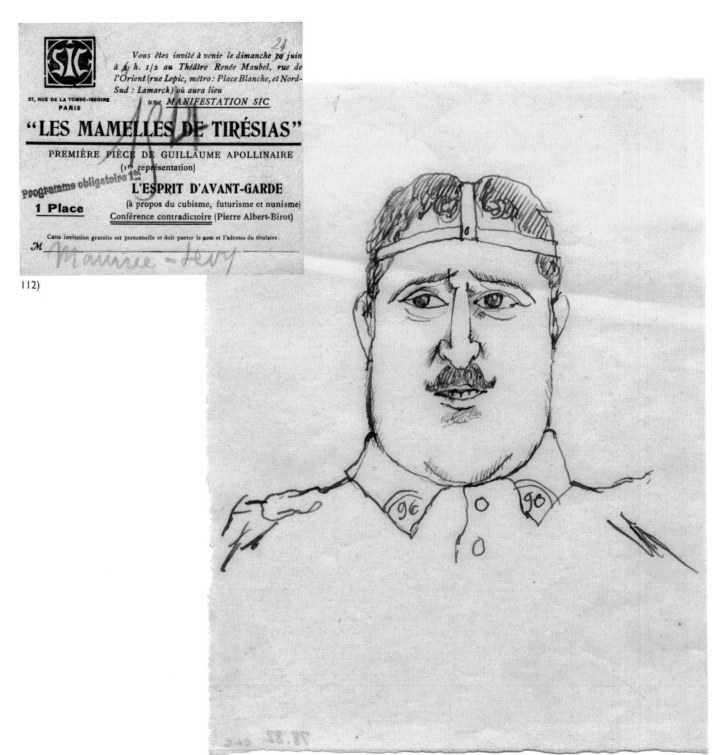

112)

113)

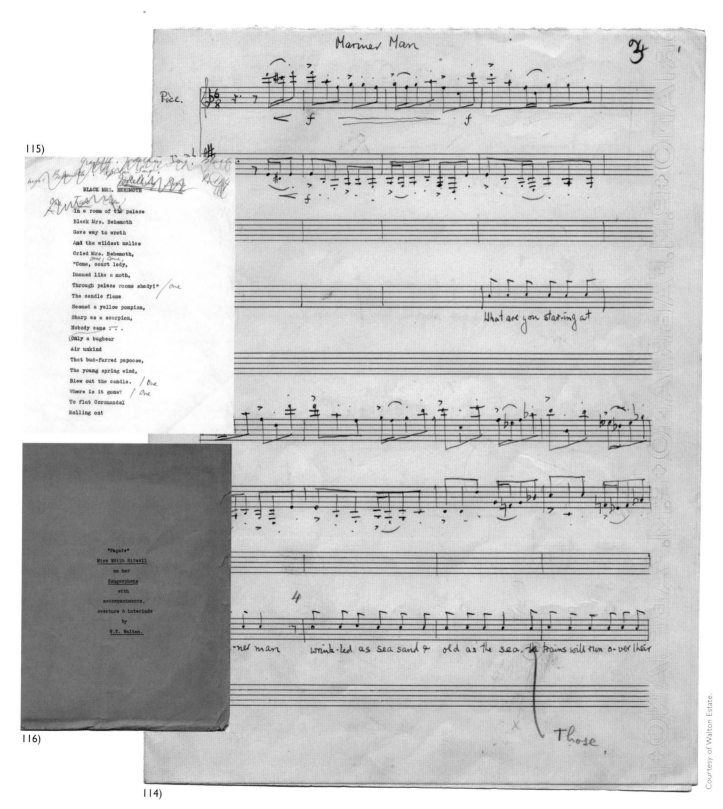

PERFORMANCE EVENTS

114) Black Mrs. Behemoth, from the autograph manuscript score of *Façade* (1922) by William Walton (1902-1983), then only twenty years old.

115) Black Mrs. Behemoth, from Edith Sitwell's reading typescript of *Façade,* with her performance annotations. Sitwell (1887-1964) came from an aristocratic family with a history of eccentricity. In chanting her poems for performance, she used a kind of bullhorn and turned her back to the audience so as, she said, to force them to attend to the sonic qualities. Many walked out.

116) Cover of the program from the first private performance of *Façade* in Osbert Sitwell's home at 2 Carlyle Square, London, January 24, 1922. One of the only surviving copies. The piece was later performed publicly, with Walton's music, at London's Aeolian Hall.

113

MAKE IT NEW: THE RISE OF MODERNISM

PERFORMANCE EVENTS

117) Pavel Tchelitchew (1898-1957), *Edith Sitwell*, oil on canvas, 1930. Tchelitchew was born in Moscow, designed sets for Rimsky-Korsakov in Berlin, and finally settled in the United States where he worked with George Balanchine and Igor Stravinsky. When he lived in Paris in 1923, Gertrude Stein hailed him as the next Picasso.

117)

ULYSSES suppressed four times during serial publication in "The Little Review" will be published by "SHAKESPEARE AND COMPANY" complete as written.

This edition is private and will be limited to 1.000 copies :

100 copies signed on Dutch hand made paper. **350** fr
150 copies on vergé d'Arches. **250** fr.
750 copies on hand made paper. **150** fr.

The work will be a volume in-8º crown of 600 pages.

Subscribers will be notified when the volume appears, which will be sent to them by registered post immediately on receipt of payment.

All correspondence, cheques, money-orders should be addressed to :

Miss *SYLVIA BEACH*

"SHAKESPEARE AND COMPANY"

12, RUE DE L'ODÉON, PARIS — VIᵉ

118)

ULYSSES

118) Announcement of the publication of *Ulysses* by Sylvia Beach and Shakespeare and Co., 1921.

119) Announcement of Valery Larbaud's lecture on James Joyce's *Ulysses*. Two hundred and fifty people attended the event on December 7, 1921 at Adrienne Monnier's bookshop.

119)

120) Sylvia Beach (1887-1962), *Ulysses* Subscription Notebook, c. 1921. The notebook contains the subscribers' names, the number of deluxe editions they subscribed for, and the amount paid or promised in payment. The subscribers included a segment of French, American, British, and international literati, as well as prominent patrons of arts, small bookshop owners, and rare book dealers. Documents like this one show a deliberate marketing strategy even for difficult, avant-garde works.

120)

115

121) Poster, "How to Enjoy… *Ulysses*," Random House publishers, circulated in conjunction with the newly uncensored American edition, 1934.

122) James Joyce and Sylvia Beach outside Shakespeare and Co. Bookshop, Alliance Paris photograph, c. 1922.

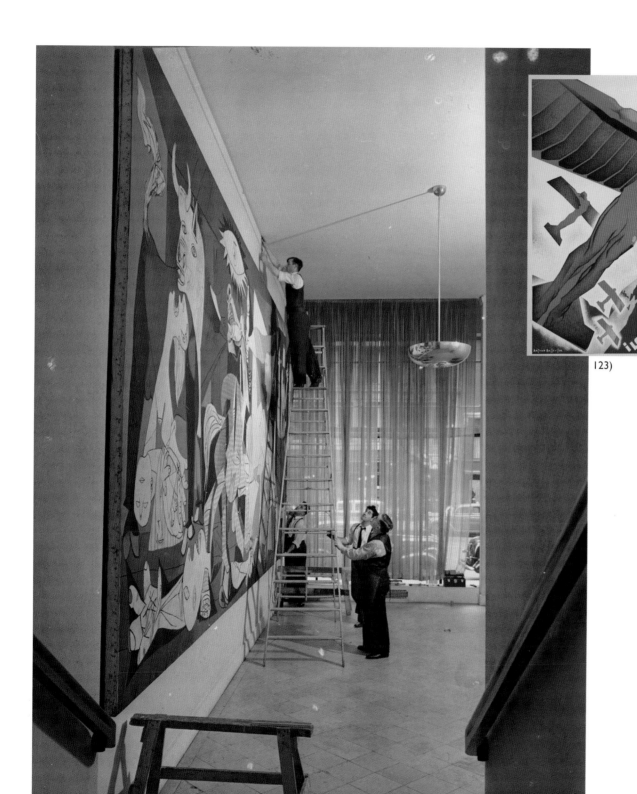

123)

124)

PRELUDE TO 1939

123) Arturo Ballester, "Loor A Los Heroes," Spanish Civil War poster, late 1930s. The Spanish Civil War (1936-39) was in many ways a try-out for World War II. It involved international intervention, an unprecedented ruthlessness toward nonmilitary targets, and a new reliance on air power. The war engaged the sympathies and volunteer labors of many writers and artists.

124) Eliot Elisofon (1911-1973), *Picasso's Guernica being mounted at the Museum of Modern Art, New York City, 1939,* silver gelatin print from deteriorated negative. John Berger calls this "the most famous painting of the twentieth century." It was begun less than a week after German warplanes obliterated the ancient Basque town of Guernica (pop. 10,000), a bombing intended to intimidate the civilian population rather than to gain a tactical advantage. This was a form of warfare that would proliferate through the rest of the century. Picasso gave the painting to MoMA on a long-term loan but with the proviso that it be returned to Spain when democracy was reestablished there. In 1981 it was returned, eight years after Picasso's death.

117

MAKE IT NEW: THE RISE OF MODERNISM

PRELUDE TO 1939

125) John Heartfield (1891-1968), *We pray to the power of the bomb,* collotype, 1934. Heartfield as a young man was influenced by soldiers on the Western front who, unable to get their reports past military censors, resorted to pasting photographs together in order to related the horror of the battlefield to those back home. Photomontages certainly capture the hybrid quality of much modernist art. In this picture, images of bullets form the spires of a cathedral, topped by symbols of international currency, an assemblage that prophetically anticipates military-industrial complexes, globalized markets, and the escalation of nuclear capabilities. Heartfield barely escaped arrest by the Nazis in 1933. When he returned to Germany in 1950, he was welcomed with a major retrospective exhibition of his work.

118

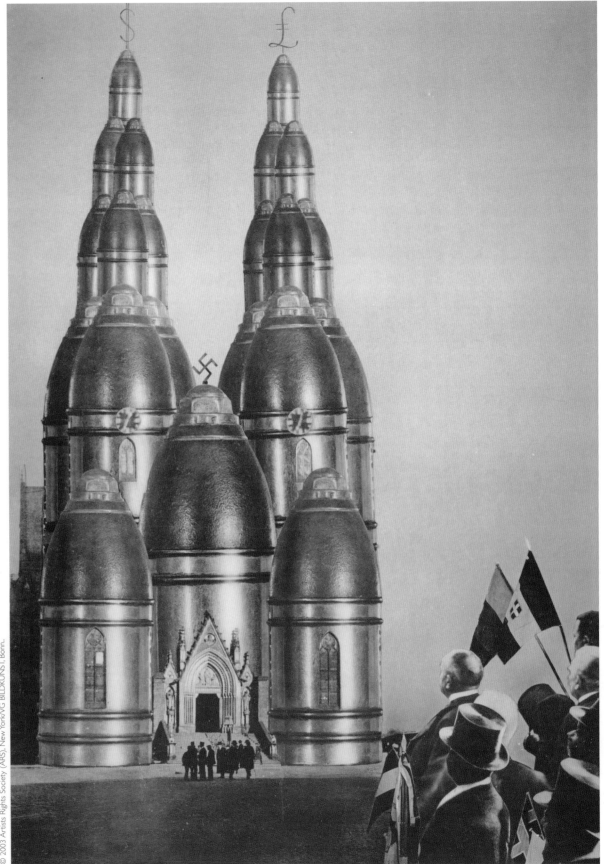

125)

GOTHAM BOOK MART

EUGENE JOLAS

Because he stands at the crossroads of three languages, Eugene Jolas occupies a unique position in contemporary letters. He was born in America, of a German mother and French father, reared and educated in Europe, and he returned to America to become a newspaperman. He is equally at home in English, French and German and has written books in all three languages. His awareness of the literary cultures of three nations has given added weight to his editorship of Transition, the magazine he founded in Paris. In the Twenties, Transition first made known such writers as Ernest Hemingway, Kay Boyle, James Farrell, etc. In recent years Transition has stressed more purely experimental writing. "Finnegans Wake," by James Joyce was first published in installments in its pages.

His quite deliberate transfusion of alien literary effects into his English writing makes Jolas at times very difficult reading. He was at the same time his writing has important values not to be found in the ordinary one-language mind. Until recently Jolas was almost mystically preoccupied with the Night Mind, the Dream World, the Unconscious. His latest writing has taken a more dynamic turn and is much more straight-forward.

Martha Foley

455. **Cinema—Poems.** With introduction by Sherwood Anderson. 12mo, boards. N. Y., 1926. o.p. $2.00

456. **I Have Seen Monsters and Angels**—Multilingual Autobiography of the Night. 16mo, wrappers. Paris, 1938. $1.00

457. **Language of the Night**—12mo, wrappers. The Hague, 1932. o.p. $1.50

458. **Secession in Astropolis**—Modernistic poem-impressions. 8vo, wrappers. Black Sun Press. 1930. o.p. $7.50

459. **Vertigralist Pamphlet**—12mo, wrappers. Paris, n.d. 25c

JAMES JOYCE

What next?
What new creation is James Joyce contemplating today?
In *Finnegans Wake* he has given us the panorama of purgatory.
He has given us a grandiose modern vision of the second part of the dantesque hierarchy.
He evoked the night, the primordial, the inter-racial, the personal, the ontological night.
He chanted the antinomies of good and evil.
He showed primal fear in a thunder-word.
He besang the heraclitean flow of the Liffey and all the rivers of the world.
He paraded the mountain-man and the river-woman in the neo-mythic inventions of Finn McCool and Anna Livia Plurabelle.
He humanized the secular and sacred heroes of mankind.
He painted the rotations of the wheel of life.
He made a hero out of Time: incessant creation and return.
He rebuilt the city across the ages in Finn's multiple metamorphoses.
He personalized history and mythology.
He re-created the genesis and mutation of language.
He introduced us to Izzy, Shem and Shaun in their childhood paradise.
He brought us face to face with the chimeras of man's nocturnal pilgrimage through purgatory.

38

126)

51 WEST 47TH STREET, NEW YORK

JAMES JOYCE (Continued)

What is the new world his genius visions today?
On the coast of Britanny, near the menhirs and dolmens of the Druid age, where he watches the tragedy of Europe today, is he thinking of continuing the dantesque cycle?
Is he building a cosmic universe in a new myth of the *scala paradisi?*
Will his new work be *verticalist?*

Eugene Jolas

460. **Anna Livia Plurabelle**—12mo, wrappers. London, 1932. o.p. $2.00

461. **Same**—12mo, boards. N. Y., 1928. First edition, signed. With post-card in holograph to James Stephens referring to a scheme of his and T. S. Eliot's to record their work. $17.50

462. **Same**—With music by Hazel Felman. 4to, wrappers. Chicago, 1936. ($3.50) $1.50

463. **Same**—Recorded by Joyce. London, n.d. $12.00

465. **Chamber Music**—8vo, cloth. N. Y., 1932. $1.50

466. **Same**—16mo, cloth. Boston, n.d. First American edition. $2.00

467. **Same**—16mo, cloth. London, n.d. First edition. $10.00

468. **Collected Poems**—Including Chamber Music, Pomes Penyeach, and Ecce Puer. 8vo, cloth. N. Y., 1937. $2.00

469. **Same**—Black Sun Press. 16mo, vellum. 1936. $5.00

470. **Same**—One of fifty copies on Japan vellum, signed. ($20.00) $22.50

471. **Dubliners**—8vo, cloth. N. Y., 1925. $1.50

472. **Same**—12mo, cloth. London, 1927. Traveller's Library ed. $1.50

473. **Same**—N. Y. Modern Library edition. 95c

474. **Exiles**—A Play in Three Acts. 12mo, cloth. London, 1921. $2.50

475. **Same**—12mo, boards. N. Y., 1918. First American ed. $2.50

476. **Same**—London, 1918. First edition, with letter in French, entirely in holograph, referring to this play. $17.50

477. **Finnegans Wake**—The completed version of WORK IN PROGRESS. 8vo, cloth. N. Y., 1939. $5.00

478. **Same**—London, 1939. $8.75

479. **Same**—Deluxe, limited edition, signed. $25.00

480. **Haveth Childers Everywhere**—12mo, wrappers. London, 1931. o.p. (40c) $1.50

481. **Same**—4to, wrappers. Fountain Press, 1930. ($20.00) $7.50

485. **The Joyce Book**—Thirteen of Joyce's poems set to music, edited by

WE MODERNS
GOTHAM BOOK MART
1920 - 1940

The Life of the Party at FINNEGANS WAKE in our Garden on Publication Day
Painting by Ruth Bower Photograph by Carl Van Vechten

127)

126) Entry in the Gotham catalog for James Joyce, written by Eugene Jolas, followed by a price list for *Finnegans Wake* in its various editions prior to the final one of 1939. An alternative image of the bomb emerges in what Jolas calls "the thunder word" from the *Wake*. There are ten of these made-up words in the novel, coined out of words for "thunder" in every language Joyce could think of and then run together—a sonic boom signifying either the creative power of the Word or the lamentable fall into the babble of language:

"bababadalgharaghtakamminar-
ronnkonnbronntonnerronntuon-
nthunntrovarrhounawnskawn-
toohoohoordenenthurnuk!"

Finnegans Wake is sometimes called the last modernist novel or the first postmodernist one, either a brilliant reimagining of language as such or an unreadable monstrosity.

127) *We Moderns: 1920-1940,* sales catalog for the Gotham Book Mart. This front cover is a photograph by Carl Van Vechten of a painting by Ruth Bower entitled *The Life of the Party at* FINNEGANS WAKE *in our Garden on Publication Day* to mark the appearance of James Joyce's novel in 1939.

119

 e asked scholars from a variety of academic disciplines to select up to three items from the *Make It New* exhibition and explain why those items were crucial to their own definition of what "Modernism" means.

FRANK LLOYD WRIGHT AND LE CORBUSIER: ESSENTIAL MODERNISTS

ANTHONY ALOFSIN

The two giants of twentieth-century modern architecture, Frank Lloyd Wright and Le Corbusier, shared bonds in their pursuits of Modernism. One of those bonds was their coming to terms with history and tradition as a fundamental foundation for their own expressions of Modernism. Wright's reconciliation with the grand tradition of classical Western architecture occurred firsthand when he ventured to Florence in 1910 to prepare the plates of his famous Wasmuth folios, *Ausgeführte Bauten und Entwürfe von Frank Lloyd Wright*, and to see the great sculptures, paintings, and buildings of the Italian Renaissance. The saga of his publications is long and complex.[1] Though Wright's critical reception among the avant-garde in Europe was more a phenomenon of the nineteen twenties than the teens and his celebrated folios had limited distribution in Europe, they became known as some of the most famous publications of modern architecture and the twentieth century. On the one hand, the redrawing of the plates according to the same stunningly beautiful graphic idiom allowed Wright's organic architecture to emerge as a fresh new, coherent direction for modern architecture. On the other hand, Wright seized the opportunity when writing the introduction to the folios to explain his explicit responses to the art and architecture of the Renaissance. In effect, the essay represents his own coming to terms with the legacy of a classical tradition. He rejected copying the styles of the past, but the ordering systems of proportion and logic in the classical tradition and its integration of all art forms—painting, sculpture, and architecture—reinforced his own intuitive approach to creating a modern organic design idiom.

Wright produced a magnum opus that ranks among the greatest of all architectural publications. In the standard edition, seventy buildings and building projects from 1893 to 1909 are shown on seventy-two plates. Emulating art publications of the period, Wright added designs printed on twenty-eight delicate tissue overlays that were attached to the plates. Many, but not all, of the plates had Wright's logo, an embossed square. The plates were contained in two folios of gray paper laid over boards and joined with cloth hinges. (A limited deluxe edition had folios bound in a single half-leather with plates printed on slightly larger Japan papers.)

The designs show the variety and versatility of Wright's work: single-family houses, public buildings, and multifamily dwellings in urban and rural settings (Fig. 1). The building types range from a mortuary to a tennis club, and from estates for the rich to housing for factory workers. The plates speak for themselves, and allow the reader to gain a serious understanding of architecture by studying the movement in Wright's plans, the careful and efficient use of space, the setting of the buildings into their sites, and the furnishings of their interiors that reflected an American version of *Gesamtkunstwerk* ("the total work of art"). However, the true impact of Wright's buildings, achieved through his masterly control of scale and his revolutionary spatial drama, can only be felt by experiencing the buildings themselves. Without that experience of the reality of his designs, his organic architecture always remained slightly outside the grasp of most architects. His Wasmuth plates became the best surrogates for his buildings and projects.

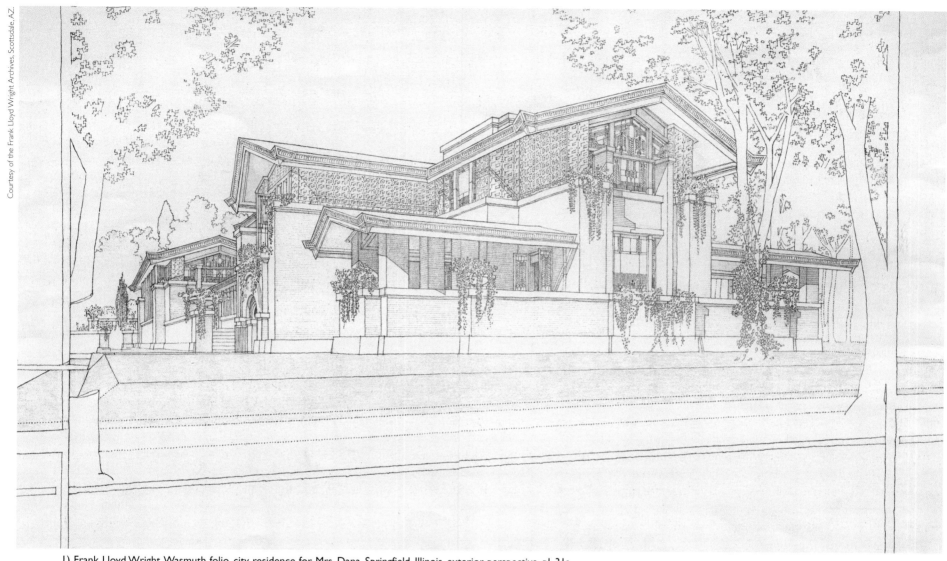

1) Frank Lloyd Wright, Wasmuth folio, city residence for Mrs. Dana, Springfield, Illinois, exterior perspective, pl. 31a.

More difficult to grasp is the complexity of Wright's written introduction to the folios. A major theoretical statement, it expressed his hopes for the future of architecture and an implicit program for his own future work. Titled simply "Studies and Executed Buildings by Frank Lloyd Wright," the introduction was dated "May 1910, Florence," in the German version, and "June 1910, Florence, Italy," in the American edition. However, Wright did not finish writing the introduction until December 1910, two months after his return to America. Sensing its significance, he needed time to reflect on its content, and he spent much effort perfecting the text. The essay summarized aspects of his direct contact with Europe and dealt with several complex and interconnected issues: historicism, education, the definition of organic architecture, the sources of true architecture in primitive and non-Western cultures, the modern American challenge, and a self-critical analysis of his own architecture.

Wright developed these themes with a circular rather than a linear organization, returning at various times to the negative impact of the Renaissance while calling for a democratic American architecture and for the study of primitive cultures. His writing style not only added to the poetic richness of the text but also to its density. The publisher in Berlin had great difficulty translating the text into German, and the resulting translation was somewhat garbled. Consequently, the circularity and opacity of Wright's introduction to the monograph has contributed to its being either misunderstood or ignored.

Despite its obscurity, this theoretical statement is a fundamental expression of Europe's impact on Wright. The introduction provided an opportunity to resolve the problems of an American architect attempting to come to terms with European traditions and to announce a new program based on pre-classical, non-classical, and non-Western traditions of architecture

Wright begins by implying that the essay was a continuation of his earlier theories and a revision of others in response to his studies in Europe.[2] He then investigates the Renaissance as it was expressed by the sculptors, painters, and architects of Florence. Wright saw that a series of interconnections had united the arts: sculptors were painters, painters were architects, and architects were sculptors. The result was a total artistic environment in which artists expressed the spirit of their age. "No line," as Wright puts it, "was drawn between the arts and their epoch."

The important lesson of Italy as the cradle of the Renaissance was not to be found in its classical vocabulary but in the way its architecture captured what he called "joy in living" by integrating color and ornament into a rich landscape of rocks, slopes, and trees. Ignoring the cultural implications of urban architecture, Wright asserted that indigenous peoples made buildings according to their needs and fitted their buildings "with native feeling" into the environments they knew and understood. The result was "buildings that grew as folk-lore and folk-song grew." Italy's gift was its embodiment of this process with principles that Wright felt were more important to study than were "academic" attempts at creating beauty. According to Wright, however, this process was subverted when the forms of the Italian Renaissance were copied by other countries that should have developed their own indigenous cultural expressions. As it passed to France, Germany, and England through a series of stylistic modifications, this historical legacy became banal, boring, and extravagant. The corrective was his own program for architecture: the study of indigenous architecture as the democratic embodiment of a people and the integration of form with its environment in a manner harmonious with nature.

Le Corbusier had an even more prolonged confrontation with the classical tradition starting with a series of trips to see not only the great monuments of Western architecture but also a rich variety of vernacular buildings. His exploration began with the first of a series of trips to the East; this journey he later called his *voyages a l'Orient*. An unpublished manuscript in the Ransom Center collections shows Le Corbusier's profound assimilation of classicism, embodied in this instance by Rome (Fig. 2). Although undated, the document was likely written between 1920 and 1925 since his use of "Le Corbusier" (the name he invented for himself) first appeared in 1920 and was used by him thereafter.

2) Le Corbusier [Charles-Edouard Jeanneret-Gris], "Rome," page 1 of a 5-page, illustrated manuscript in which Le Corbusier analyzes Rome as forms in space, calling it "a prodigious poem of geometry and nature."

Le Corbusier described the city in fragmentary terms: "Rome is clarity. A sign that expresses a precise concept. One of the forms of character: a conscious force."[3] To identify these forms he drew the simple geometric forms that comprise Rome: arcade, dome, coffered dome, arches, and platonic solids of cylinder on an extruded rectangular base. They are essential expressions as seen in his diagram of the Roman Forum. He notes its triumphal arch, temple, the court of justice, altar, and sculptures of heroes and the virtues—all of which connote "unities of collective gestures." He draws a plan of an urban residence organized around an atrium, the coliseum, and the landscape which embraces all. He concludes, "Rome makes unities, architectural and urbanistic wholes."

This was not the first time Le Corbusier had analyzed Rome and used its lessons as principles for his manifesto of a modern architecture. "Studies of Rome" provided a chapter for his monograph, *Vers une Architecture*, published in Paris in 1923 and translated into English in 1927. This book alone is comparable in influence to Wright's Wasmuth folios, and may have had an even greater impact on the course of modern architecture. Le Corbusier's references to history also formed a profound part of his argument for radical alterations of cities as seen in his tract, *Urbanisme*, published in 1925 and translated into English in 1929. Indeed, the illustrations of Rome—identified as representing "geometry, implacable order, war, organization, civilization"—are the same sketches in the Ransom Center's essay.[4]

That Le Corbusier had copies made of his own sketches which he used for publication is confirmed by the series of letters, begun in 1922, which he sent to Maurice Raynal: these, too, are in the Ransom Center's collection. Raynal, a journalist and art historian, had written favorably about the aesthetics of Le Corbusier's *Cité Contemporaine*, an early vision for a rationalized, vast, modern city of skyscrapers and housing blocks amid immense green spaces. Much of the subsequent exchange involved discussions about publications of Le Corbusier's work. By 1940 (Ransom Center, letter of 28 October 1940) he had sent to his publisher, Fernand Sorlot, twenty-nine proofs and illustrations for his book *Destin de Paris* (1941), a further attempt to press for the realization of his evolving vision of the new modernist city. A mock-up is included along with much detail about the contents and organization of the publication. The correspondence concludes with a French official's refusal to pay an invoice for 140 pamphlets (*plaquettes*) of Le Corbusier's book.

a des tics divers. Il vit dans une société; il s'y cogne ou plie : il peut être fier ou bas, il peut être héroïque ou faible...

Le public. L'événement machiniste a dissipé l'équivoque qui pesait sur les arts plastiques : le contrôle abusif du public sur l'artiste. La *ressemblance* est la raison d'être du document. Les arts plastiques — peinture et statuaire — furent tenus longtemps d'assumer le double rôle de fixer des images et d'émouvoir. On connaît l'histoire récente : l'objectif — la photographie puis le cinéma —, à l'extrémité de cycles déjà plusieurs fois millénaires des arts plastiques, a brisé la double idole. Et par là, brisé la carrière d'artistes, bouleversé une corporation, "estonné" le public, fait le vide au sein d'une activité sûre d'elle-même, enlevé désormais les moyens immédiats d'appréciation ou de jugements faciles. La *ressemblance* a renouvelé ses moyens techniques; du relatif elle a

3) Le Corbusier [Charles-Edouard Jeanneret-Gris], page 4 from the maquette of *Le Corbusier : Oeuvre plastique, peintures et dessins architecture* (Paris: A. Morancé, 1938).

Le Corbusier's involvement with the design of his publications is also seen in the Ransom Center's transmittal letter and mock-up for this book, *Oeuvre plastique, peintures et dessins architecture*, published by Editions Albert Morancé. Le Corbusier gives specific indications for layout and paste-up of text and drawings. The book is filled with drawings from 1910 of ensembles

of vernacular buildings, churches, and barns, as well as *objets types* and figural drawings from 1920 to 1937 (Fig. 3).

Le Corbusier's focus on the publication of his work and the manner of the publication leads us back to a fundamental connection to Frank Lloyd Wright. Both architects realized the power of the media to disseminate their agendas and devoted considerable energy to the design, layout, and graphics of their publications. Wright not only edited and controlled the layout of the Wasmuth folios (the mock-ups are in the collections of the State Historical Society of Wisconsin) but also gave a similar intense attention to the designs of publications under his control throughout his career, including the summary of his opus, *The Life-Work of American Architect Frank Lloyd Wright*, published in the Netherlands in 1925 by Hendricus Wijdeveld, editor of the journal *Wendingen*. There is no doubt that Le Corbusier would have known of the publication, seen its buildings, observed its design, and thereby seen the work of his main rival in America. Although he denied early knowledge of Wright, he already owned a copy of the small picture book, *Ausgeführte Bauten*, that, by 1915, accompanied the big folios.[5] Despite their being competitors of genius, both architects sought parallel reconciliations with history and tradition as the foundation of their own agendas for Modernism. In this absorption they differed from modernists in the visual arts who made a complete rupture with the past. Yet, like the most extreme avant-gardists, they clearly seized a core idea of Modernism: namely, that images and words are inseparable as tools for the advancement of an ideological avant-garde.

NOTES

1. See Anthony Alofsin, *Frank Lloyd Wright: The Lost Years, 1910-1922* (Chicago: 1993); idem, Introduction to *Studies and Executed Buildings by Frank Lloyd Wright*, rpt. (New York: Rizzoli International, 1998).

2. Wright's most recent significant theoretical statement was "In the Cause of Architecture," *Architectural Record* 23 (March 1908): 155-221. His first theoretical statement was "The Art and Craft of the Machine" (1901), reprinted in *Frank Lloyd Wright: Collected Writings*, Vol. 1., ed. Bruce Brooks Pfeiffer (New York: Rizzoli, 1992), pp. 58-69.

3. C-E Jeanneret-Gris, *Rome*, 5 pp., no date. Ink on note paper, signed "Le Corbusier," Carlton Lake Collection, Harry Ransom Center. Translation by author.

4. Le Corbusier, *The City of Tomorrow and its Planning* (New York: Payson & Clarke, 1929), p. 61. The English edition was translated from the 8th French edition of *Urbanisme* by Frederick Etchells. The original edition appeared as Le Corbusier, *Urbanisme* (Paris: G. Cré & cie, 1924).

5. See Alofsin, *Frank Lloyd Wright, The Lost Years*, p. 334, n. 36.

THE SUNWISE TURN: THE MODERN BOOK SHOP

EDWARD BISHOP

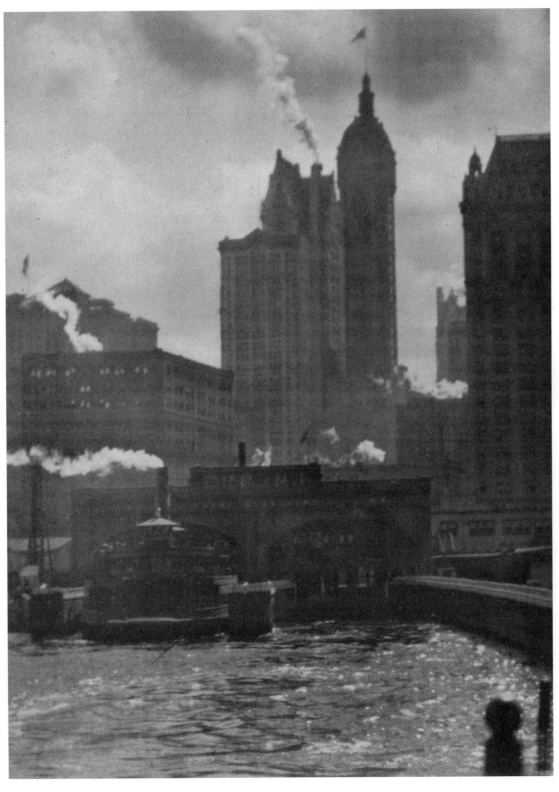

In 1916 in New York City, two women, Madge Jenison and Mary Mowbray-Clarke opened The Sunwise Turn: The Modern Book Shop on East 31st Street in New York City. It was one of the first bookstores in America to be owned and operated by women. They sponsored lectures and readings by Robert Frost, Theodore Dreiser, Amy Lowell, and others. They sold paintings and sculpture. And in 1917 they hosted a meeting of women in the publishing trade who subsequently organized the Women's National Association of Booksellers and Publishers. They published a few of their own books, and even briefly considered publishing *Ulysses*.

They also prepared libraries for company boardrooms and had a mail-order service which would provide a customer with the best new books on a subject of their choosing—sort of like the Book-of-the-Month Club's selection of the month. The owners saw themselves as cultural missionaries in the capitalist jungle of Manhattan. The name, deliberately chosen, was not "sunrise" (though correspondents often made that mistake) but "sunwise," which meant to follow the course of the sun, to be in harmony, in other words, with the rhythms of nature, and, implicitly, to provide relief from the mechanical rhythms of the city.

The owners viewed The Sunwise Turn as a cottage amongst the sky-scrapers (Fig. 1). A glance at the publicity pamphlet for the bookshop makes it clear that they were creating a space for *reading*, not just *buying* books. The image looks simultaneously like a gingerbread cottage and like a featherbed, with the chimneys doubling as bedposts and clouds (unlikely in midtown Manhattan) for pillows. At the center of the roofline is a device suggestive of two hands holding a book. It is all meant to evoke refuge, repose, and reading (Fig. 2).

One of the documents preserved in the Ransom Center's archive for the bookshop is the bill for draperies and furniture coverings:

1) Alfred Stieglitz, *The City of Ambition*, photogravure, 1910 (*Camera Work*, no. 36, October 1911). The dramatically backlit skyscrapers, viewed at a distance from an offshore vantage point, seem heroically proportioned. Smoke is a sign of industry but resembling clouds.

$211.75 for 25 yds linen, 19 yds Tudor, 2 yds Damask, 2 yds Agra, 6 yds Gauze
and then $302.40 for 38 sq ft of tapestry, purple, for sofa;
39 sq ft plain tapestry, orange-red for two arm chairs;
36 ft of plain tapestry, blue, for 3 side chairs;
47 sq ft of plain tapestry for outside covering

To spend over $500 for fabric in 1919, when a fireman would have been paid $100 a month, might seem outrageous, but the purchases were deliberate, part of the owners' ideal of creating a space that was designed to do more than simply maximize sales. In a speech given to a class for booksellers at the New York Public Library in 1922, Mary Mowbray-Clarke defined their bookstore in opposition to the stark office buildings around them. They wanted "architecture with personality" and they saw their bookstore as an example of "modern art expression," refusing to capitulate to the dictates of the new science of advertising:

Every hide-bound advertiser would tell us that we cannot sell books as well from small windows as from large ones, but we think we do a few things to people besides sell them books, and architecture with personality is not often enough a consideration in America in spite of our sky scrapers…. Our physical setting has meant a great deal to us. Both at the old 31st street [sic] shop… and in the shop built to our own design for us by the Yale club we have kept the aspect of a modern art expression… .

Windows (as a Ransom Center patron can appreciate) are important:

Even our mullioned windows and our great tiled wall sign are a protest against the mediocrity of the eternal plate-glass…. The selling of books in a derivative and imitative atmosphere would seem a crudity, believing as we do in the interdependence of all the arts.

As the pamphlet indicates, The Sunwise Turn described itself as a "Modern Book Shop." Mary Mowbray-Clarke saw The Sunwise Turn as part of a movement, a movement of "little" bookshops, like little theatre or little magazines. In 1917 she established a connection with the Arts and Crafts Theatre in Detroit, who set up a bookstore in their box office. In her talk she calls the bookstore a "performance" and goes on,

We are a "Modern" Book-Shop because we conceive the term "modern" to apply to the 20th century consciousness of all the factors in the life itself— even those sub-conscious ones the psychanalyst [sic] is unearthing for us— and we believe that our way of sell-ing books is our way of searching for those factors.

Many writers see the little magazines of the modernist period as an extension of the manifesto, and certainly the banner, of Margaret Anderson's *Little*

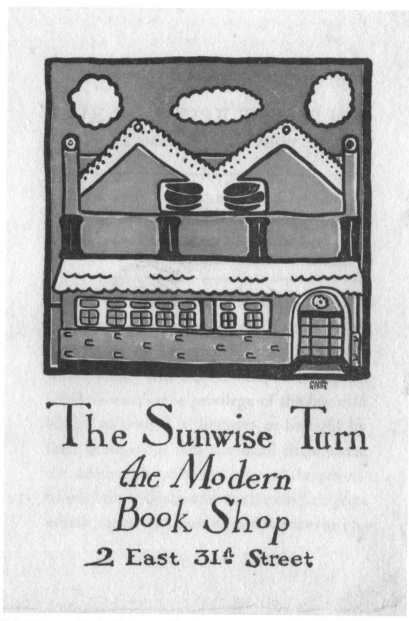

2) Publicity pamphlet for The Sunwise Turn Bookshop, cover.

Review—MAKING NO COMPROMISE WITH THE PUBLIC TASTE: this could be taken as the motto of The Sunwise Turn.

Mowbray-Clark called herself a "book-shop keeper":

I like that term because it sounds like light-house-keeper in my mind and that brings in connotations of courage and steadfastness and other virtues common and necessary to both.

[We are contributing] something more concentrated than is possible in the large merchandising Book-shops where books are— may I say it? perhaps sold as ordinary commodities rather than as what they seem to us to be— food for the soul of man— tools for the pursuits of life.

Little magazines and the little theater movement existed to promote new ideas or new forms of art, rather than sales. So too with the little bookshop, which championed even "not great authors" like "Virginia Wolff" (sic):

I think I can claim the honor of introducing Mr. Clive Bell to a wider public in America a year or two earlier than he would inevitably have reached us, and over 2/3 of the American edition of Roger Fry's Vision and Design was sold in [our shop], and A. E. has been a true best seller at the Sunwise Turn…. If English books of value are not brought out here or come out here and fail to take well and so are dropped, we try to keep them for their chance. We did this notably for "South Wind" and Virginia Wolff and "The Pilgrim of a Smile" not great authors these, but contributors.

But small presses, little magazines, and little bookstores by definition did not make money. Mowbray-Clarke was unrepentant on this point:

"But do you make any money?" ask all the business friends, who think everything we do a little foolish, yet continue to come to us nevertheless. "No, we do not," we have to answer. We do everything but make money. We've sold some hundreds of thousands of dollars worth of books, we've almost doubled each year the number of our steady customers, we've made good friends we hope, but we do not make money. With our methods our selling costs are necessarily high, we've done many things that were foolish and unnecessarily expensive perhaps and which we will never do again, but we have not compromised our original idea.

Brave words. But little magazines usually have a short run. Funded by a small group of supporters, and a few paying subscribers, when they lose the enthusiasm of their backers, they die. So too with independent bookstores.

Mowbray-Clarke couldn't know it, but she was enacting a pattern that would become almost a cliché of Modernism, the idealistic rise of an organization and its descent into bitterness and bankruptcy. The Sunwise Turn lasted a full decade, from 1916 to early 1927, but it really peaked after four years. The 1920 minutes of the Board of Directors record refinancing, the election of a new board, and the resignation of Mowbray-Clarke's partner and co-founder, Madge Jenison.

By 1922 Mowbray-Clark was firing some workers, putting one on part-time, considering renting space to the Encyclopedia Britannica, and trying to force Jenison and other former members to give up their back salaries. By this point

the former friends were communicating only through their lawyers.

By 1924 Jenison was publishing her chirpy memoir of the bookstore, while, in a heavily-cancelled manuscript for what appears to be another talk to booksellers, we find Mowbray-Clarke declaring bitterly,

Those who write for the magazines on bookshops are generally people…who write delectable moonshine about dream shops into which the shadow of the credit man never enters.

She rails against the non-bookbuying public:

The same people who exclaim at the price of a book go from our shop to [to buy] a silk shirt that fades away in a month without a feeling of extravagance.

The dream of the cottage was long gone. Mowbray Clark struggled on for three more years before finally giving up and selling out to Doubleday, who added it to their chain of stores.

Ironically, the site today is occupied by a custom shirt shop.

"ORIGINAL SIN AND THE HEART OF DARKNESS": WHEN T. E. HULME MET JOSEPH CONRAD

CHRIS FLETCHER

In a letter of 13 March 1915 to R. A. Scott-James, man of letters and recipient of the George Cross for conspicuous bravery, Joseph Conrad, world-famous writer, described his escape from Poland at the outbreak of the Great War:

I was actually in Cracow with wife and boys when the war broke out. It was 2 months before (after many efforts and by the help of good friends) we managed to cross the Italian frontier, learn the truth and breathe freely at last. (Fig. 1)

A little over two years from the date of this letter, T.E. Hulme, obscure Imagist poet, modernist theorist, and author of the posthumously published *Speculations* (Fig. 2), was blown to pieces by a shell near Nieport in Flanders. Wyndham Lewis, a fellow blaster and bombardier in the fields of both art and war, was in a neighboring battery. In 1937 he recalled Hulme's death:

I did not see him hit, but everything short of that, for we could see their earthworks, and there was nothing between to intercept the view. I watched, from ours, his battery being punched full of deep craters, with large naval shells: and from the black fountains of earth that spouted up, in breathless succession, occasional debris hurtled around us as we looked on. I remember a splintered baulk of wood sailing over and striking the dugout at my back.[1]

Although the fact is little known—and neither mentions it—Conrad and Hulme met once before becoming caught up in the maelstrom of war. The person who brought them together, probably in 1913, was the man of letters Richard Curle, later to become Conrad's literary executor. "One can see the logic of [Curle's] thinking," notes Robert Ferguson, Hulme's recent biographer, "but after they exchanged stilted pleasantries for half an hour in a hotel south of the Strand the meeting broke up and Original Sin and the Heart of Darkness went their separate ways."[2] The absence of further comment from Ferguson offers an opportunity here to look at what the logic of Curle's thinking might have been in bringing Hulme and Conrad together and, in so doing, to trace a common pattern of thought through the early history of modernist ideas in Britain.

One can understand the "stilted pleasantries." On the face of it, Hulme and Conrad shared little in common. Hulme, barely thirty, was a working-class Yorkshireman who was twice kicked out of Cambridge, carried knuckle-dusters (fashioned for him by the sculptor Gaudier-Brzeska), and once hung Lewis by his trouser turnups from the railings of Soho Square. He was an aesthetic agitator responsible for a few Imagist poems who met his violent end at the height of his intellectual powers. Those of his theoretical writings which survived went largely unpublished until the posthumous *Speculations* of 1926. Although admired by T. S. Eliot and Ezra Pound and described by Ferguson as "one of the half-dozen midwives of the modernist aesthetic in poetry," a statement which can be extended to his influence upon the plastic

1) Letter from Joseph Conrad to R.A. Scott-James, 13 March 1915.

arts in Britain, he has thus far gone unrecorded in the British *Dictionary of National Biography*.

Joseph Conrad, well into his fifties and on the cusp of fame when introduced to Hulme, was born to minor nobility in Poland. Orphaned and exiled at an early age, he sailed the seas for some fifteen years before settling down in 1893 as a naturalized Englishman to write, in his third language (French being his second), a series of novels, novellas, and essays many of which have come to be regarded as seminal works in the modernist canon. *Heart of Darkness* (1899), his extraordinary indictment of modern civilization, perhaps stands chief among these (Fig. 3). His novel *Chance*, published in 1914, both established him as a commercial success and signalled that his most innovative

work was well behind him, although he continued to write until his death in 1924.

After their mysterious meeting, Ferguson notes, Conrad and Hulme "went their separate ways"—Hulme, no doubt, to one of London's many Bohemian salons, melting pots of the avant-garde; Conrad to his large, comfortable, isolated Kentish farmhouse. But what intellectual route had they travelled which brought them close enough for Curle to decide upon the wisdom of a rendezvous?

Hulme's uncompromising philosophical position amounted to a wholesale rejection of what he considered to be a long-prevailing tradition of anthropocentric thought in which the notion of human "goodness" advancing along a continuum of "progress" was paramount:

Before Copernicus, man was not the centre of the world; after Copernicus he was. You get a change from a certain profundity and intensity to that flat and insipid optimism which, passing through its first stage of decay in Rousseau, has finally culminated in that state of slush in which we have the misfortune to live. [3]

2) Unidentified photographer, bust of T. E. Hulme by Jason Epstein, frontispiece to Speculations, ed. Herbert Read (London, 1936).

This slide into the slush of subjectivism Hulme would trace back to losing sight of the "sane classical dogma of Original Sin" (117), a religious principle which made clear man's proper, "fixed and limited" (116) place in the eternal scheme of things. The sickly symptoms attending this subjectivist fallacy—"that man, the individual, is an infinite reservoir of possibilities" (116)—could be read in all the forms of essentially heretical, humanist, expression which had prevailed since science and reason began to displace the awe-struck reverence of the Middle Ages: Naturalism, Realism, Romanticism and, finally, Impressionism.

Hulme's doggedly anti-humanist thesis played an important part in later critical and cultural interpretations of Modernism as an extreme movement with unsavory political and social implications. His more specific (but related) foray into the field of aesthetics was, by his own admission, heavily influenced by the theories of the German "psychologist of style," Wilhelm Worringer (1881-1965). Worringer's work of 1908, *Abstraction and Empathy* (*Abstraktion und Einfuhlung*), whose importance cannot be understated in the history of modernist thought, argued that artistic expression should not be read in terms of a linear progress through a vocabulary of ever "improving" styles, but seen in terms of a "will-to-form" determined by man's ever-changing psychological relationship with the world.

Thus (in Hulme's epitome of Worringer), "Abstract" expression, such as the schematic, geometrical forms characterizing "primitive" art, indicates not a lack of technical facility or inability to "copy from nature," but a search for formal certainty—"an absolutely enclosed material individuality"—in a world of "flux" beyond ready comprehension (89). Conversely, expression characterized by "Empathy," such as that embodied in the naturalistic forms of the Renaissance, is no more or less accomplished than "primitive" art, just symptomatic of a confidence in the world as it appears, a willingness on the part of the artist to repose in, rather than to seek an escape from, nature.

Worringer's thesis offered Hulme an excellent theoretical framework in which to locate the new forms of non-representational expression emerging from the studios and studies of his peers and, crucially, to do so by way of propagandizing his own cultural manifesto: "this is really the point I am making for—that the re-emergence of geometrical art may be the precursor of the re-emergence of the corresponding attitude towards the world, and so, of the break up of the Renaissance humanistic attitude" (78). Hulme saw—first in the post-Impressionism of Gauguin, Maillol, and Brancusi (94), and subsequently (and more forcefully) in the inorganic, geometric work of his friends Wyndham Lewis, Gaudier-Brzeska, David Bomberg, William Roberts, Lawrence Atkinson, and Jacob Epstein—a hardening towards abstraction. This suggested to him that modern man (one might say "modernist man") stood far closer to "primitive" man in his efforts to seek "refuge from the flux and impermanence of outside nature" (86) than to his more recent humanist forebears, whose "happy pantheistic relation" (86) with the world resulted in an essentially naturalistic art. Hulme's own chosen form of expression, Imagism, stood, of course, as testimony to the urge to abstraction, in which language, rather than serving to convey or represent some aspect of the world subjectively conceived, was stripped down to the purest possible approximation of "the thing itself."

In his personal assault upon the "Renaissance humanistic attitude," Hulme found no more satisfying or immediate target than Impressionism, a movement which represented at its apotheosis a "deification of the flux" (94), a kind of excessive, late-Romantic or "Empathic" celebration of the world, and thus the exact counterpoint of the abstraction witnessed in the new modern geometric art or, indeed, in his own Imagism. Hulme's attack upon Impressionism was broad. But were he to be looking for a specific flag-bearer for the movement, many commentators would agree that no better candidate

> 1899.] *The Heart of Darkness.—Conclusion.* 657
>
> "I pulled myself together and spoke slowly.
>
> "'The last word he pronounced was—your name.'
>
> "I heard a light sigh, and then my heart stood still, stopped dead short by an exulting and terrible cry, by the cry of inconceivable triumph and of unspeakable pain. 'I knew it—I was sure!' She knew. She was sure. I heard her weeping, her face in her hands. It seemed to me that the house would collapse before I could escape, that the heavens would fall upon my head. But nothing happened. The heavens do not fall for such a trifle. Would they have fallen, I wonder, if I had ren-dered Kurtz that justice which was his due? Hadn't he said he wanted only justice? But I couldn't. I could not tell her. It would have been too dark—too dark altogether. . . ." *
>
> Marlow ceased, and sat apart, indistinct and silent, in the pose of a meditating Buddha. Nobody moved for a time. "We have lost the first of the ebb," said the Director, suddenly. I looked around. The offing was barred by a black bank of clouds, and the tranquil waterway leading to the uttermost ends of the earth flowed sombre under an overcast sky—seemed to lead also into the heart of an immense darkness.

3) First serial publication of *The Heart of Darkness* in Blackwood's *Edinburgh Review*, February-April 1899, last page.

might be found than Conrad. Indeed, R. A. Scott-James, the recipient of the letter quoted at the start of this essay, wrote in 1908 of his correspondent's ability "to apply the modern spirit of self-consciousness to the panorama of nature," a virtual definition of Impressionism or, indeed, of the subjective investment in the world characterizing Worringer's "Empathy." [4]

Back, then, to the unsuccessful meeting in the Strand. Did Hulme see in Conrad an aging Impressionist responsible for "deifying the flux"? Was Hulme's search for certainty in abstract form so much nonsense to Conrad? It is time to indulge in our own speculations, and imagine what might have happened if, rather than the hapless Curle, it had been Wilhelm Worringer who had brought these two figures together in the obscure hotel. For he, more clearly than anyone else, would have been able to see that, far from being poles apart in their thinking, the younger and the older man were in fact arguing from two sides of the same coin he had himself used to cash out his aesthetic theories.

First and foremost, Worringer would have chastised Hulme (who had travelled to meet him in Berlin in 1913) for burying the essentially dialectical quality of his thesis in favor of adopting "abstraction" as a battle cry for the new geometrical work of his friends.[5] He might have reminded him that while

abstraction and empathy "are antitheses which, in principle, are mutually exclusive," in actual fact, "the history of art represents an unceasing disputation between the two tendencies," capable even of attaining a synthesis which "finds its apotheosis in Gothic." [6]

Next, by way of instruction, he might have pointed to certain passages in works by none other than Conrad himself which might serve as the very model for his dialectical thinking. Famous passages such as that from the preface of *The Nigger of the Narcissus*, in which the artist's duty is described:

> *To snatch in a moment of courage, from the remorseless rush of time, a passing phase of life is only the beginning of the task. The task approached in tenderness and faith is to hold up unquestioningly, without choice and without fear, the rescued fragment before all eyes and in the light of a sincere mood.* [7]

For if the "remorseless rush of time" can be read here as a synonym for Impressionistic flux, what else is the "rescued fragment" (Worringer might have argued) but Hulme's own abstract "enclosed material individuality"? A pure, hard prose fragment, for example, such as can be found in *Heart of Darkness* when Marlow's Impressionistic musings upon "A continuous shower of small flies" that "streamed upon the lamp, upon the cloth, upon our hands and faces"[8] suddenly throws out a piece of shrapnel in the form of the manager's boy's proclamation: "Mistah Kurtz – he dead." (This piece of shrapnel, it is worth noting, is embedded as the epigraph-epitaph to "The Hollow Men" by T. S. Eliot, who described his own poem *The Waste Land* as "fragments I have shored against my ruin.")

Heart of Darkness also contains the famous passage in which Conrad, through his narrator's description of Marlow's story-telling technique, reveals his own:

> *to [Marlow] the meaning of an episode was not inside like a kernel but outside, enveloping the tale which brought it out only as a glow brings out a haze, in the likeness of one of those misty halos that, sometimes, are made visible by the spectral illumination of moonshine.* [9]

The critic Ian Watt has pointed to this as a metaphor for two distinctive qualities in Conrad's novel, which he sees as Symbolist ("the abstract geometry of the metaphor") and Impressionist ("the sensory quality of the metaphor").[10] But we might draw this theory out further to suggest that Conrad is playing with the process of antithesis and synthesis familiar to Worringer, in which a constant interplay can be found between two apparently opposing expressive impulses: the abstract hardness of the kernel or the moon both disclosed by and disclosing the Impressionistic, Empathic, flux of the "outside" haze or mist.

The idea of a conjunction between the Impressionistic on the one hand and the Abstract on the other, the vague and the exact, finds in Conrad's own

aesthetic a perfect exemplar: the characteristics of language itself. Thus again in his preface he states that

> it is only through complete, unswerving devotion to the perfect blending of form and substance; it is only through an unremitting, never-discouraged care for the shape and ring of sentences that an approach can be made to plasticity, to colour; and the light of magic suggestiveness may be brought to play for an evanescent instant over the commonplace surface of words: of the old, old words, worn thin, defaced by ages of careless usage (xlix).

How interesting, then, that Hulme, writing on Bergson, should arrive at a position in which he considers the artist (in the widest sense) capable of seizing what is vivid and real from the devalued currency of words:

> It is not sufficient to say that an artist is a person who is able to convey over the actual things he sees or the emotions he feels. It is necessary before that he should be a person who is able to emancipate himself from the moulds which language and ordinary perception force on him and be able to see things freshly as they really are (166).

Returning to Conrad, what set of cultural circumstances might require this focus on form and shape? What engenders the artist's "approach to plasticity" which so strongly anticipates Hulme's quest for certainty in an "enclosed material individuality"? Nothing less than the stripping away of the "temporary formulas of his craft":

> Realism, Romanticism, Naturalism, even the unofficial sentimentalism (which, like the poor, is exceedingly difficult to get rid of); all these gods must, after a short period of fellowship, abandon him—even on the very threshold of the temple—to the stammerings of his conscience and to the outspoken consciousness of the difficulties of his work.[11]

Conrad here rejects the humanist tradition also rejected by Hulme. His vision of the artist, denied the comfort of his amenable "gods" to face the "the stammerings of his conscience" and the difficulty of his work, seems the very definition of Worringer's own "urge to abstraction" and "the outcome of a great inner unrest inspired in man by the phenomena of the outside world."[12]

After all, didn't each man acknowledge, as Worringer did, that "[h]aving slipped down from the pride of knowledge, man is now just as lost and helpless vis-à-vis the world picture as primitive man"(18)? Wasn't Conrad's Mr. Kurtz, a civilized "emissary of light," nothing less than Hulme's "humanist" laboring under his delusions of progress and continuity? And when Kurtz "stepped over the edge" in his rejection of those values to embrace "savagery,"

did he not anticipate, in his brutally honest acknowledgement of being "lost and helpless," Hulme's call for "the re-establishment of the temper or disposition of mind which can look at a gap or chasm without shuddering" (4)?

Curle, it seems, was pursuing a good logic. The closer one looks, the more likenesses begin to reveal themselves between Conrad and Hulme—likenesses owed to a common intellectual inheritance most immediately embodied in the form of Wilhelm Worringer, but which can be traced all the way back to the dialectical aesthetics of Kant and Hegel. Perhaps, after all, the meeting in the Strand broke up not as the result of a failure to understand each other's point of view but because it became all too obvious that underlying their ostensibly different positions, each was really saying the same thing, thus leaving little else to be said.

NOTES

1. Wyndham Lewis, *Blasting & Bombardiering* (London, 1937), 105.

2. Robert Ferguson, *The Short Sharp Life of T. E. Hulme* (London, 2002), 149. Ferguson's source is unclear. In his *Caravansary and Conversation* (London, 1937), Curle notes, "I did once try the experiment of bringing Conrad and Hulme together: it was not a success."

3. T. E. Hulme, *Speculations: Essays on Humanism and the Philosophy of Art*, ed., Herbert Read (London, 1924), 80.

4. R. A. Scott James, *Modernism and Romance* (London and New York, 1908), 234.

5. Robert Ferguson notes that what Hulme "added to Worringer was an application of his perception to modern times. He 'Hulmified' it and slotted it into his own developing Weltanschauung, relating it to the truth of original sin and using it as further proof of his theory that progress was a myth" (154).

6. Wilhelm Worringer, *Abstraction and Empathy: A Contribution to the Psychology of Style*, translated by Michael Bullock (London, 1953), 45- 48. First published as *Abstraktion und Einfühlung: ein Beitrag zur Stilpsychologie* (Munich, 1908).

7. Joseph Conrad, *The Nigger of the Narcissus*, ed. Cedric Watts (London, 1988), xlix.

8. Joseph Conrad, *Heart of Darkness*, ed., Richard Kimbrough (New York, 1988), 68-69.

9. *Heart of Darkness*, 9.

10. Ian Watt, *Conrad in the Nineteenth Century* (Berkeley and Los Angeles, 1979), quoted in Kimbrough, 312.

11. *Nigger of the Narcissus*, l.

12. *Abstraction and Empathy*, 15.

"MAKE IT NEW": THE RISE OF AN IDEA

KURT HEINZELMAN

Let's start with commonsense. If modernism isn't about what's new, then what on earth is it about? The problem with commonsense, though, is that it's often at odds with history, which uses a different shutter speed and has a different depth of field than the evolution of ideas. In the case of newness, most of human history has not regarded it as a virtue.

The sixteenth-century poet Thomas Wyatt (and many of his male compatriots) spoke of their lovers as practicing "newfangledness," a newly minted term referring to women who were susceptible of "chaunge," vulnerable to "muta-bilitie" of affections, and liable to be (another newly coined word) "beguil'd." These sexist innuendoes regarding newness—particularly women practicing new feelings as if they were new fashions—have never died away. They may even lie behind the Marxist critic Walter Benjamin's dour one-liner, "Fashion is the eternal recurrence of the new."[1] But sexism acquired a new political legitimacy when what was new began to be understood not just as a kind of beguilement but as a form of sedition and treason, a deviation from ancient and fixed, solid and traditional. This change started happening in Wyatt's time and attained full exposure in the middle of the seventeenth century.

A new valorization of "the new" also came to pass in the latter part of the eighteenth century when a relatively uncontroversial word radically changed its meaning. I am speaking of the word "original" which, in its changed form, became a keyword both in political and aesthetic theory.

Heretofore, what was original was what went back to origins. Originality was grounded in the *auctoritee* of the past, and this authority was accessed by the "new" writer primarily through the device of allusion. This device only works, of course, if the reader has the same educational background, or at least shares the same cultural milieu, as the author. That is why John Milton doesn't sound more alarmed in *Paradise Lost*, his late seventeenth-century epic, when he admits that his audience is "fit...though few." Fitness was more important than size. When the narrator appears to boast at the beginning of the poem that his "advent'rous Song" "with no middle flight intends to soar / Above th'Aonian Mount, while it pursues / Things unattempted yet in Prose or Rhyme," Milton trusts the reader to recognize that his is not a claim for innovation.[2] In fact, Milton's assertion alludes, albeit ironically, to the opening of *Orlando Furioso*, an early sixteenth-century epic, where Ariosto makes the same claim, knowing full well that the Roland story had been attempted any number of times before him. Like Ariosto, Milton is not saying that he will do something wholly new but only something that newly engages the *topos* or theme of newness, inherited wholesale from the authority of the past.

Slightly before the outbreak of the French Revolution—if one were being somewhat playful one could say in precisely 1759—the meaning of "original-ity" changed from "going back to origins" to "being without origins." This date marks the publication of Edward Young's *Conjectures on Original Composition*, and Young's monograph is the direct ancestor of Ezra Pound's

commandment, "make it new," which is by far the most famous poetic slogan of the twentieth century.

Pound's phrase is often cited by both scholars and practitioners of all the arts (and not just of poetry) to explain modernist principles. The phrase is almost always understood to call for a creation *ex nihilo*, out of nothing, without regard for tradition but with the highest regard for individual talent and craftsmanship. To Americanists, this meaning of "make it new" is grounded in Ralph Waldo Emerson's nineteenth-century idea of the American as some-one who looks at the world as if no one had looked at it before.[3]

It is often erroneously claimed, and almost universally assumed, that, as one scholar put it as recently as 2002, "Ezra Pound urged American poets [to 'make it new'] in 1914."[4] Neither this phrase nor (arguably) this exact senti-ment appeared in Pound's work, however, until his career was almost half over, some twenty years later. (If I were to speculate on who came closest in 1914 to saying the equivalent of "make it new," at least in the sense that phrase has come to possess, I would cite Ford Madox Hueffer's wish "to register my own times in terms of my own time...,[preferably] in the language of my own day."[5]

So far as I can tell, Pound uses the phrase "make it new" for the first time in canto 53, written probably in the early 1930s but not published in book form until 1940. The phrase is also used for an eponymous book, *Make It New*, published in 1934 or two years before William Butler Yeats's epoch-making anthology *The Oxford Book of Modern Verse* appeared. In Pound's book, the phrase "make it new" appears only on the title page where it is accompanied by four Chinese characters (Fig. 1). The meaning of these char-acters is not explained anywhere in the book, though the essays, dating back twenty or twenty-five years, are almost all on the art of translation. Nor are these characters explained explicitly in canto 53, though we can see that their form is chiastic. Their meaning, we now know, could be rendered, *make new, day by day, make new*, the "it" of "make it new" being an interpolation.[6]

About the craft and cultural value of translation Pound made repeated and consistent claims, both early and late in his career: "every new exuberance, every new heave is stimulated by translation, every allegedly great age is an age of translation."[7] What Pound equates with the new, though, is not the making of an original work of art *ex nihilo* but the excavating of what had not been apprehended before, by means of translation, from a prior act of creation.

To think of the imperative "make it new" *as a call for translation as if it were a kind of original composition*, is to remind oneself that the new, eigh-teenth-century meaning of "originality" itself mistranslates the Latin verb *innovare* to which it would seem to have direct affinity. The primary sense of *innovare* in Latin is "to renew" or "to restore" or, more exactly, "to add some-thing new to," not "to create anew." The "in-" prefix is an intensifier, like the "in-" of "inflame." *Innovare* means essentially to introduce some new element into what was already given, rather than to create originality out of formless-

ness. The English word "innovate" is, therefore, an innovative variant on its own Latin root.

Ideas are in part—some would assert in very large part—a function of the language that expresses them. Because we are seeking to understand here the commonsensical association between "the modern" and "the new," and because "make it new" has been so germinal for so much of the past century, it is vitally important to understand this phrase's origins.

The phrase is not original. That's my first point. It means exactly the opposite of what commonsense tells us it means. That's my second point. To suggest the causes and consequences of these misunderstandings is my small purpose in this essay.

To start with, Pound came across the Chinese ideograms in an eighteenth-century work written in French, J.-A.-M. de Moyriac Mailla's *Histoire Générale de la Chine*. Mailla was a French missionary who had set out to compose the history of China from known Chinese documents. He used contemporary—that is, eighteenth-century—Manchuan versions of twelfth-century Chinese texts by a group of neo-Confucians led by Chu Hsi. The passage that most resonated for Pound is by the emperor Tching Tang who reigned in the mid-eighteenth century B.C. or some 3000 years before the oldest translation Pound used. We are told by Pound that Emperor Tching, the founder of the Shang dynasty,

> prayed on the mountain and
> > wrote MAKE IT NEW
> on his bath tub.[8]

What Tching actually wrote in the 18th century B.C. resembled the four characters given on the title page of Pound's 1934 book, *Make It New*, but what Pound read first were these words written in the 18th century A.D.: "*& fit graver sur le basin dont il se servoit tous les matins pour se laver le visage,*

1) Ezra Pound, *Make It New* (London, 1934), title page.

ces paroles: Souviens-toi de te renouveller chaque jour, & plusieurs fois le jour...." One of the few Poundians to go back to the original French, Douglas Mao, a North American scholar of Chinese origins, observes, "It is surely worth noting how...Pound's...transformation of 'Souviens-toi de te renouveller' into 'Make it new'...not only shifts the locus of newness from subject [*toi*] to object ('it') but adds a suggestion of material fabrication simply absent from Mailla's phrase."[9] Fabrication is absent, yes, but "make it new" here actually means the physical, material act of washing one's face. Also important to notice, perhaps, is that Pound's phrase MAKE IT NEW is not merely a mistranslation but a kind of cultural sounding: it is a translation (from French) of a translation (from Manchuan or Mongolian Chinese) of a translation (from twelfth-century neo-Confucian Chinese) of a text of greater antiquity than the earliest parts of the Hebrew Bible. So, what is "new" has here passed through four excavations, traversing nearly four millenia.

Pound's faith in the translatability of languages is analogous to Mailla's Enlightenment faith in history and knowledge. Pound believes there is transubtantive force in language itself, a renewableness that is precisely contained in Mailla's word *renouveller*—a word that better translates, in fact, the Latin idea of "innovation" than its English cognate does. The poet, or maker, is one who can best *carry* that renewable force *across* from language to language. In saying so, I am merely translating the literal meaning of the Latinate roots, *trans-* and *-latio*, even as Pound's 800-page work called *The Cantos* translates classical epic into a very long modern poem that derives its title not from the name of a hero (as in *The Odyssey*, *The Aeneid*, or *Orlando Furioso*) but from the name of the compositional unit that carries epics. Yeats thought he was criticizing Pound for "not [getting] all the wine into the bowl" when he compared Pound to "a brilliant improvisator translating at sight from an unknown Greek masterpiece."[10] In fact, the apotheosis of translation into the vehicle for disclosing what remains new about antiquity is one of Pound's most luminous claims.

Perhaps the happiest, or at least the most Poundian, moment in the history of "making it new" occurred in the fourteenth century. Dante's pilgrim meets in canto 26 of the *Purgatorio* several poetic interlocutors who, while alive, had bequeathed him the "new style" of his own verse practice. The second of these, Guido Guinizzelli, modestly wonders at Dante's admiration of him and then diverts Dante's praise to one whom Guido calls a "better artisan of the mother tongue" (*miglior fabbro del parlar materno*).[11] This better maker is the great Languedoc poet Arnaut Daniel, who lived about a century before Dante and whose mother tongue was not Italian at all but Provençal. As Dante approaches Arnaut, the elder poet speaks. Remember that Dante made a radical choice from the outset to write his epic in his own vernacular, the northern Italian dialect, rather than in Latin. The convention of the *Commedia* is that everyone (including Rome's greatest poet, Virgil) speaks Dante's historical language. But not Arnaut. Arnaut, whose chiseled style inspired Pound to translate his little-known (in the twentieth century) poetry into English as well as to write a linguistics dissertation on the langue d'oc itself, speaks to Dante in *his* vernacular. But in doing so, Arnaut also rhymes his language with Dante's. Dante's pilgrim says that Arnaut "began to speak freely to me," but the Italian word for speak, *dire*, is almost immediately rhymed by Arnaut himself, who replies that he neither would nor could conceal himself (*cobrire*) from the pilgrim.

Arnaut goes on to speak a total of eight lines, but Dante has the last word. Literally, his pilgrim speaks the last line of the canto, and the last word of that last line, *affina* (refines), rhymes with Arnaut's *al som de l'escalina* (at the top of the stairs). In effect, Dante has returned Arnaut's compliment, climbing arm-in-arm with him the staircase of a century's poetic practice.

This cross-rhyming between Italian and Provençal will remind modern readers—like ourselves, like Pound—of the way Faust teaches Helen the modern device of end-rhyme in Goethe's epic play written five centuries after Dante. Helen is both shocked and charmed to hear how German can link like-sounds in ways unknown to her classical Greek. As Faust in the play teaches Helen how to do it, their cross-rhyming enacts a kind of copulation and out of its music a child is born who is named Euphorion and whose allegorical identity is understood to be Goethe's younger contemporary, Lord Byron. As Goethe makes clear elsewhere, Byron was the last modern poet to marry ancient Greek thematics with modern poetics; indeed he lost his life fighting for Greek independence. And it was Byron who provided Ezra Pound with one of his first and most durable models for the composition of *The Cantos*.[12] Like Pound's *Cantos* (and utterly unlike Dante's epic), Byron's book-length poem *Don Juan* is a centerless (or multi-centered) digressive poem that both is very, very long and finds its creative impetus not in a predetermined story-line but in the author's will to sustain the piece as long as he can continue writing.

Here, then, is a kind of snapshot or series of snapshots or historical *kinema* of what "make it new" came to mean for Pound. In part, these moving pictures reveal Pound's deepest faith that all languages rhyme. Or, more precisely, that they can be *made* to rhyme. It is the making that is new and that must be discovered anew by those who are modern, but the true makers are as old as language itself. To put it another way, the "it" in the phrase "make it new" may be understood to constitute a hitherto uncatalogued archive of past poetic practices, and the "making" is an act of archival retrieval and arranging. Ultimately, Pound's phrase "make it new" does not mean "make it new once and for all" but rather, "find out what is new about the old, and do so again and again." Pound's sense of "the new" is that it is an archive which is not exhausted by being boxed and sorted, not depleted by being used and exhibited.

That Pound's oft-cited phrase has been so often misunderstood as sponsoring unsponsored originality—an anti-archival sentiment—is curious, but what is curiouser and curiouser is how the phrase itself arrives on the scene so late in the history of modernist practices. By the thirties, Modernism had either peaked, many would say, or was in decline. The history of "make it new" therefore duplicates—or rather, rhymes with—the history of the word "Modernism" itself, for that word was applied only retroactively to artistic practices in the first half of the twentieth century. A recent scholar says that the term emerges "as a category of literary study" in the 1930s, which makes it exactly coincident with Pound's use of the phrase "make it new."[13] Like most period names for historical epochs, therefore, "Modernism" came belatedly, after what was aesthetically new about the period was no longer entirely news.[13] Like "make it new," "Modernism," too, is archival; it is a way of archiving modernity.

Maybe we are now in a position to understand better why the conjunction between "the new" and "the modern" is so attractive to commonsense. The beguiling premise that originality begins in the present distracts us from a more unsettling, even shocking, paradox identified by our contemporary, the sociologist Bruno Latour, that we have never been—nor perhaps will we ever be—modern.[14]

I am very much indebted to Brian Bremen for helping me think through some of the implications of the present essay.

1. "Central Park," trans. Lloyd Spencer, *New German Critique*, 34 (Winter 1985), p. 46; cited in Peter Nicholls, *Modernisms: A Literary Guide* (Berkeley: U. of California Press, 1995), p. 7.

2. *Paradise Lost*, I.12-5, in *Complete Poems and Major Prose*, ed. Merritt Y. Hughes (New York: Odyssey Press, 1957).

3. Never mind, as William Carlos Williams would later point out, that the first Anglo-Americans came to the New World and looked, say, at a thrush-sized bird with a brick-red breast, its coloration going almost to its stomach, and called this bird a robin, after the sparrow-sized bird which sports a little rosy blush under its neck, which they knew in England. These were not settlers who were seeing the world with "original" or transparent eyeballs but rather people translating known verbal terms into new ornithological forms.

4. Alfred Appel, Jr., *Jazz Modernism: From Ellington and Armstrong to Matisse and Joyce* (New York: Alfred A. Knopf, 2002), p. 27. See also Lynn Keller, *Re-making It New: Contemporary American Poetry and the Modernist Tradition* (Cambridge: Cambridge U. Press, 1987), p. 3: "Anglo-American poetic modernism took shape in the years immediately preceding and following World War I, when a number of young poets were struggling to revitalize the techniques of their art, or in Ezra Pound's words, to 'make it new.'" The point is not to criticize these scholars but only to suggest how ubiquitous the equation is between "make it new" and the years surrounding the *First* World War, rather than the years leading up to the *Second*.

5: See Ford Madox Hueffer, "Preface," *Collected Poems* (London: Max Goschen, Ltd., 1914), p. 13, 28. Curiously, Hueffer, who claimed he had been speaking this same wish for twenty-five years, cited "Mr. Pound" by name as someone who did not believe in making poetic language truly contemporaneous.

6. Carroll F. Terrell, *A Companion to The Cantos of Ezra Pound* (Berkeley: U. of California Press, 1993), p. 205.

7 *Literary Essays of Ezra Pound*, ed. T. S. Eliot (New York: New Directions, 1968), pp. 34-5.

8. *The Cantos of Ezra Pound* (New York: New Directions, 1970), Canto LIII, p. 265.

9. Douglas Mao, *Solid Objects: Modernism and the Test of Production* (Princeton: Princeton U. Press, 1998), p. 279.

10. W. B. Yeats, "Introduction," *Oxford Anthology of Modern Verse* (New York: Oxford U. Press, 1936), p. xxvi.

11. All quotations from Dante's *Purgatorio* are from the verse translation by Allen Mandelbaum (New York: Bantam, 1984). The pilgrim here replies to Guido's modesty, "It's your sweet lines that, for / as long as modern usage (*l'uso moderno*) lasts, will still / make dear your very inks." The honorific use of "modern" is noteworthy, for Guido is not a modern: he died in exile while Dante the poet was just an infant. Dante's narrator is speaking archivally, praising modern—that is contemporary—usage for keeping old Guido's lines sweet… against all odds, against commonsense.

12. See Pound's letter to H.L. Mencken of 18 April 1915 in *The Letters of Ezra Poiund 1907-1941*, ed. D. D. Paige (London: Faber & Faber, 1951), p. 102: "As to the best form [of a book of cantos]. A long, really long narrative like *Juan* is probably the best. . . ." The first, and still the best, short study of Pound's ur-cantos is Myles Slatin, "A History of Pound's *Cantos I-XVI*, 1915-1925," *American Literature* 30.2 (May 1963): 183-95.

13. Sara Blair, "Modernism and the Politics of Culture," in *The Cambridge Companion to Modernism*, ed. Michael Levenson (Cambridge: Cambridge U. Press, 1999), p. 157. With greater space and time, I would be inclined to speculate that what was new in the early 1930s—that is, frighteningly new, the way newness had been regarded since at least the European Renaissance—was the figure of the "new" Jew, whom T. S. Eliot in his lectures of 1933 called "free-thinking" and whom Pound was also castigating at this time. How members of the world's oldest organized religion came to be seen as horrific figures of modern "newness" is another story, but it is not unrelated to the present one.

14. Bruno Latour, *We Have Never Been Modern*, trans. Catherine Porter (Cambridge: Harvard U. Press, 1993).

MODERNISM'S QUEST FOR INVISIBLE REALITIES

LINDA DALRYMPLE HENDERSON

When Ezra Pound reflected in 1913 on what was required to be a "serious artist," he turned to contemporary science to demonstrate the type of vitality he envisioned: "We might come to believe that the thing that matters in art is a sort of energy, something more or less like electricity or radioactivity, a force transfusing, welding, and unifying."[1] Significantly, Pound did not cite Einstein or Relativity Theory as the touchstone for the new creation, but rather the radioactivity and electricity (and electromagnetic waves) that were central to the era's sense of a radically new paradigm of reality. Specifically, this was an invisible world of forms and energies just beyond the grasp of human perception that had been revealed by a series of highly publicized scientific discoveries in the late 1890s. Of these revelations, which included the X-ray (1895), radioactivity (1896, 1898), and the electron (1897), as well as the emergence of wireless telegraphy based on Hertzian waves, the X-ray photograph was unquestionably the single most important sign of this new invisible realm.

1) Early X-ray (1896-97).

The other major indicator of early Modernism's preoccupation with the invisible was the highly popular concept of a spatial "fourth dimension," of which our familiar three-dimensional world might be simply a cross-section. Once again, this was not the now more familiar definition of the fourth dimension as time in the space-time continuum of Relativity Theory, which had first been formulated by Hermann Minkowski in response to Einstein's original formulation of Special Relativity in 1905. That view of time as a fourth dimension linked to three dimensions of space in "space-time" would not become widely known until 1919. In that year experiments during a solar eclipse confirmed one of the postulates of Einstein's 1916 General Theory of Relativity, and he became an international celebrity. Before that point, however, from the 1880s to the 1920s, the fourth dimension was almost universally understood as a suprasensible spatial phenomenon.[2] In the current exhibition both E. A. Abbott's dimensional allegory of 1884, *Flatland: A Romance of Many Dimensions by a Square*, and Claude Bragdon's *A Primer of Higher Space (The Fourth Dimension)* of 1913 represent this other major element of the modernist world view.

The challenges to traditional conceptions of external reality offered by the X-ray and the fourth dimension were accompanied by a growing recognition in the later nineteenth century that the perceiving self was likewise more complex than previously thought. Sigmund Freud, often cited, like Einstein, as one of the key arbiters of Modernism, connected the two realms in *The*

Interpretation of Dreams (1900). The unconscious, which is "the true psychical reality," Freud said, "is just as imperfectly communicated to us by the data of consciousness as the external world by the reports of our sense organs."[3] However, before Freud's theories gained their broad following in subsequent decades, a different approach to the issue of consciousness was highly influential around the turn of the century and retained a remarkable staying power. This was the belief in the ongoing evolution of consciousness to higher states, represented in the exhibition by Dr. Richard Maurice Bucke's paper "Cosmic Consciousness," read before the American Medico-Psychological Association in 1894. Bucke, a Canadian physician and disciple of Walt Whitman, developed his ideas fully in his 1901 book *Cosmic Consciousness: A Study in the Evolution of the Human Mind*, which, directly and through its incorporation into P. D. Ouspensky's 1911 *Tertium Organum*, had a profound impact on a number of modernist writers and artists.

All three of these phenomena—the X-ray, the spatial fourth dimension, and cosmic consciousness—stimulated bold innovation on the part of artists, writers, and musicians who felt the inadequacy of present language to express the complexity of new realities, both external and internal.

Although the existence of an invisible realm that might be intuited by the sensitive artist or poet was already a leitmotif of the Symbolist era, everything changed with Wilhelm Conrad Röntgen's discovery of the X-ray in 1895 (Fig. 1). An invisible world beyond human perception was no longer a matter of purely mystical or philosophical speculation; it was now empirically established as scientific fact. Röntgen's publication of his findings triggered a massive scholarly and popular response in the form of thousands of articles and books as well as cartoons, poems, and songs. The immediate impact of the X-ray was to make solid matter transparent, revealing previously invisible forms and suggesting a new, more fluid relationship of those forms to the space around them. That lesson was to be central for French Cubist and Italian Futurist painters. As the Futurist Umberto Boccioni declared in April 1910, "Who can still believe in the opacity of bodies? Why should we forget in our creations the doubled power of our sight, capable of giving results analogous to those of the X-rays?"[4] Modern writers such as H. G. Wells (*The Invisible Man*, 1897), August Strindberg (*The Ghost Sonata*, 1907), and Thomas Mann (*The Magic Mountain*, 1924) also responded creatively to the penetrating vision provided by the X-ray.

Yet the extrasensory reality revealed by X-rays pointed to an even more fundamental lesson of Röntgen's experiments: the inadequacy of human sense perception. As the astronomer Camille Flammarion argued in his book *L'Inconnu* [The Unknown] of 1900, "The late discovery of the Röntgen rays, so inconceivable and so strange in its origins, ought to convince us how very small is the field of our usual observations.... This is indeed a most eloquent example in favor of the axiom: it is unscientific to assert that realities are stopped by the limit of our knowledge and observation."[5] Popular articles on X-rays often included diagrams charting the ranges of invisible radiations of varying frequencies surrounding the narrow band of visible light perceptible to the human eye. As identified fully in later years, the electromagnetic spectrum extends from gamma rays through X-rays, ultraviolet, visible light, infrared, and microwaves to radio waves (i.e., the Hertzian waves supporting the then-new wireless telegraphy); their wavelengths range from 1 billionth of a meter for X-rays, to 1 millionth of a meter for visible light, to anywhere between one meter and a kilometer for radio waves.

Both the X-ray and the Hertzian waves of wireless telegraphy focused public attention on a new image of space as filled with vibrating waves. Conceptions of matter were likewise challenged at this moment. If the X-ray made objects transparent, their very solidity and stability was overturned by J. J. Thomson's identification of the speeding electron in 1897 and the revelation that the new radioactive elements discovered by the Curies in 1898 were continuously emitting subatomic particles. Individuals could observe these emissions in their homes using the popular "spinthariscope," a tiny cylindrical instrument in which alpha particles from a speck of radium produced flashes of light as they struck a zinc-sulphide screen within.[6] Scientific popularizer Gustave Le Bon, author of the bestselling *L'Evolution de la matière* of 1905, believed that radioactivity was a universal phenomenon and argued that all matter was simply "a stable form of intra-atomic energy" in the gradual process of decaying back into the ether, the hypothetical medium believed to fill all space and serve as the transmitting vehicle for wave vibrations.[7] Like the X-ray, the world-filling ether—thought possibly also to be the very source of matter itself—was a central tenet of early Modernism's view of reality as a realm of cohesion, diffusion, and vibration.

Like the concept of a fourth dimension of space, the ether was largely displaced from the popular scientific worldview with the 1920s triumph of Relativity Theory, which denied any mechanical properties to such an etherial medium and redefined the fourth

2) E. A. Abbott, *Flatland: A Romance of Many Dimensions* by A Square (1884).

dimension as time.[8] Unlike the ether, however, the spatial fourth dimension lived on in a variety of guises through the twentieth century to return in full force by its last decades, abetted by the emergence of cyberspace and discussions of multidimensional universes in string theory in physics. The X-ray played a crucial role in the initial cultural impact of the fourth dimension: after Röntgen's discovery, who could refute the argument that such a supraspatial dimension might exist?

The theoretical notion that space might have four dimensions emerged in the wake of the development of *n*-dimensional geometries (i.e., four or more dimensions) in the first half of the nineteenth century. Abbott's *Flatland* (1884), a cautionary tale of a two-dimensional world's refusal to admit the possibility of higher dimensional space, was the first major popularization of the idea (Fig. 2). Advocates of a fourth spatial dimension found support in the revival of idealist philosophy in the later nineteenth century and often invoked Plato's allegory of the cave to suggest that the visible world might be only the shadow or section of a truer, higher-dimensional reality (Fig. 3). In addition to geometry and philosophy, the fourth dimension would soon come to be discussed in terms of mystical consciousness, infinity and the sublime, science fiction, and science itself.[9] X-rays, for example, offered a model of the clairvoyant vision a higher spatial dimension would make possible; similarly, a minute extension of the ether into a fourth dimension would explain its mysterious ability to penetrate all matter. The vast amount of popular literature on the fourth dimension from the 1890s through the 1920s makes clear the widespread public fascination with the topic.

Modern artists, in particular, were drawn to this new conception of space, which effectively undercut traditional artistic techniques such as three-dimensional perspective. Between 1908 and 1930 artists in nearly every modern movement engaged the fourth dimension: Cubists and Marcel Duchamp in Paris, Italian Futurists, Russian Futurists as well as Suprematists and Constructivists, Dutch De Stijl artists, László Moholy-Nagy of the Bauhaus, Dadaists and Surrealists, and American artists in the Alfred Stieglitz and Walter Arensberg circles as well as designer Buckminster Fuller. For authors of science fiction working in this period, such an alternative spatial realm was a natural stimulus, and Wells utilized a spatial fourth dimension in a number of his tales. Although the fourth dimension was less prevalent in other genres of modern literature, writers such as Gertrude Stein, Pound, D. H. Lawrence, James Joyce, Andrei Belyi, and Jorge Luis Borges also responded to the idea. Like many modern

artists, musician Edgard Varèse, along with Stein, believed that current languages—artistic, literary, and musical—were insufficient to deal with a completely new dimension of space.[10]

A number of these artists and writers read the works of the Russian mystic and mathematician P. D. Ouspensky, whose 1911 *Tertium Organum, The Third Canon of Thought: A Key to the Enigmas of the World* preached the evolution of human consciousness to a state of four-dimensional "cosmic consciousness." In *Tertium Organum* Ouspensky quoted extensively from R. M. Bucke's 1901 *Cosmic Consciousness*, an elaboration of his 1894 lecture (Fig. 4). Although both Ouspensky and Bragdon, who published the first translation of Ouspensky's book in 1920, tied cosmic consciousness specifically to mathematics and to a comprehension of four-dimensional space by highly sensitive individuals, Bucke argued for the eventual evolution of all humanity to a level of mystical higher consciousness unrelated to the dimensionality of space.[11]

The director of the London [Ontario] Insane Asylum, Bucke had embraced Robert Chambers's theory of progressive evolution from simple to complex forms in nature, set forth in his 1844 *The Vestiges of the Natural History of Creation*. By 1894 Bucke had focused for twenty years on the question of "mental evolution," augmenting his clinical observations with his penchant for mysticism, an extensive knowledge of world religions, and a passion for Whitman's poetry. The result was his view that the mind had developed from the lowest form of "mere excitability" through stages of simple consciousness and self consciousness and that a new level of "Cosmic Consciousness" had begun to appear. Bucke found his earliest examples of this mystical illumination and resultant "consciousness of the life and order of the universe" in the writings of the Buddha, the Apostle Paul, and Mohammed. Citing such subsequent cases as Dante, William Blake, Balzac, Whitman, and Bucke's fellow Whitmanite, the British mystic and socialist reformer Edward Carpenter—and noting their increasing frequency—Bucke believed that the human race as a whole would ultimately experience the leap from self consciousness to Cosmic Consciousness.[12]

Carpenter may well have been Bucke's source for his terminology, since the former spoke of "*universal* or *cosmic* consciousness" in his 1892 book *From Adam's Peak to Elephanta*, based on his meetings with a yoga master while traveling in India. The Hindu Upanishads were a primary stimulus for Carpenter's understanding of cosmic consciousness as "a consciousness in which the contrast between the *ego* and the external world, and the distinction

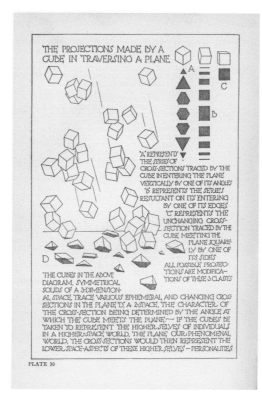

PLATE 30

3) C. F. Bragdon, *A Primer of Higher Space*, (1913), plate 30.

between subject and object, fall away," just as Bucke equated the phenomenon with the Buddhist Nirvana.[13] Unlike Bucke, however, Carpenter pointed to developments in "modern science" to buttress his case for evolving consciousness. Specifically, he noted the "extraordinary phenomena of hypnotism" and the work of figures such as Frederic Myers in demonstrating the existence of other levels of consciousness. Myers's study of spiritualist mediums to investigate the "subliminal consciousness" was characteristic of the milieu of pre-Freudian psychology that also included Karl Du Prel's theory of a "movable threshold of sensibility," set forth in his *Philosophy of Mysticism* of 1884, and William James's exploration of mystical states in his 1902 book *The Varieties of Religious Experience*.[14]

The theme of evolving consciousness, signaled in Bucke's 1894 lecture and advocated by Carpenter, is an important reminder of the alternatives to Freudian psychology that dominated early modernism—a widespread interest in Indian philosophy and mystical experience and an openness to what James McFarlane has termed the "debatable phenomena" explored by groups such as the Society for Psychical Research.[15] In an era in which many artists and writers were members of the Theosophical Society and major scientists such as Flammarion and Sir William Crookes were deeply interested in spiritualism and telepathy, the boundaries between science and occultism were clearly far more fluid than in the post-World War I era. Painter Marsden Hartley's response to Bucke's writings in a December 1912 letter to his patron Alfred Stieglitz is not atypical of the era: "It [my new style] is what I call for want of a better name subliminal or cosmic cubism.... You know that Dr. Maurice Bucke in his book on cosmic consciousness says that these varied illuminations come to the individual between twenty-five and forty, sometimes later. You know what they are for you have them yourself."[16]

In *From Adam's Peak to Elephanta* Carpenter had cited a second aspect of "modern science" to support his belief in the evolution of consciousness: speculation on the existence of a fourth dimension of space, which "makes many things conceivable which otherwise would be incredible."[17] Noting that the interiors of objects would be visible to an individual with cosmic consciousness, Carpenter highlighted the clairvoyance associated with four-dimensional vision that would subsequently be manifested by the X-ray in 1895. If the connection of cosmic consciousness to the fourth dimension was only incidental to Carpenter (and absent from Bucke's philosophy), it was

137

MAKE IT NEW: THE RISE OF MODERNISM

essential for Ouspensky's and Bragdon's geometrically oriented conception of evolutionary consciousness. Ouspensky quoted extensively from Bucke's book, but rejected his theory of general, passive mental evolution. Instead, he argued that cosmic consciousness could be attained only by certain highly developed individuals and that such figures could actually cultivate their own evolution. "Art [including painting, music, and poetry] in its highest manifestations is a path to cosmic consciousness," Ouspensky asserted. For Bucke and Carpenter, reading poetry—especially the Romantics and Whitman—had been an activity conducive to the onset of mystical cosmic consciousness. For Ouspensky, poets now needed to invent unprecedented languages for the new realms of consciousness.[18]

4) Dr. R. M. Bucke, "Cosmic Consciousness," (1894).

This belief in possibility—that human capabilities could evolve or develop as necessary to address newly revealed or theorized invisible realities—was a widely held view in the early twentieth century. In a world of pulsating energies and forces as well as potential higher dimensions, artists and poets would have to be highly sensitive registering instruments or "antennae of the race," as Pound wrote, "on the watch for new emotions, new vibrations sensible to faculties as yet ill understood."[19] Radically different languages would be necessary to respond to the complexity of the new inner and outer realities, languages that would challenge and stretch their creators and their audiences. Wassily Kandinsky summed up this view in a letter to Arnold Schoenberg after first hearing his music in January 1911: "'today's' dissonance in painting and music is merely the consonance of tomorrow."[20] The X-ray, the fourth dimension, and the belief in evolving consciousness stand as emblems of the cultural landscape that produced such optimistic visions and inaugurated the creative expression now known as Modernism.

NOTES

1. Ezra Pound, "The Serious Artist," *The New Freewoman* 10 (Nov. 1, 1913), 194.

2. See Linda D. Henderson, *The Fourth Dimension and Non-Euclidean Geometry in Modern Art* (Princeton: Princeton University Press, 1983; new ed., Cambridge, MA: MIT Press, 2004), App. A. For a fuller discussion of Einstein's theories and their reception, see Helge Kragh, *Quantum Generations: A History of Physics in the Twentieth Century* (Princeton: Princeton University Press, 1999), 90-104.

3. Sigmund Freud, *The Interpretation of Dreams*, in *The Basic Writings of Sigmund Freud*, trans. A. A. Brill (New York: Modern Library, 1938, 510.

4. Umberto Boccioni, "Technical Manifesto of Futurist Painting," in *Futurist Manifestos*, ed. Umbro Apollonio (New York: Viking Press, 1973), 28. On the cultural and artistic impact of the X-ray, see Linda D. Henderson, "X Rays and the Quest for Invisible Reality in the Art of Kupka, Duchamp, and the Cubists," *Art Journal* 47 (Winter 1988), 323-40.

5. Camille Flammarion, *The Unknown* (New York and London: Harper & Brothers, 1901), 14.

6. Ernest Rutherford actually formulated the theory of radioactive decay in 1902-3, following upon the Curies' initial discoveries. For an excellent overview of this period in the history of science, see Alex Keller, *The Infancy of Atomic Physics: Hercules in His Cradle* (Oxford: Clarendon Press, 1983). Mina Loy, among numerous other modernists, responded to the theme of radioactivity, writing of Gertrude Stein in 1924: "Curie / of the laboratory / She

crushed / the tonnage / of consciousness / congealed to phrases / to extract / a radium of the word" (Mina Loy, *The Lost Lunar Baedaeker: Poems of Mina Loy*), ed. Roger Conover [New York: Farrar, Straus, Giroux, 1996], 94).

7. See Gustave Le Bon, *L'Evolution de la matière* (Paris: Flammarion, 1905), 9. On the largely forgotten ether, see the excellent essay by Donald Benson, "Facts and Fictions in Scientific Discourse: The Case of the Ether," *The Georgia Review* 38 (Winter 1984), 825-37. On the modernist response to the ether, see Linda D. Henderson, "Vibratory Modernism: Boccioni, Kupka, and the Ether of Space," in *From Energy to Information: Representation in Science and Technology, Art and Literature*, ed. Henderson and Bruce Clarke (Stanford: Stanford University Press, 2002), 126-49. In addition to a transformed conception of matter and ether as interpenetrating, the other most overt impact of the ether on Modernism in the period was by means of the vibrating Hertzian waves of wireless telegraphy, at times encoded in the symbol of the Eiffel Tower. In 1912 Italian Futurism's founder F. T. Marinetti proclaimed the Futurists' invention of "wireless imagination" or the use of words without the connecting wires of syntax (see F. T. Marinetti, *Marinetti: Selected Writings*, ed. R. W. Flint [New York: Farrar, Straus and Giroux, 1972], 89). Guillaume Apollinaire answered the Futurists' typographical experiments in his visual poem "Lettre-Océan" of June 1914, centered on the motif of the Eiffel Tower with words radiating outward like Hertzian waves. Apollinaire's friend, the artist Marcel Duchamp, had already adopted wireless telegraphy as the model for the communi-

cation between the Bride and the Bachelors in his masterwork, *The Bride Stripped Bare by Her Bachelors, Even* (1915-23); see Linda D. Henderson, *Duchamp in Context: Science and Technology in the Large Glass and Related Works* (Princeton: Princeton University Press, 1989), chap. 8.

8. See Kragh, *Quantum Generations*, 87-89, 91. Although Einstein's 1905 Special Theory of Relativity is sometimes cited as the "death" of the ether, the delayed popularization of Relativity and the continued championing of the ether by prominent scientists such as Sir Oliver Lodge kept it alive as the ultimate sign of continuity and connectivity into the 1920s and beyond.

9. For this history, see again Henderson, *Fourth Dimension*, as well as Henderson, "Mysticism, Romanticism, and the Fourth Dimension," in Los Angeles County Museum of Art, *The Spiritual in Art: Abstract Painting 1890-1985* (New York: Abbeville, 1986), 219-37. Abbott's text, first published by Seeley & Co in London in 1884, remained in print throughout the twentieth century; the best introduction to the book is by longtime Abbott student Thomas Banchoff (1991 Princeton University Press edition).

10. All of the artists named are discussed in Henderson, *Fourth Dimension*, as are Wells (33-35), Varèse (224-28), and Stein (203-10). Wells's 1895 *The Time Machine*, with its focus on a temporal fourth dimension, was almost unique in the pre-Relativity era in extending the eighteenth-century notion that time itself could be considered as a dimension. For the interest of other modern writers in

the fourth dimension as well as in Ouspensky (noted below), see Henderson and Bruce Clarke, eds., *Modernism's Fourth Dimensions* (University Park: Penn State University Press, forthcoming).

11. See "Cosmic Consciousness: A Paper Read Before the American Medico-Psychological Association, 18 May 1894, by Dr. R. M. Bucke" (Philadelphia: The Conservator, 1894); and Richard Maurice Bucke, *Cosmic Consciousness: A Study in the Evolution of the Human Mind* (Philadelphia: Innes & Sons, 1901; New Hyde Park, NY: University Books, 1961). Bucke's book was in its 25th printing at E. P. Dutton in 1968. For Ouspensky's use of Bucke, see P[eter] D[emianovich] Ouspensky, *Tertium Organum, The Third Canon of Thought: A Key to the Enigmas of the World* (1911), trans. Nicholas Bessaraboff and Claude Bragdon, 2nd. Amer. ed. rev. (New York: Knopf, 1922), chap. 23. For Bragdon's theories, see Claude Bragdon, *A Primer of Higher Space (The Fourth Dimension)* (Rochester, NY: The Manas Press, 1913).

12. For the references in this paragraph, see Bucke, "Cosmic Consciousness," 1, 4-8, 10, 18. On Bucke's intellectual history and sources, including Chambers, see Ramsay Cook, "Richard Maurice Bucke: Religious Heresiarch and Utopian," in *The Regenerators* (Toronto: The University of Toronto Press, 1985), chap. 6.

13. Edward Carpenter, *From Adam's Peak to Elephanta: Sketches in Ceylon and India* (London: Swan Sonnenschein, 1892), 155-56; for Bucke's reference, see "Cosmic Consciousness," 12. Bucke quoted extensively from Carpenter's book

in the chapter devoted to him in *Cosmic Consciousness* (chap. 14).

14. For Carpenter's reference, see *From Adam's Peak*, 159-60; quoted in Bucke, *Cosmic Consciousness*, 202-3. Carpenter discussed Myers's ideas further, along with the work of James, in his 1904 *The Art of Creation*. On these figures as well as Du Prel, see Linda D. Henderson, "Mysticism as the 'Tie That Binds': The Case of Edward Carpenter and Modernism," *Art Journal* 46 (Spring 1987), 29-37. On Carpenter, Bucke, and Ouspensky as well as Myers et al., see also Henderson, "Mysticism, Romanticism, and the Fourth Dimension."

15. James McFarlane, "The Mind of Modernism," in *Modernism: A Guide to European Literature 1890-1930*, ed. Malcolm Bradbury and James McFarlane (London: Penguin Books, 1976), 75.

16. Undated Hartley letter to Stieglitz, received Dec. 20, 1912, Stieglitz-O'Keefe Archive, Collection of American Literature, Beinecke Library, Yale University.

17. Carpenter, *From Adam's Peak*, 161; quoted in Bucke, *Cosmic Consciousness*, 203.

18. For Ouspensky's reference to "art," see *Tertium Organum*, 331; for an overview of his philosophy, see Henderson, *Fourth Dimension*, 245-55. On Bucke's and Carpenter's devotion to poetry, see, e.g., Bucke, *Cosmic Consciousness*, 7-8, 198, 207. Ouspensky also proposed a system of alogical logic for individuals to practice in order to free themselves from the

tyranny of three-dimensional thought (see *Tertium Organum*, chap. 21); for his belief in the need for new language, see Ibid., pp. 122-23.

19. Pound, "The Wisdom of Poetry," *Forum* 47 (April 1912), 500; for the "antennae" reference, see "The Teacher's Mission" (1934), in *Literary Essays of Ezra Pound*, ed. T. S. Eliot (London: Faber and Faber, 1960), 58.

20. Wassily Kandinsky letter to Arnold Schoenberg, Jan. 18, 1911, in *Arnold Schoenberg/Wassily Kandinsky: Letters, Pictures, Documents*, ed. Jelena Hahl-Koch (London: Faber and Faber, 1984),

"THE SLOPED WHIMSICAL IRONIC HAND OUT OF MISSISSIPPI ATTENUATED": *ABSALOM, ABSALOM!* IN MANUSCRIPT

JAMES G. WATSON

One achievement of American modernist writing is summed up in what Hugh Kenner characterized as "a homemade world" of self-consciously crafted literary artifacts. William Faulkner famously called his fictional world "a cosmos of my own," insisting in 1955 that "not only each book had to have a design but the whole output or sum of an artist's work had to have a design."[1] His Yoknapatawpha County is the great example of American modernist fiction, and *Absalom, Absalom!*, with its appended genealogy, chronology and map of Yoknapatawpha, is the great example of Faulknerian fictional design. From the outset Faulkner was careful to distinguish the book from a "historical novel"—a *Gone With the Wind*, for example, which was published in the same year. Quentin Compson, from *The Sound and the Fury*, would be the protagonist, he said, "To keep the hoop skirts and plug hats out, you might say."[2] In fact, the book is very much about history—what Quentin makes of it and it of him—but it is also an extended meditation on historical narration and representation, the control of which began with the controlled, decorative design of the physical manuscript.

Faulkner was careful of his manuscripts—he saved them to sell against need, and he gave them as gifts of love over the years—but the *Absalom, Absalom!* manuscript is an aesthetic artifact in itself, as precisely drafted and crafted as the handmade and illustrated manuscript books of the 1920s that he modeled on the work of *fin de siècle* poets and artists. His debts to the visual arts, and to modern painting in particular, carried readily from apprentice work into the major fiction. In their steady formal transformations, the great modernist works that preceded *Absalom, Absalom!* reflect significant aspects of those early experiments in combined linguistic and pictorial design. The four-part structure of *The Sound and the Fury* in 1929, for example, becomes openly Cubist in the fifty-nine block-like chapters of *As I Lay Dying* a year later, and implicitly Cubist juxtapositions thereafter order the counter-posed third-person narratives of the revised and rewritten *Sanctuary* in 1931 and *Light in August* in 1932. *Absalom, Absalom!* is literally *about* the geometries of palimpsestic narration that give it form. It is Faulkner's most modernist novel, and the pictorial elegance and draftsman-like precision of the 175-page manuscript reflect the richly interwoven narratives transcribed there.

Faulkner's was an exacting visual imagination; he disliked what he called "fumbling" in any form. He illustrated his letters from the Royal Air Force in Toronto in 1918 with sophisticated line drawings of himself in uniform (Fig. 1)

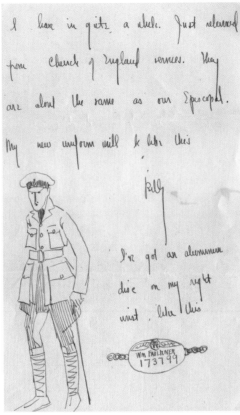

1) Drawing of officer, letter from William Faulkner in Toronto, 1918.

and contributed *art nouveau* drawings and cartoons to the University of Mississippi annual for 1919-1920. Living in New Orleans in 1925, among the artists of the Vieux Carré, he would remember Swinburne for the spatial qualities of his verse, calling him "a flexible vessel into which I might put my own vague emotional shapes without breaking them."[3] The stylized forms of *fin de siècle* poetry led him early to Oscar Wilde and to the pictorial modes of Wilde's illustrator, Aubrey Beardsley. In 1920 he hand-printed and -bound perhaps seven copies of his *commedia dell'arte* verse play *The Marionettes*, illustrating the text with Beardsleyan pen-and-ink drawings that imitate those in Wilde's *Pierrot* (Fig. 2). From New York in the fall of 1921, he wrote to his mother of his intention to test his "purely personal" ideas about line drawing by enrolling in a night drawing class.[4] He never did, but in Paris in 1926 he supplemented his Metropolitan Museum experience of Cézanne with "the more-or-less moderns, like Degas and Manet and Chavannes" at the Louvre and "a very modernist exhibition" at a small gallery of Futurist and Vorticist paintings (SLWF, 13). Internal evidence in *As I Lay Dying* suggests that he also knew and admired the collage works of artists such as Paul Klee. As Cash Bundren says in that novel, "Folks seem to get away from the olden right teaching that says to drive the nails down and trim the edges well always like it was for your own use and comfort you were making it."[5] Home from Paris in January 1926, he gave Helen Baird the manuscript book *Mayday*, with its Beardsleyan drawings in the front and back endpapers and three gorgeous watercolor miniatures, the last of which appears to be set in Cézanne's Forest of Meudon. In October that year, he made for Estelle Oldham Franklin the little book *Royal Street: New Orleans*: the crowned woman and cherub in the front endpapers are adapted from Beardsley's drawing "The Eyes of Herod" from Wilde's *Salome* (Fig. 3).

The visual experiments in such early, personal work and the self-conscious designs that extend from the illustrations to the stylized calligraphy are reflected on the pages of the *Absalom, Absalom!* manuscript (Fig. 4). The broad, carefully hand-drawn margins at the top and left of each sheet are so regular that they appear machine printed. The first page bears the date March 30, 1935, in the top left-hand corner and in the upper margin the double underlined title *Absalom, Absalom!*; balanced below on either side of the title are the note "Begun Oxford, 1935 / Continued, California, 1936 / Finished, Oxford, 1936" and the signature "William Faulkner / Oxford, Miss." Successive sheets

contain a page number or numbers in the upper left quadrangle formed by the margin lines, the cancellations indicating Faulkner's rearrangement of scene and sequence as his conception of the book evolved. The left margin accommodates brief emendations and additions to the text; tiny, penciled numbers 1 through 6 at each tenth line mark the sixty-line 1000-word blocks by which the novelist measured his deliberate progress on the book. Framed by the margins the lines of delicate, barely legible handwriting are so straight and evenly spaced that they might have been written on invisibly lined paper, or typed, perhaps, on Faulkner's ancient Underwood in a tiny hieroglyphic font, fifteen to eighteen words to each line. Single words and short phrases are cancelled with a single straight line; extended cancellations are outlined and cross-hatched; and on many sheets rectangular pieces clipped from previously written leaves are pasted in, sometimes over existing text, the writing parallel and the margins carefully aligned. There are 509 such paste-ins in the manuscript. The four colors of ink on the manuscript sheets and paste-ins offer intriguing hints about the composition history of the manuscript, but the immediate effect of these revisions and emendations is strikingly pictorial. The nineteenth manuscript sheet bears cancelled page numbers 18, 10, and 18 at the top followed by the number 11; two pasted-in sections of text, one in blue and one in green ink, dominate the page, framed at the top by two lines of text in black ink and three cancelled lines in black at the bottom. A brief emendation to each paste-in is penned in black ink in the margin. Inscribed in Faulkner's own "sloped whimsical ironic hand out of Mississippi attenuated," the carefully divided sheet that became page eleven, the regular lines of writing in different ink colors, and the faint edges and slightly raised corners of the paste-ins resemble nothing so much as a Cubist collage.[6]

The text of the novel reflects these strongly visual effects in its photographic and cinematic images and in the several direct references to Faulkner's painterly sources. Faulkner owned a good Leica camera in the 1930s and learned photographic processing from the Oxford photographer and portraitist J.R. Cofield. He worked as a script-writer for Howard Hawks on two films related in their narrative situation to *Absalom, Absalom!*: *Today We Live* (1932), which he helped to adapt from his own story "Turn About," and *The Road to Glory* (1936). In a scene of extended photographic imagery in Chapter IV of the novel, Mr. Compson imagines Charles Bon exposing Henry Sutpen to New Orleans as he might expose a photographic plate to light, "stroking onto the

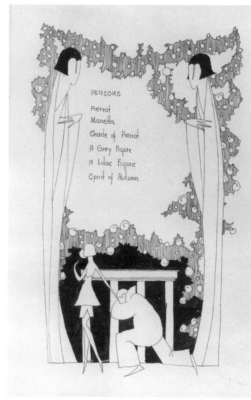

2) Pen-and-ink drawing in *The Marionettes*.

plate himself now the picture which he wanted there" (AA!, 88). Although Faulkner insisted in the 1930s that film-making was collaborative hack-work, he turned to the visions and revisions of collaborative telling when he turned back to *Absalom, Absalom!* in March 1935, and to the conventions of script-writing. The scene in the Civil War camp that Quentin and Shreve imagine near the end of the book draws special theatrical force from stage directions: "Now Henry speaks," "Bon pauses and looks at Henry," "He swings the cloak from his shoulders and holds it out" (AA! 283-284). Like the fateful Player who oversees Thomas Sutpen's "design" in *Absalom, Absalom!*, Faulkner is the literal "stage manager" of the manuscript as of the novel (AA!, 57), the "Sole Owner & Proprietor," as he describes himself on the map, of the world of the book.

In *Light in August* in 1932 he had turned again to Aubrey Beardsley, whose drawings he had imitated in *The Marionettes*, to describe Joanna Burden "in the wild throes of nymphomania, her body gleaming in the slow shifting from one to another of such formally erotic attitudes and gestures as a Beardsley of the time of Petronius might have drawn."[7] Now he invoked the same source in an expanded scene where Mr. Compson imagines Charles Bon's octoroon mistress and son visiting his grave. Even in the slightly notational style of the manuscript, the scene is powerfully pictorial.

> there she was, with the 10 year old boy and it must have been fine, like a garden scene in Oscar Wilde; late p.m. the dark cedars, the sun, the very light just right and the graves, the 3 pieces of marble like they had been cleaned and polished and arranged by the scene shifters, presently to be struck and carried, hollow fragile and without weight, back to the storehouse until they would be needed again—and the pageant, the scene, entering the stage—the magnolia~~colored~~ <faced> woman a little plump now, ~~in a soft voluminous~~ [MARGIN: ~~languid and in a costume which~~] a woman created ~~for darkness~~ of by and for darkness <whom Beardsley himself might have dressed> in a soft voluminous gown.[8]

Like the stories-in-stories of the *Absalom, Absalom!* narrative, this tableau is a picture transcribed upon a pictorial page. The names of Wilde and Beardsley, the *fin de siècle* formal garden, the imagery of costumes and theatre, and especially, perhaps, the carefully observed quality of light combine linguistic and visual allusions in a complex design that recalls, on this decorative page, the

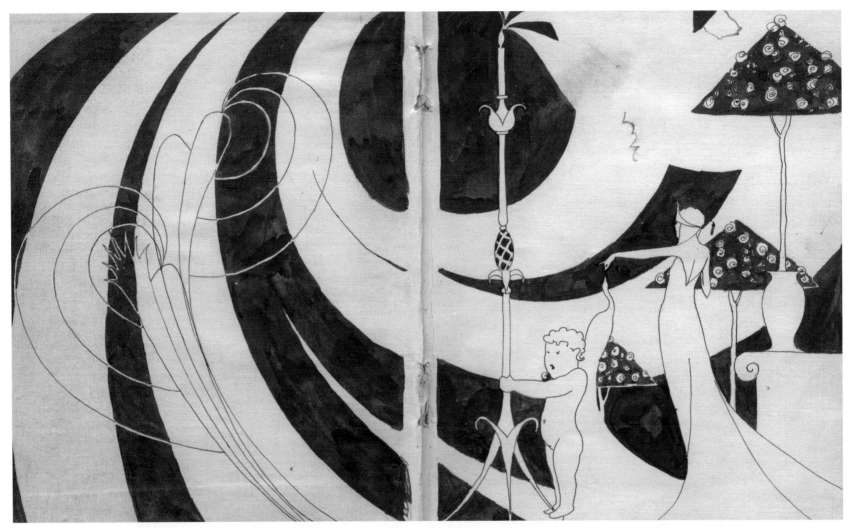

3) Crowned woman and cherub, front endpapers, *Royal Street: New Orleans.*

manuscript books by which Faulkner once declared himself poet, dramatist, fabulist, illustrator and artist.

More even than those works, however, the *Absalom, Absalom!* manuscript seems an exotic artifact made exclusively for the artist's own pleasure—the intimate, secret pleasure of solitary imaginative performance. Crucial to the compositional process, the manuscript never was intended to be shared with an editor. Indeed, since he typed and revised the book chapter by chapter as he composed it, he not only was its maker but its first and probably only reader—at least until he sent it to a bookseller who had it bound for sale in 1939. In 1931 he remembered that in writing *The Sound and the Fury* he had experienced what he called "that ecstasy, that eager and joyous faith and anticipation of surprise which the yet unmarred sheets beneath my hand held inviolate and

unfailing."[9] He thought then that the emotion would not return, but the self-conscious aesthetic design of the manuscript he began in March 1935 and finished a remarkable ten months later on January 31, 1936, belies that. He must have known in that period of intense creativity the elation of creating his character's design in the image of his own, "the *Be Sutpen's Hundred*," as Quentin imagines it, "like the oldentime *Be Light*" (AA!, 4). The yet unmarred sheets on which he transcribed that design must have offered a refuge, too, from a world of financial and personal difficulties that included his wife's filing for divorce on grounds of desertion in October and the death of his youngest, and favorite brother, Dean, in November. As he had in a time of intimate difficulties eight years before, he retreated to the sanctuary of his homemade world and the daily ecstasy of its creation.

4) Ms. page of *Absalom, Absalom!* (1936).

NOTES

1. Hugh Kenner, *A Homemade World: The American Modernist Writers* (New York: William Morrow, 1975); *Lion in the Garden: Interviews with William Faulkner, 1926-1962*, ed. James B. Meriwether and Michael Millgate (NY: Random House, 1968), p. 255.

2. *Selected Letters of William Faulkner*, ed. Joseph L. Blotner (New York: Random House, 1977), p. 79. Cited hereafter as SLWF.

3. "Verse Old and Nascent: A Pilgrimage," *William Faulkner: Early Prose and Poetry*, ed. Carvel Collins (Boston: Little, Brown, 1962), p. 114.

4. *Thinking of Home: William Faulkner's Letters to His Mother and Father, 1918-1926*, ed. James G. Watson (New York: Norton, 1992), p.159.

5. *As I Lay Dying*, Corrected Edition (New York: Random House, 1990), p. 234.

6. *Absalom, Absalom!* Corrected Edition (New York: Random House, 1986), p. 301. Cited hereafter as AA!

7. *Light in August*, Corrected Edition (New York: Random House, 1990), pp. 259-260.

8. The transcription is Gerald Langford's in *Faulkner's Revision of Absalom, Absalom!: A Collation of the Manuscript and the Published Book* (Austin: University of Texas Press, 1971), pp. 202-203.

9. "An Introduction to *The Sound and the Fury*," *A Faulkner Miscellany*, ed. James B. Meriwether (Jackson: University Press of Mississippi, 1974), p. 160.

FROM *PELLÉAS TO PARADE*: THE CHANGING FACE OF FRENCH MUSICAL MODERNISM

M A R I A N N E W H E E L D O N

By a unique stroke of irony, this public which demands "something new" is the same one that is bewildered by, and jeers at, anything new or unusual, whenever someone is trying to break away from making the customary hullabaloo. This may seem hard to understand, but one must not forget that with a work of art an attempt at beauty is always taken as a personal insult by some people.
—Claude Debussy, "Why I Wrote Pelléas," April 1902

Debussy's comments, written less than a month before the première of *Pelléas et Mélisande*, would prove to be well-founded.[1] The final dress rehearsal, which was open to the critics and general public, was the scene of much commotion. At different points throughout the performance there were outbursts of laughter at portions of the text and Mélisande's Scottish accent, sarcastic comments hurled at the more unbelievable elements of the plot, and cries of protest at the perceived immoralities of the drama. With advance negative publicity surrounding *Pelléas*, and the critics poised to report on this disastrous public dress rehearsal, the success of Debussy's opera was not at all certain.

Yet after a shaky start, *Pelléas* managed to succeed artistically and at the box office. Perhaps because of the controversy, as Jann Pasler reports, "the work made more money than such established repertoire items as *Carmen* and *Manon* and for most of its performances, significantly more than the monthly average of all operas."[2] Moreover, the continued debate over *Pelléas* in every newspaper and journal helped to keep Debussy's opera in the repertory. From 1902 to 1914, the Opéra-Comique performed *Pelléas* in every season except two, and presented its hundredth performance on January 25, 1913.[3]

The artistic success of the opera owed much to a group of young students who attended not only the dress rehearsal and première, but all fourteen performances of the 1902-03 season (and many more in seasons to follow). With their applause and cheers emanating from the balcony, these fervent admirers of Debussy ensured that there would always be supporters present to counterbalance any future protests. The *Debussystes*, as they became known, declared the composer the leader of a new school and lauded him for his innovation, daring, and originality. *Pelléas et Mélisande* broke away from the prevailing dominance of the Italian style (and, to a certain degree, from Wagner) to create an opera without arias, vocal virtuosity, or rousing choruses and dances (Fig. 1). The novel harmonic sounds, unusual timbres, and original forms of *Pelléas*, the *Debussystes* believed, liberated French music from the ossified rules and alien traditions of music composition, and cleared

1) Opening of Act 1, Scene 1 *Pelléas and Mélisande* (vocal score, Paris, E. Fromont, c. 1902).

the way for a new and truly modern style. Among this influential group were the composers Maurice Ravel and Charles Koechlin; the conductor D.E. Ingelbrecht; the poet Léon-Paul Fargue; the pianist Ricardo Viñes; and the music critics Louis Laloy, Emile Vuillermoz, and M.D. Calvocoressi, who used their positions to regularly propound *Debussyste* views in the press.

Another among this group of supporters was the composer Erik Satie who, like the *Debussystes*, regularly attended performances of *Pelléas* but, unlike most of that group, actually numbered among Debussy's closest friends. Though accounts differ on how and when the two composers met, the music scholar Robert Orledge speculates that they first befriended each other in 1891 or 1892, and continued to meet "once a week, *chez* Debussy over a period of more than 25 years.[4] The enduring friendship between Satie and Debussy at first seems to be an attraction of opposites. Debussy, a distinguished graduate of the Paris Conservatoire and a *Prix de Rome* winner in 1884, lived and worked in Paris in a style that grew only more comfortably bourgeois after the success of *Pelléas* (Fig. 2). Satie, on the other hand, was expelled from the Paris Conservatoire after two years of study, was never considered for any competitions, labored in obscurity for most of his career, and in 1898 left Paris in order to find cheaper accommodations in the suburb of Arcueil.

Yet the two composers had more in common than such outward appearances would suggest. They both despised the outdated traditions of the Conservatoire; they shared interests in the cabaret, music hall, and the occult; and Debussy was financially as badly off as Satie, as he sank further and further into debt trying to support a lifestyle he could not afford. Their weekly conversations—spurred on by much fine wine and gourmet food—involved long discussions on music with the composers playing their latest works at the piano. Thus Satie was privy to the entire nine-year genesis of *Pelléas*: from Debussy's discovery of Maeterlinck's play (1893), through the composition of the piano score (1893-95), the negotiations and setbacks of trying to secure its performance (1895-1901), to the orchestration of the piano score and the final rehearsal period in the months leading to the première (January 13-April 30, 1902).

In retrospect, *Pelléas et Mélisande* would prove to be a turning-point for both composers. For Debussy, the success of his opera catapulted him to the forefront of modern French composition, and the *Debussystes*, who had formed after the première of *Pelléas*, continued to support (and dog) him for the rest of his career. For Satie, on the other hand, the effect of *Pelléas et Mélisande* forced him to reconsider his musical path. As Jean Cocteau recalled, Satie had lamented to him that "nothing more can be done in this

direction; I must search for something else or I am lost."[5] Satie's career path after *Pelléas* was certainly unusual, and one can speculate the degree to which Debussy's opera was the catalyst. After the opera's first season, Satie composed very little, completing only one work, which cobbled together a group of unpublished cabaret songs and instrumental sketches. In 1905, at the age of forty and after a year of struggling with composition, Satie made the startling decision to return to school. From 1905-1908, he enrolled at the Schola Cantorum in the counterpoint classes that were a prerequisite of the composition program. After receiving his diploma in counterpoint in 1908, Satie continued to take composition classes at the Schola until 1912, though ultimately he never completed the program.

Satie's decision to attend the Schola Cantorum was prompted by insecurities over his compositional training, insecurities that were no doubt compounded by the towering technical achievement of *Pelléas et Mélisande*. For seven years, Satie assiduously applied himself to exercises in counterpoint, fugue, canon, sonata forms, and orchestration—studies that not only filled huge gaps in his musical education, but also distanced him from Debussy, who had received a very different training from the Conservatoire. It was while he was still at the Schola that Satie began to receive a measure of recognition for his early compositions, which no doubt contributed to his decision to discontinue his studies there. In 1911, Ravel organized a concert of Satie's music and, following suit, Debussy conducted his own orchestrations of Satie's compositions in a performance a few months later. These delayed debuts of his music—some of the works performed were now over twenty years old—introduced Satie to a new audience, one that previously knew him (if they had heard of him at all) as a composer for the cabaret and music hall. At this point, Satie's luck changed: his works began to be published, performances grew more frequent, and he started to receive commissions for the first time in his career (Fig. 3).

Perhaps the most important engagement to propel Satie to the vanguard of modern French music came from Diaghilev and the *Ballets Russes*. From 1909 to 1914, this company represented all that was chic and controversial, with Diaghilev acting as "the premier purveyor of artistic newness" in Parisian culture.[6] If the choices of Diaghilev signaled the "hot" composer of the moment, then the move away from Ravel (*Daphnis et Chloé*) and Debussy (*L'Après-midi d'un faune* and *Jeux*), and the decision to remain with Stravinsky (*Le Sacre du printemps*) and move to Satie (*Parade*) illustrates not only Satie's ascendancy but also the changing direction of French music. In fact, the decision to commission Satie for the *Ballets Russes* rested not with Diaghilev but with Jean Cocteau. Cocteau had previously created a scenario

2) Ivan Thièle, portrait of Claude Debussy, soft-ground etching, signed, 1927.

for a *Ballets Russes* production of 1912, and he was desperate to work again with the company. Diaghilev's advice to Cocteau in this regard amounted to nothing more than the words "Étonne-moi, Jean" (Astonish me, Jean) and Cocteau—upon hearing Satie's music for the first time in 1915—felt that Satie's collaboration would help to guarantee the astonishment that Diaghilev demanded. Along with Picasso (sets and costumes) and Léonide Massine (choreography), Cocteau created a scenario that was unique for its appropriation of the sights and sounds of the fairground spectacle to the realm of high art (Fig. 4).

The music Satie composed for *Parade* correspondingly combined his talents as a cabaret composer with the contrapuntal skills he acquired at the Schola Cantorum. The centerpiece of *Parade* presents a pastiche of Irving Berlin's "That Mysterious Rag," while the "Choral"—which opens and closes the ballet—displays Satie's newly-refined fugal writing. The other movements feature pared-down textures, cabaret-infused numbers, with miniature melodic and rhythmic ideas that are mechanically repeated. Perhaps the most radical feature of the ballet, however, is the inclusion of everyday noises in the musical score. The sounds of sirens, a typewriter, revolver shots, Morse code signals, and a steamboat foghorn surprise listeners even today. But it was Cocteau, not Satie, who specified these sounds, and Satie only reluctantly allowed them a place in his music.[7]

The première of *Parade* took place on May 18, 1917 in a matinee performance for the War Benefit Fund. This was the first performance of the *Ballets Russes* since the outbreak of war, and expectations were high. With Satie's unusual score, Cocteau's fairground scenario and futurist noises, Picasso's Cubist designs, and an audience expecting to see something akin to the opulence of the pre-war *Ballets Russes* productions, the reception was riotous. The audience booed the production, and insults such as "sales boches" (dirty Krauts), "trahison" (treason), and "art munichois" (Munich art) were hurled at the performers: the production was considered too avant-garde, and all advanced art had been deemed un–French and unpatriotic since the start of the war.[8]

Like Debussy with *Pelléas*, Satie now had his own *succès de scandale* which only underscored his rising fortunes on the Parisian musical scene. Unfortunately, Satie's newfound success as a composer led to the deterioration of his friendship with Debussy. Debussy, though his place at the forefront of modern French music remained secure, could not understand his friend's growing reputation. The first signs of ill-will between the two composers occurred in 1911, when Satie was first receiving notice for music. In a letter to his brother Conrad, Satie complained:

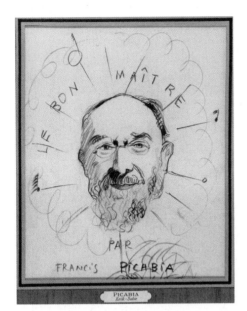

3) Francis Picabia, portait of Erik Satie ("Le Bon maître par Francis Picabia"), pencil drawing, signed, no date.

One person who isn't pleased is the good Claude…. The success achieved by the Gymnopédies *at the concert conducted by him at the Cercle Musical—a success which he did everything to turn into a failure—gave him an unpleasant surprise…. Why won't he allow me a very small place in his shadow?* [9]

And the attention given to *Parade* caused the composers to break entirely. Satie wrote to Debussy's wife Emma to explain that he will no longer be visiting, and complained of "painful teasing" from Debussy that was "quite unbearable." Six months later, another letter confirms the end of the friendship: "You speak to me of Debussy? I no longer see him. *Parade* separated me from a great many friends." [10]

Though *Parade* severed some ties for Satie, it also created many new ones. Satie now became the leader of *Les Nouveaux Jeunes*, a group of young composers that later crystallized into *Les Six*. This next generation of musicians believed that Satie's compositional style pointed the way toward a new aesthetic in music, one that repudiated the achievements of the pre-war years and looked to a leaner, sparer, and more "classical" style that was often infused with the sounds of popular music. The vast and virtuosic symphonic works of the pre-war years now seemed over-indulgent in the newfound austerity of the war years. The orchestral mastery manifest in Debussy's *Pelléas et Mélisande*, and in subsequent works of his such as *La mer* (1903-5) and *Jeux* (1913), was something that Satie could never have achieved but, fortuitously, had now gone out of fashion. Thus, the première of *Parade* effectively ended Debussy's tenure as one of the leaders of French musical modernism, with Satie now assuming that place. Although the two composers never spoke again, they did manage to reconcile: just weeks before Debussy's death in 1918, Satie sent his old friend a note of apology, to which Debussy is said to have quietly muttered an apology of his own in return. [11]

NOTES

1. Claude Debussy, *Debussy on Music*, ed. and trans. Richard Langham Smith (New York: Knopf, 1977) 75.

2. Jann Pasler, "*Pelléas* and Power: Forces Behind the Reception of Debussy's Opera," *Nineteenth-Century Music*, Vol. 10, No. 3 (1987) 244.

3. Roger Nichols, "*Pelléas* in performance I—a history," *Claude Debussy: Pelléas et Mélisande*, ed. Roger Nichols and Richard Langham Smith (Cambridge: Cambridge University Press, 1989) 149.

4. Robert Orledge, "Debussy and Satie," *Debussy Studies*, ed. Richard Langham Smith (Cambridge: Cambridge University Press, 1997) 154.

5. Jean Cocteau, "Fragments d'une conférence sur Eric [sic] Satie (1920)," *Revue musicale*, 5 (1924) 217-23. Cited in Robert Orledge, *Satie the Composer* (Cambridge: Cambridge University Press, 1990) 55.

6. Kenneth Silver, *Esprit de Corps: the Art of the Parisian Avant-Garde and the First World War, 1914-1925* (Princeton: Princeton University Press, 1989) 114.

7. Steven Moore Whiting, *Satie the Bohemian: From Cabaret to Concert Hall* (Oxford: Oxford University Press, 1999) 481.

8. Silver, *Esprit de Corps*, 116 and 118.

9. Erik Satie, *Satie Seen Through his Letters*, ed. Ornella Volta, trans. Michael Bullock (London and New York; Marion Boyars, 1989) 147.

10. Satie, *Satie Seen Through his Letters*, 148-9.

11. Orledge, "Debussy and Satie," 177.

4) Pablo Picasso, signed pencil drawing of Jean Cocteau, creator of and librettist for *Parade*, with Marie Chabelska, who danced the role of the Little American Girl. Picasso sketched the caricature while they were in Rome during the winter of 1917 for rehearsals of *Parade*.

The grotto, Act II, Scene iii, *Pelléas and Mélisande*, original production, Opera Comique, Paris, 1902, sets by Lucien Jusseaume and Eugéne Ronsin.

DANIEL ALBRIGHT

Daniel Albright teaches English at Harvard University. His books include *Quantum Poetics: Yeats, Pound, Eliot, and the Science of Modernism* (1997) and *Untwisting the Serpent: Modernism in Music, Literature, and Other Arts* (2000). Two books are forthcoming this year: *Beckett and Aesthetics* (Cambridge University Press) and *Modernism in Music: An Anthology of Sources* (University of Chicago Press).

ANTHONY ALOFSIN

Anthony Alofsin is Roland Roessner Centennial Professor of Architecture and Professor of Art History at the University of Texas at Austin. For 2003-2004 he is Ailsa Mellon Bruce Senior Fellow, Center for Advanced Studies in the Visual Arts, National Gallery of Art, Washington, D.C.

EDWARD BISHOP

Edward Bishop has done considerable work on the relationship between modernism, publishing, and the creation and use of archives. He is Professor of English at the University of Alberta, Edmonton.

CHRIS FLETCHER

Chris Fletcher completed a Ph.D at Edinburgh University, Scotland, on the aesthetics of British Modernism and has published on a number of literary subjects including Joseph Conrad. He is curator of literary manuscripts at the British Library.

KURT HEINZELMAN

Kurt Heinzelman is Professor of English and Executive Curator of Academic Programs at the Harry Ransom Center, University of Texas at Austin. He is the author of several prize-winning books, including *The Economics of the Imagination*, and has been a Fulbright Fellow at Edinburgh University and a Fellow of the Society for the Humanities at Cornell University.

LINDA DALRYMPLE HENDERSON

Linda Dalrymple Henderson is the David Bruton, Jr. Centennial Professor in Art History at the University of Texas at Austin and is the author of *The Fourth Dimension and Non-Euclidean Geometry in Modern Art* (Princeton, 1983; new ed., MIT Press, 2001) and *Duchamp in Context* (Princeton, 1998).

JAMES G. WATSON

James G. Watson is Francis W. O'Hornett Professor of English at the University of Tulsa, editor of *Thinking of Home: William Faulkner's Letters to His Mother and Father, 1918-1926* (1992), and author of *William Faulkner: Self-Presentation and Performance* (2000).

MARIANNE WHEELDON

Marianne Wheeldon received a Ph.D in Music Theory from Yale University. In 2001 she joined the faculty of the School of Music at the University of Texas at Austin as an Assistant Professor.

154

Jean Epstein (1897-1953), *Bonjour Cinéma*. Collection des tracts. Paris: Editions de la Sirène, 1921. Like Apollinaire, Epstein was Polish-born. Working in Paris, mainly on film theory, he also produced some films with Luis Buñuel. Epstein believed that cinema was first and foremost a kind of machinery and that it should avoid, at all costs, narrative, with its over-emphasis on chronology and representational subjects.

MODERN TIMES

AFTERWORD

The title of Charlie Chaplin's film, *Modern Times* (1936), is inherently ironic, for any era called "modern" is becoming, even as it happens, a part of history. Therefore, being modern requires historical consciousness. Bruno Latour, the sociologist of science, says that the modern always signifies "a break in the regular passage of time." His colleague, the French literary critic Henri Meschonnic, puts it even more bluntly: "La modernité est un combat."

Some fifty different aesthetic "-isms" flourished between 1886 and 1924, and to these movements one could add communism, nationalism, colonialism, imperialism, and fascism. Yet the word "Modernism" itself did not enter our general vocabulary until the 1930s, as an historical term for the first few decades of the century.

Experience, the life we actually live, is a function of history. Being modern is a function of culture, and culture is what helps us temper the ravages of history. Culture bequeaths the knowledge that experience can be shaped and arranged—that it can, therefore, carry meaning beyond the solitariness of one's own experience. And culture is also what confirms that such meaning will, sooner or later, matter. Whether or not we can ever *be* modern, we always live *in* modern times.

(K H)

COLOPHON

Gill Sans and Electra, the typefaces used in this book, were created by two preeminent typographers whose influence on modern typographic design continues today. Gill Sans was created by Eric Gill (1882-1940), an English stonecutter working in Wales. Eric Gill's Sans was influenced by the current thinking of his time—that modern type design led toward simplicity and functionality, veering from the decorative type styles of the past. The creator of Electra, William Addison Dwiggins (1880-1956), designed typefaces specifically for the linotype machine. In the 1930s and 1940s, he also created the typographic house style of Alfred A. Knopf, Inc., in New York. Both of these typographers are significantly represented in the collections of the Harry Ransom Humanities Research Center, which also houses the archive of the Knopf publishing firm, founded in 1915.

HARRY RANSOM
HUMANITIES RESEARCH
CENTER

THE UNIVERSITY OF TEXAS AT AUSTIN